HELL'S CORNER

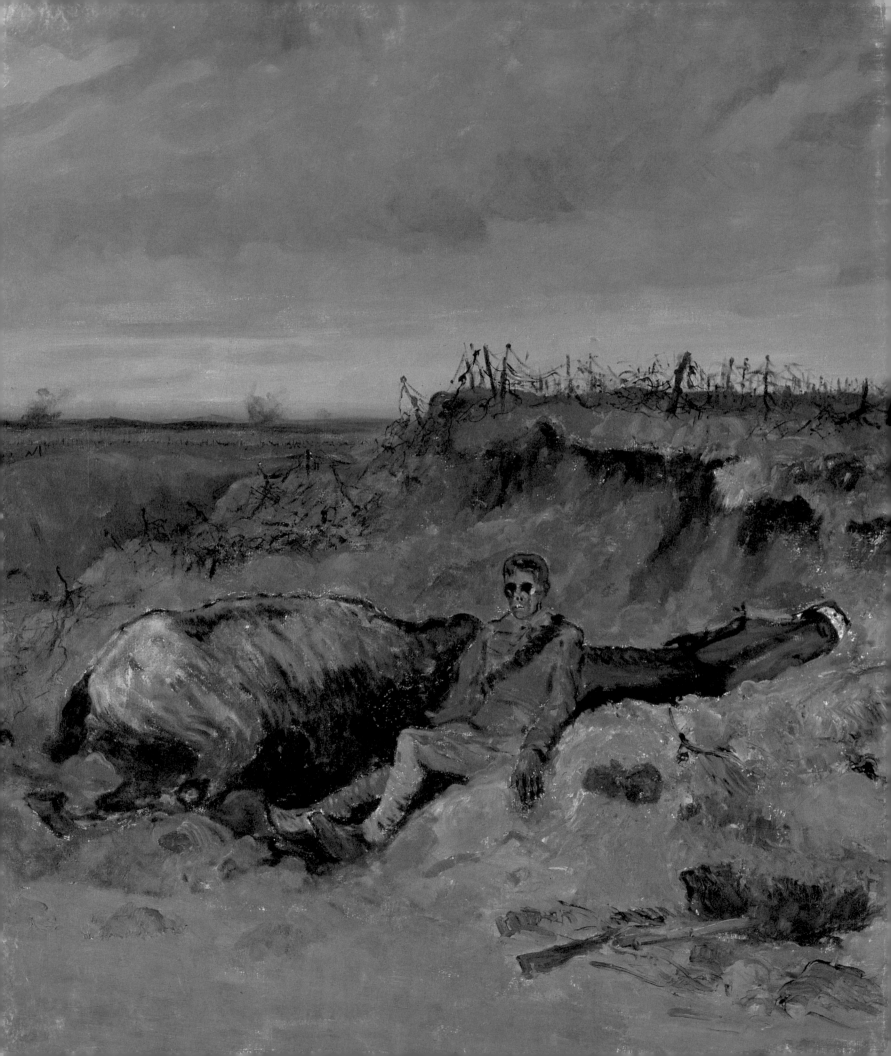

J.L. GRANATSTEIN

HELL'S

AN ILLUSTRATED HISTORY OF CANADA'S GREAT WAR | 1914–1918

CORNER

Douglas & McIntyre

VANCOUVER/TORONTO

04 05 06 07 08 5 4 3 2 1

Douglas & McIntyre Ltd.
2323 Quebec Street, Suite 201
Vancouver, British Columbia
Canada V5T 4S7
www.douglas-mcintyre.com

National Library of Canada Cataloguing in Publication Data
Granatstein, J. L., 1939–
Hell's corner : an illustrated history of
Canada's Great War, 1914–1918 / J. L. Granatstein.
Includes index.

ISBN 1-55365-047-6

I. World War, 1914–1918—Canada—Pictorial works. I. Title.
D547.C2G72 2004 940.3'71 C2004-900109-4

Editing by John Eerkes-Medrano
Jacket and text design by Peter Cocking
Front jacket photograph: CWM 19910162-009 P.81
Back jacket photograph: National Archives of Canada PA-003286
Frontispiece image: CWM Cullen 8140
p. vi photo: CWM 19680113-001#1 P.65F
Printed and bound in China by C&C Offset
Printed on acid-free paper

We gratefully acknowledge the financial support of the
Canada Council for the Arts, the British Columbia Arts Council,
and the Government of Canada through the Book Publishing Industry
Development Program (BPIDP) for our publishing activities.

CONTENTS

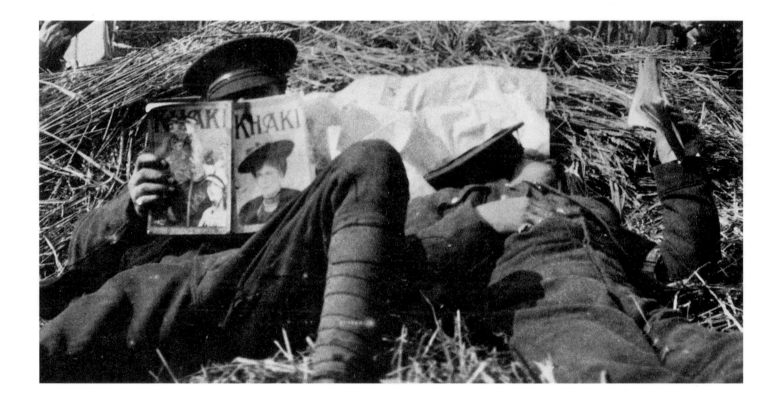

ACKNOWLEDGEMENTS

I HAVE, AS ALWAYS, benefited from the assistance of individuals and institutions. Gabrielle Nishiguchi did the photographic and war art research for me with great skill and industry. Dr. Serge Bernier, the director of history and heritage at National Defence Headquarters, Ottawa, graciously gave permission for me to use the superb maps prepared by his directorate and the Department of National Defence. I am most grateful to him.

The Canadian War Museum facilitated research in its photographic and war art collections, neither hitherto used as much as they ought to be. I was director and CEO of the museum from 1998 to 2000 and, in the spirit of full disclosure, I should say that this project began after I returned to private life in Toronto. The payment for use of CWM materials was negotiated between Scott McIntyre, the publisher, and the museum. In other words, this was a normal business transaction. The only way in which "insider" information was involved was that, while I was at CWM, I became fully aware of the richness of its resources and determined to make use of them in my future work.

J.L.G.
Toronto, 2004

INTRODUCTION

THE ILLUSTRATED LONDON NEWS of April 21, 1917, had extraordinary news to report. It published a full page of photographs to mark "America's Entry into the War: The Stars and Stripes in London," including British prime minister David Lloyd George's visit to the American Luncheon Club, where Washington's ambassador, Walter Hines Page, presided. Lloyd George spoke happily as he saluted "the American nation as comrades in arms" in the "struggle against military autocracy throughout the world."

Less heartening for the Allies was the menacing situation in Russia. "The Russian Revolution: Historic Scenes in Petrograd," the *News* reported, darkly pointing to "the types of men who took part in the street fighting" and showing "a regiment with the Red Flag outside the Tauris Palace." What was to come no one could yet comprehend, but if Russia left the war the Allied cause was surely in doubt.

The featured event for the magazine, however, was a victory: "The Great Canadian Exploit: The Taking of Vimy Ridge." Five pages of photographs showed the Canadian Corps' Easter Monday assault on the hitherto impregnable German position, and the text made clear that this was "a splendid feat of arms." Philip Gibbs, the British war correspondent, reported that "the Canadian attack yesterday was astoundingly successful and was carried out by high-spirited men . . . who had before the advance an utter and joyous confidence of victory." "The opening of the bombardment," another journalist said, "was as stupendous a spectacle as anything ever seen in war. Hardly anybody was prepared for the magnitude

of the artillery concentration which we brought to bear." The enemy defenders "were eager to surrender," *The Illustrated London News* cheered, and "as the Canadians came up to them with wave after wave of bayonets, the German soldiers streamed out and came running forward with their hands up." The Canadians had won the day, scoring a glorious victory by removing "from our path the great barrier for which ourselves and the French have fought through bloody years."

The taking of Vimy Ridge, a great and spectacularly successful set-piece battle, has become part of Canadian lore. The four divisions of the Canadian Corps had taken a position that no one else had managed; and their triumph, coming well before the Americans put troops at the front and while Czarist Russia trembled on the brink of collapse, provided hope and comfort for the Allies. What no one at the time mentioned was that the Canadians had suffered 10,600 casualties in capturing the ridge, a sixth of the total front-line strength of the corps' four divisions and almost a third of the infantry involved.

For Canadians, the victory was a coming of age, a sign of national maturity—or so it was painted. Typical was Lieutenant-Colonel Alex Ross, a battalion commander at Vimy, who said: "It was Canada from Atlantic to Pacific on parade. I thought . . . that in those few minutes I witnessed the birth of a nation." But it had been a long, bloody road for the Canadians from the outbreak of war in August 1914, and the Canadian Corps' road past Vimy was destined to be bloodier still.

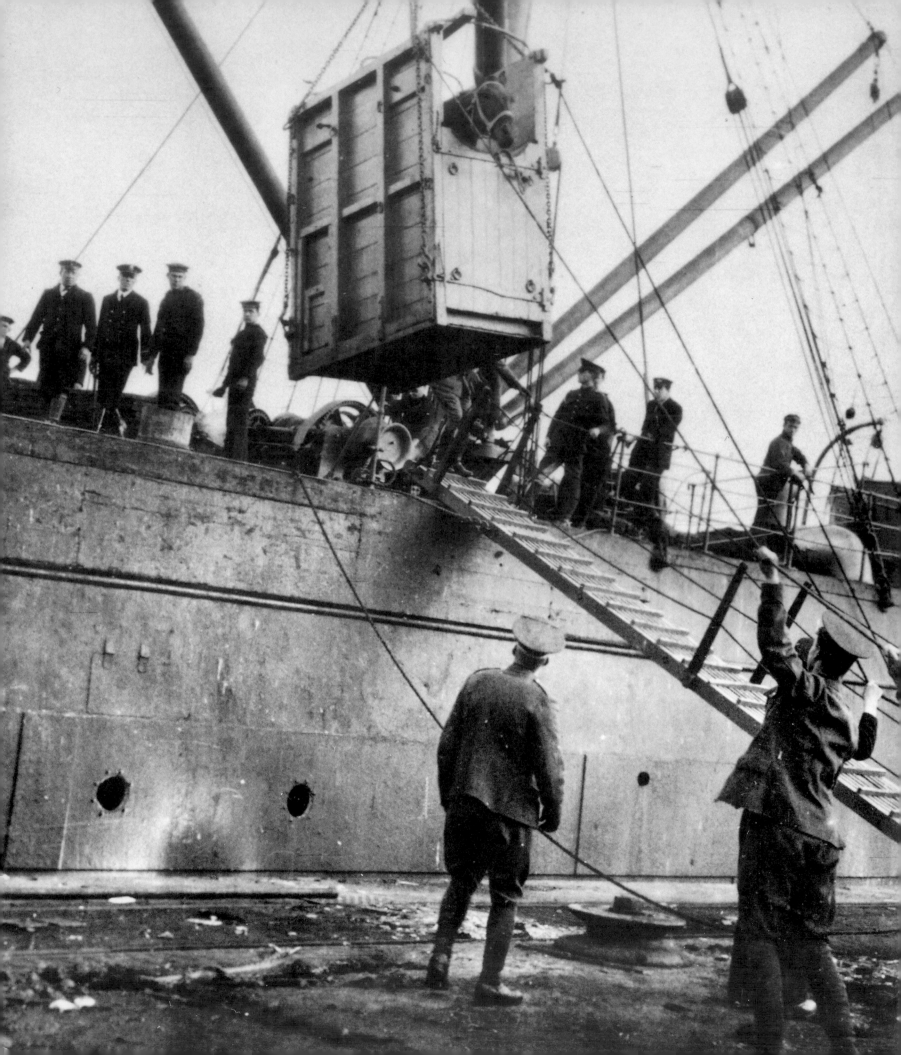

LEFT: Loading the ships with the men and equipment of the First

Contingent was a Herculean task, one that was largely messed up by

Sam Hughes's planners. Here we see a horse being winched aboard

ship at Quebec City. (CWM 19950115-006 P.21)

1 | FORMING UP: CANADA GOES TO WAR

"READY AT MOMENT'S NOTICE," militiaman Will VanAllen wired from Calgary to his militia unit in Rosetown, Saskatchewan, on August 7, 1914. His officer, Lieutenant Wilson, replied a week later in equally terse terms: "Come home at once, Rosetown troop called out." Canada was going to war, and Trooper Will VanAllen was eager to go along for the adventure, wherever it might take him.

THE COUNTRY THAT WENT OFF to fight with such eagerness and so little forethought in 1914 was a rough, sprawling place. The population was only some eight million, despite the floods of immigrants from Britain and eastern and southern Europe, as well as some from Asia, who had come to the New World in the past two decades. There were three million French-speaking Canadians, mostly in Quebec but also in eastern Ontario, parts of the Maritimes and the West, all strongly Roman Catholic and almost all fearful of the assimilationist attitudes of their Protestant and English-speaking countrymen. There were German-speakers in southwestern Ontario, tens of thousands of Galicians (as Ukrainians were popularly known then) in the West, and a huge mixture of other nationalities and religions, most in the city slums or on hardscrabble farms in the Prairies. But Canada was no melting pot, and there had been no organized efforts to make Canadians out of those who had chosen to come here.

Yet there was a nascent Canadian nationalism, at least among "old stock" Canadians. You could see this in the way the United Empire Loyalist descendants remembered—and talked and wrote incessantly about—the victories over the Americans in the War of 1812 and the Fenian Raids after 1866. That these "victories" had largely been won by British

1

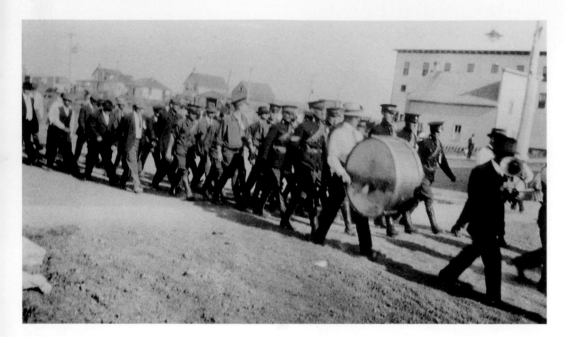

troops in 1812–14 didn't matter, any more than the fact that most of the Fenian Raids had been mere skirmishes that the Irish Americans won. The United States was there, rich and inviting, but those who lived in Canada took a perverse pride in being tougher, less materialist, stronger in spirit. After all, Canada had rejected reciprocity—or free trade—with the Yanks in 1911. Similarly, you could see the developing nationalism in the way Canadians invariably bristled at being high-hatted by British lords, but at the same time showed their devotion to the idea of Empire and their personal loyalty to the king, George V. Quebec was *nationaliste,* inward looking and devoutly religious, but there were Quebecers who looked to Sir Wilfrid Laurier, the prime minister from 1896 to 1911 and still Liberal leader, as their pan-Canadian model. Laurier was jealous of French Canada's rights, but he was also a Canadian, conscious of the benefits of British-style democracy and fully aware that his horizon extended from the Maritimes to beyond the Rocky Mountains. In his view, so should French Canada's.

English Canada, like French Canada, was divided in its loyalties. It was Canadian, but it was at once strongly pro-British and resentful of British condescension. It was Canadian, but admiring of American energy and dynamism, yet fearful of becoming Americanized. It was Canadian, but divided by religion, language, class and region. In other words, Canada in 1914 was not all that different from what it is today, still torn and conflicted by the pressures of living in a much-favoured continent in a world of uncertainty.

Then, as now, there was also pride in Canada and in its military achievements. Old men and women had learned of victories in the War of 1812 at their fathers' knees. Their children knew that the Dominion had sent British and Canadian militia troops to the Red River in 1870 to chase down Louis Riel, and had posted thousands of militiamen to the Northwest in 1885 to finish off the Metis rebel. There even was a tiny, ill-trained professional military, its origins dating from the 1870s, when Canada had been obliged to take over fortifications and stocks of weaponry from the British garrisons, which had been recalled home by parsimonious governments in London. The Permanent Force, as it was known, had as its pri-

mary duty the training of the militia, the "Saturday night soldiers" who existed in almost every city and town. It had also provided some of the officers and non-commissioned officers for the more than seven thousand volunteers Canada had sent to fight in the South African War between 1899 and 1902, and a freshly raised volunteer battalion of the Royal Canadian Regiment had played a key role in the victory at Paardeberg in February 1900.

No one should doubt, however, that Canada was totally unprepared for war in 1914. There were nominally sixty thousand militiamen, almost all largely untrained except for parade-square drill and rudimentary manoeuvres in annual two-week-long summer camps. The men were keen and proud of their regiments, some of which dated back to the 1850s and, being citizen soldiers, were deeply resentful of Permanent Force officers. That professionals were idlers and parasites was a deeply felt opinion. Had not Sam Hughes, the minister of militia and defence in Sir Robert Borden's government, always declared that the defence of Canada was safe so long as the nation's men were ready to pick up their

rifles and defend their native soul? That most militiamen lacked rifles—and every other weapon, not to say uniforms, training and any sense of military organization or tactics—was immaterial. The minister and most of his compatriots believed the country was ready to fight at Britain's side. What seemed to worry Canadians that lovely August was that the Allied victory parade down Berlin's Unter den Linden would have already been held before Canada's sons had the chance to take part in the fighting. "We were all afraid it would be over before we got to the front," Captain Walter Moorhouse remembered.

IN 1914, CANADA WAS a British colony, independent in its domestic policies but subordinate to London in foreign policy. Thus, after the assassination of the Austro-Hungarian Empire's archduke Franz Ferdinand and his wife in Sarajevo in July 1914 began the chain of events that started the Great War, Britain's declaration of war against Germany and the Austro-Hungarian Empire on August 4 automatically made Canada a belligerent. The Dominion could decide for itself how it would participate in the conflict, but its seaports were subject to attack, its merchant ships to sinking or seizure, and its citizens abroad, as British subjects, to internment. Even if Canada had wanted to remain aloof, the rules of war and international law, as well as the realities of Empire, made this virtually impossible.

But Canadians did not want to stay out of the war, whatever the legalities. The public, especially the English-speaking political and economic leaders of the nation, wanted Canada to join the fight against German militarism. Before the British declaration of war on August 4, many feared the United Kingdom might not go to war and might shirk its treaty obligations to Belgium, invaded by Kaiser Wilhelm's armies, and there was a heartfelt sigh of relief when Britain decided to fight alongside the French Republic. "Wait till we get at them, we'll give them hell!" men in Edmonton said, and they meant it. "Everybody just jumped up and wanted to go to war," recalled Jack Burton, who lived near Fredericton. "You know, banners waving and bands playing! It was just like a fever."

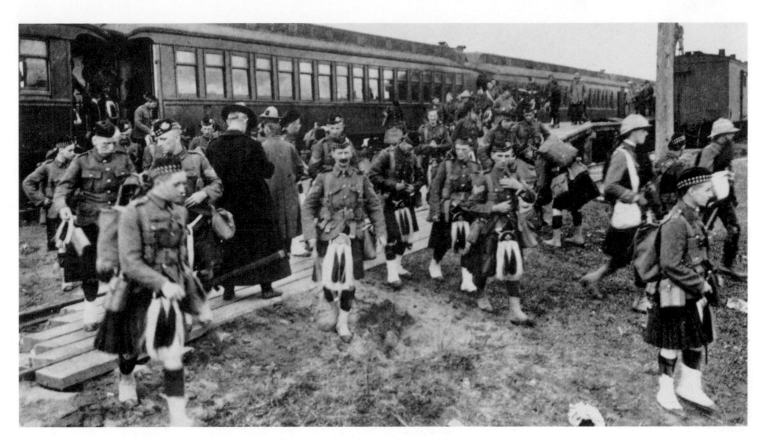

Germans were popularly seen as obnoxiously bumptious and brutally aggressive, and their efforts to seize colonies and build up their navy in the preceding fifteen years had frightened many Canadians. Fearing the loss of the Royal Navy's supremacy, the British government had been pressing Canada to contribute capital ships to the fleet. This idea had stirred strong opposition in Quebec and rural Canada, and Canada had created its own small navy instead. But the political debate over "dreadnaughts," sharpest between 1910, when Sir Wilfrid Laurier's government had created the beginnings of a Canadian navy, and 1913, when the Liberal-dominated Senate finally rejected the Borden government's offer to provide the funds for two battleships to Britain, had begun to sensitize Canadians to military questions. As a result, many people took sides when the war began. Although French Canada had been caught up in the fervour in August 1914, and although some patriotic francophones had rushed to enlist, Quebec soon proved uneasy about military commitments, just as it had over the South African War in 1899 and the cash gift to the Royal Navy. Germany was no threat to Canada, Quebecers believed, and no loyalty was owed to France, atheistic and republican as it was. It was English Canada's war, French Canadians soon seemed to agree, so let them fight it!

For their part, recent immigrants from central Europe understandably worried about the impact of war on their friends and relations in the old country. The federal government's hasty internment of many enemy aliens, including Ukrainians, who had come to

RIGHT: Supplies, equipment, all
had to go to the right ship and the
proper hold. Here artillery is being
hoisted aboard at Quebec City's
docks. (CWM 19800038-001 P.45A)

Canada from the vast territories of the Austro-Hungarian Empire but did not ordinarily feel part of it, alienated many recent immigrants. At the same time, Ontario and Prairie farmers, whatever their ethnicity, worried about their overseas markets for wheat, and export industries fretted that the dislocations caused by the war would worsen the recession that had the country in its grip. The divisive strains in society had already begun to increase under the pressures of war.

The task of mobilizing Canada's military fell to Colonel Sam Hughes. A long-time member of Parliament, the minister of militia and defence was a newspaper owner and property speculator from Lindsay, Ontario, a militia stalwart, and a veteran of the South African War. Although he was sixty-one years old, Hughes had inexhaustible energy, the driving force of a demon and the strong attachments and detestations of a man who believed that his ideas were always the right ones. He was also an Orangeman, strongly anti-Catholic, an imperialist and simultaneously a strong Canadian nationalist, and his South African War experiences had persuaded him that Canadians could teach the English a thing or two about soldiering. Now he had the chance to show them.

The day after Britain's declaration of war, Hughes announced that Canada was to send an infantry division, some 25,000 officers and men, to war. A mobilization plan had been drafted in 1911 by the army's tiny general staff, but the minister impulsively decided to scrap it. Instead of the rational, orderly process laid out by the planners, Hughes called on the 226 commanding officers of every militia unit across the land to raise men and send them to Valcartier, Quebec, where, he decided, he would construct a huge camp in the bush to prepare the Canadian Contingent for departure for Britain from Quebec City.

While contractors set out for Valcartier to begin laying out roads, sewers and water lines, putting in electricity, building rifle ranges and digging latrines, volunteers began to collect across the country. "I'm going to join the army," Dean Walker of Toronto told his pals. "Everybody else is going. I don't know what it's all about, but I'm going anyway." The war was an adventure, a chance to escape humdrum daily life and all its obligations, and to see the world. No one had the slightest idea what war could mean to each man who volunteered, to their country or to the world.

By the middle of August 1914, men were entraining for Quebec. Private Roy Macfie, a twenty-three-year-old farm boy from Dunchurch, north of Parry Sound, Ontario, who

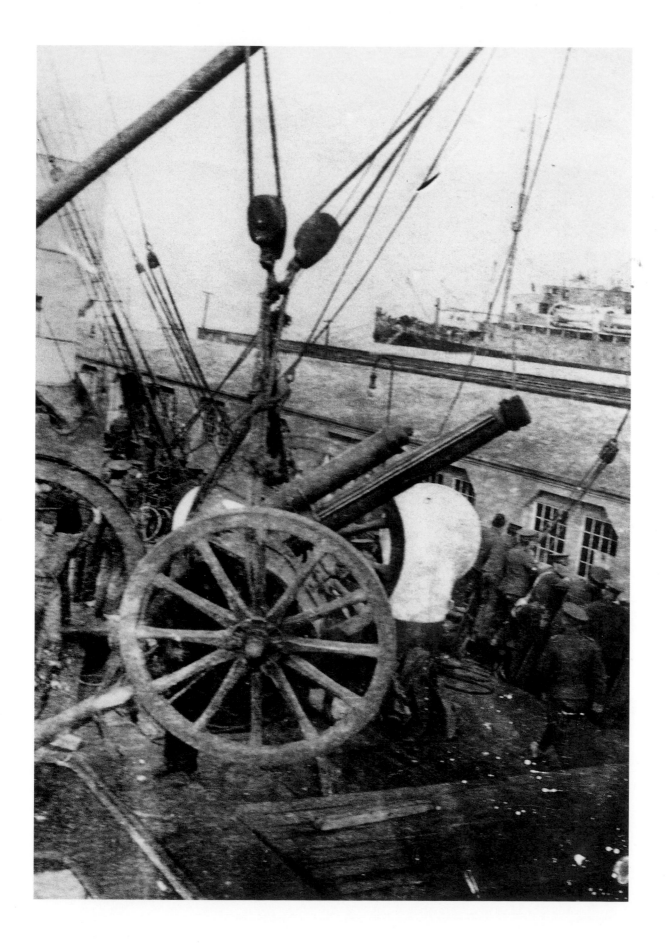

joined up at the earliest possible moment, wrote home from Valcartier on August 23 to say: "There are fifteen thousand men here now . . . a dozen or more train loads of men arrive every day." Another, Lieutenant Alex Thomson of Port Credit, Ontario, had told his mother two days earlier that Valcartier "is a wonderful camp there are tents as far as you can see." Men had been crammed into those tents, and there were almost no uniforms and equipment for them yet. In Lethbridge, Alberta, the largest-ever crowd in that town gathered to cheer the local contingent departing for Valcartier. In Medicine Hat, the *News* declared truthfully that "men are wild to go to the front."

Hughes and his staff were placing contracts for everything soldiers needed, all being done in great haste and almost without regard for cost. The minister ordered fifty thousand uniforms for delivery by September 2, and his agents scoured the United States for Colt machine guns. Hughes's private secretary, Ena MacAdam, designed a shovel with a hole to shoot through, and Hughes enthusiastically spent $33,750 to provide these shovels to the contingent. Like so much else that was bought in the first weeks of war, the MacAdam shovel was good for neither digging nor shooting, and it was scrapped soon after the men went overseas. Other contracts for boots, packs and belts became scandals once the first flush of excitement passed, while Hughes's agents purchased 8,500 spavined nags in Canada to meet the army's needs for horses—at the highest possible price. Hughes also ordered an array of Canadian-made trucks and automobiles, most of which proved unable to fit on the ships provided to move the contingent to England and—because too many models and makes were provided—were difficult to repair. The minister wanted Canadian firms and individuals to get the contracts, a worthy goal, but the boot and uniform makers and wagon builders seized their advantage in the crisis and defrauded the government. Many of them later turned out to have been Sam Hughes's cronies.

Then there was the Ross rifle, the Canadian-designed and -built weapon that had been championed by both the previous Liberal militia minister and Hughes. The Ross had an enviable reputation on the rifle ranges: its accuracy was said to be superior to that of the British Lee-Enfield, the standard Imperial small arm. The

GREAT EUROPEAN WAR, 1914—1st Canadian Expeditionary Force

Numbering 33,000 Officers and Men.
Assembled at Valcartier, Quebec, August, 1914.
Embarked for England at Quebec, Sept. 26th, 1914.
Landed at Plymouth, October 16th 1914.

SHIPS OF CONVOY.
H.M.S. "MAGNIFICENT."
H.M.S. "ECLIPSE," G.R.H.U. H.M.S. "DIANA," G.R.D.H. H.M.S. "CHARYBDIS," G.Q.R.M. (flagship)

	No.	Name	Code	No.	Name	Code	No.	Name	Code
H.M.S. "AARON"	1.	Megantic	HPCF	12	Carribean	LVCN	22	Tunisian	RNLC
	2.	Ruthonia	RPQM	13	Athenia	VQRT	23	Arcadian	RJQT
	3.	Bermudian	HBPK	14	Royal Edward	HMDG	24	Zealand	HJLD
	4.	Alaunia	JDKM	15	Franconia	HSDC	25	Corinthian	RQBH
	5.	Ivernia	RNJD	16	Canada	PLMN	26	Virginian	HCJG
	6.	Scandinavian	QDST	17	Monmouth	RTBF	27	Andania	JCPL
	7.	Sicilian	RKBG	18	Manitou	PWJL	28	Saxonia	RPNQ
	8.	Montreal	RSKQ	19	Tyrolia	RLVM	29	Grampian	HLKW
	9.	Lapland	LQSN	20	Scotian	HSKG	30	Lakonia	RGMC
	10.	Cassandra	HJBG	21	Laurentic	HNML	31	Montezuma	HHKW
	11.	Florizel	HNLT				32	Royal George	HLTW

Rear Cruiser: H.M.S. "TALBOT," G.V.C.L.

This little-known painting by F.S. Challener portrays
"Canada's Grand Armada" taking the Canadian Contingent
overseas. (CWM Challener 8134)

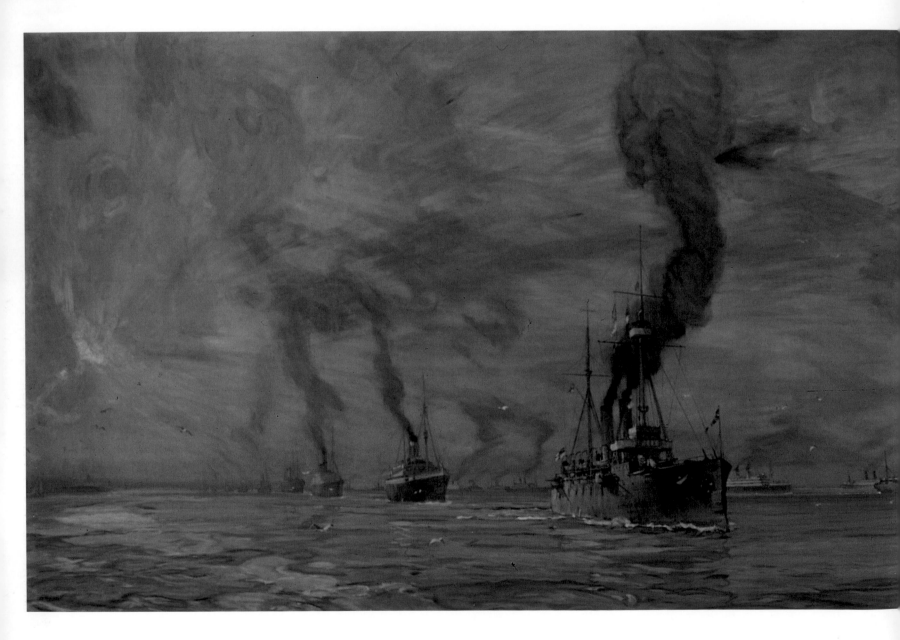

HELL'S CORNER

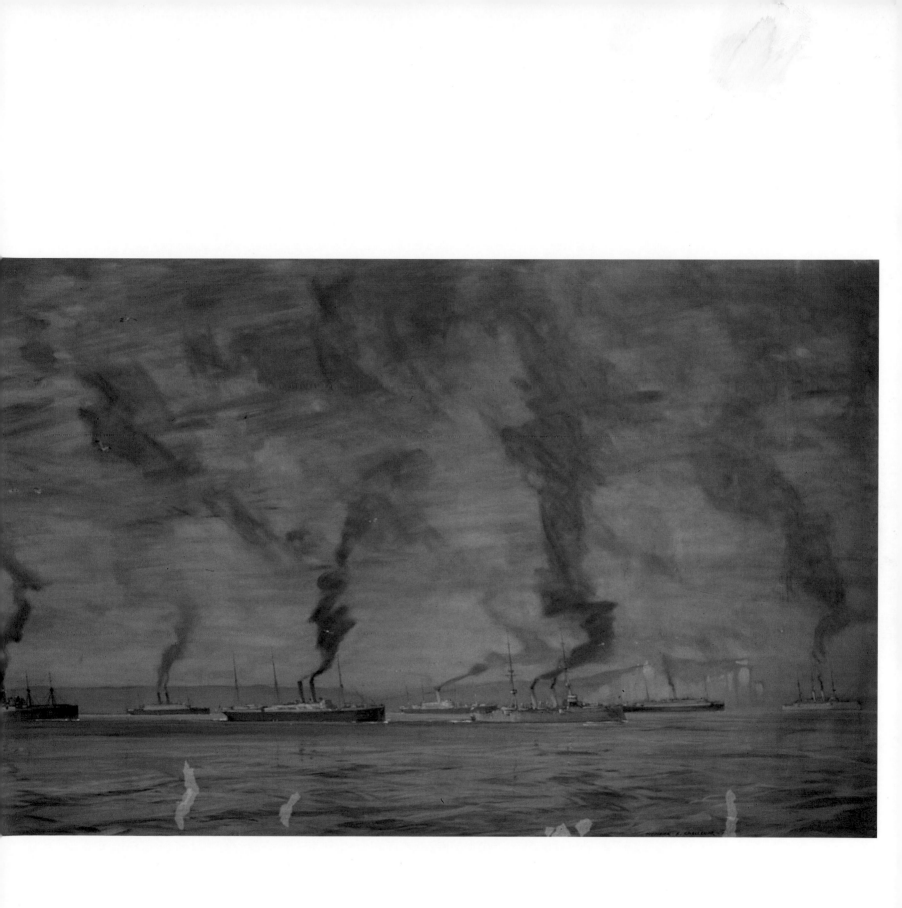

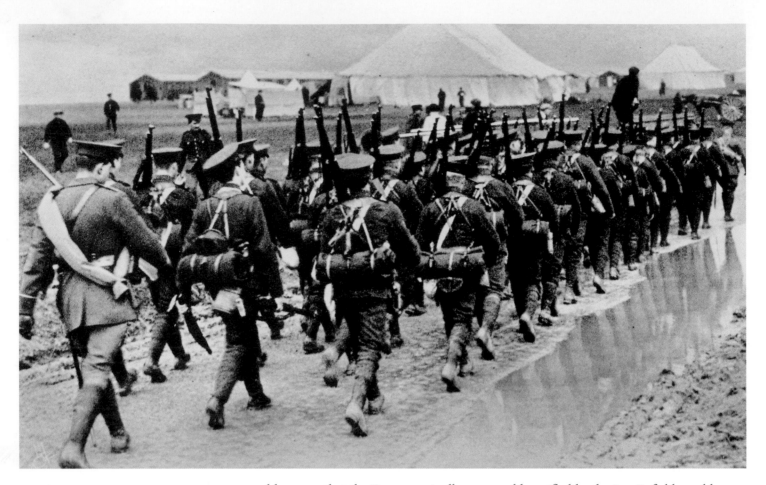

problem was that the Ross, nominally a .303 calibre rifle like the Lee-Enfield, could over-heat when used in rapid fire—and the standard cartridges could jam. At Valcartier, how-ever, where there were said to be 1,700 targets on the ranges, that problem was not yet a difficulty. Lieutenant Alex Thomson put it succinctly: "If we had enough rifles we could soon shoot."

Hughes, meanwhile, was deciding who the officers for his division should be. Good Conservatives and good militia stalwarts usually received the nod, and only with extreme efforts by, among others, the governor general, the Duke of Connaught, were any Perma-nent Force (PF) members allowed into the contingent. The vice-regal representative also prevailed on Hughes to include the two PF cavalry regiments and the PF artillery regiment in the contingent. The governor general, however, could not dissuade the minister from stupidly sending the Royal Canadian Regiment, the country's sole PF infantry unit, to re-lieve a British infantry battalion on garrison duty in Bermuda. The brigade commanders, chosen by the minister, were Lieutenant-Colonel M.S. Mercer, Lieutenant-Colonel Arthur Currie, Colonel R.E.W. Turner, V.C., and Lieutenant-Colonel J.E. Cohoe. All were militia officers—two from Ontario, one from Quebec and one from British Columbia. Turner had won his gallantry decoration in South Africa, Mercer was a Toronto lawyer and Cohoe

a militia officer from the Niagara peninsula, while Arthur Currie, a Victoria property speculator and militia regiment commander, was a friend of Garnet Hughes, the minister's son. As yet, there was no divisional commander, and Sam Hughes half-hoped he could lead the Canadians into battle and simultaneously remain minister. Instead, Prime Minister Sir Robert Borden persuaded Sam that he was too valuable to be taken away from Ottawa, and Lieutenant-General E.A.H. Alderson, a competent if unspectacular British officer who had commanded Canadian troops in the South African War, got the nod.

All in all, the arrangements made to take Canada to war were at best semi-organized chaos. Hughes's efforts created Valcartier Camp out of the wilderness, mobilized the contingent and crammed its tent lines, but in the shambles there was neither much organization nor much time for training. Men fired their rifles on the range and did repeated route marches and parade-square drill, but there was little time for more serious tactical exercises. "We are in no shape to go into action," one officer wrote on September 24. "We will surely be held and drilled until we are soldiers in more than name." There were, however, three grand reviews of the contingent, and Harry Crerar, a Royal Military College graduate and artillery officer, complained that these were for "Hughes' benefit and for moving picture operators. A damn nuisance and a waste of time." Even worse was the fact that the battalions and brigades organized and reorganized, and reorganized again. Some of this was the minister's fault; but the War Office in London also could not decide what it wanted. The frustrated Canadians kept trying to catch up to demands from overseas. In many units, commanding officers came and went with bewildering speed, and the paper trail for orders given and rescinded disappeared at the minister's office.

Somehow, despite Sam Hughes's best efforts, the First Contingent of 32,665 men was formed into a divisional organization. There were three brigades of artillery and four infantry brigades, each consisting of four battalions (plus a seventeenth battalion of surplus men). The old militia regimental names disappeared, as Hughes decided to group men together into battalions organized on a roughly regional basis and to number them from one through sixteen. Alex Thomson noted that his 7th Battalion included men from the 10th Royal Grenadiers, the 13th Regiment, the 12th York Rangers, and the 19th, 34th, 35th, 36th and 44th Regiments; he himself soon transferred to the 10th Battalion. Militia stalwarts were furious at the way their traditions were swallowed whole.

And the men, the soldiers Canada was paying $1.10 a day? The statistics are revealing: of the 36,267 men eventually deemed to be part of the First Contingent (a number that included all who proceeded overseas by the end of March 1915), only 10,880 had been born in Canada and only 1,245 of these were French-speaking. Astonishingly, two thirds of the men were British-born—23,211 in all. In the first few days of the war, the pattern of Canadian enlistment was already clear. Their ties to Britain still stronger than their links to the Dominion, the British-born were most eager to fight. English Canadians were somewhat less so; French Canadians, with ten generations in Canada, no ties to Britain and only ancestral memories of France, were the least eager. Only among the officers did the Canadian-born dominate. Private Roy Macfie, now a member of the 1st Battalion of the 1st Brigade, noting the preponderance of British immigrants at Valcartier, wrote to his family that "it seems a very funny thing this is supposed to be a Canadian Contingent and I think that two thirds of the men that are here are Old Country men, if not more. There are an awful lot who have been through the Boer war." He added, "A lot of them have medals. There must be something nice about it when they want to try again."

On October 2, the last ships carrying the Canadian Contingent set sail from Quebec City. Predictably, the loading of the ships had been chaotic, a jumble of 30,617 men, 7,697 horses, 127 guns, heavy equipment and light. Roy Macfie wrote his brother Arthur that his battalion had proceeded to the docks on September 25 and "got on the boat . . . and stayed at the dock that night, but there was so many got off in spite of guards, and got drunk, that they pulled out into the river a piece and anchored there." On October 15, finally arrived in England, Macfie said: "We've been on this boat 21 days now . . . We were a whole week in Gaspe Bay waiting till the fleet all gathered there and then were 13 days crossing." It took nine frustrating days to unload the convoy and sort out the mess that had been created when the loading in Quebec had been mismanaged. The minister, however, made certain that his farewell message to the troops reached the ships. "Soldiers," Hughes had declared grandiloquently, "the World regards you as a marvel."

Although the men of the Canadian Division who arrived in Britain that autumn wore uniforms, they were neither disciplined nor trained. A British officer, J.F.C. Fuller, later one of the leading theorists of armoured warfare, watched the unloading of the Canadians. The rank and file, he thought, could become good soldiers "after six months of training,"

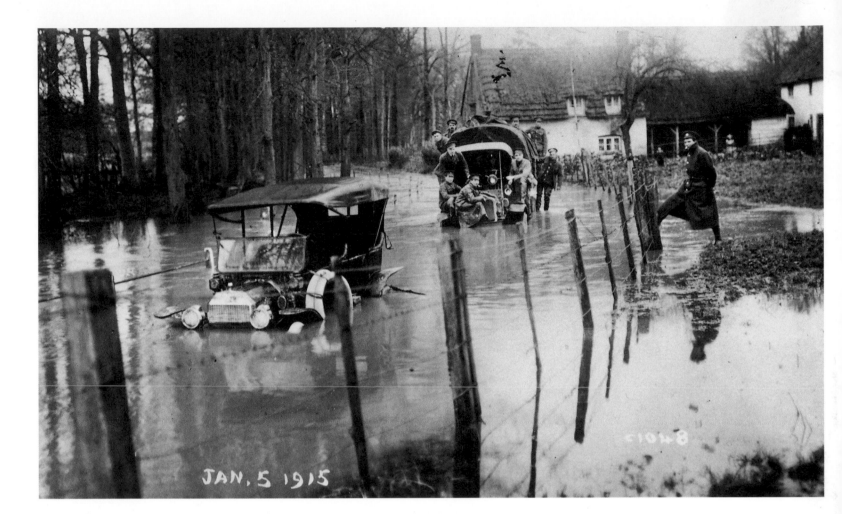

JAN. 5 1915

but only, he added, "if the officers could all be shot." There was a kernel of truth in that sour observation, and the Canadians soon acquired a reputation for sloppy ill-discipline. "We came here to fight," the soldiers said, "not to salute," and they almost never did. The Canadians had to begin the process of becoming soldiers from scratch.

THIS WAS NO EASY TASK. Although the weather in England was glorious when the Canadians arrived, the cold rains started on October 21 and seemed never to stop. For the contingent, based in an old British Army camp on Salisbury Plain, the weather proved as much as any could withstand. Housed in old leaky tents, up to their knees in mud, the men and their horses found themselves in a battle against disease. The British authorities belatedly tried to help by finding billets for some of the troops in neighbouring towns until rough huts could be made available or be newly constructed. But this resulted in the spread of venereal disease, which infected 1,249 men, and even more widespread drunkenness. Men who had been cooped up aboard ship expected, indeed demanded, the opportunity to unwind—and they took it.

Private Roy Macfie once more was a careful observer. He remarked in one letter soon after his arrival in England that his company commander told the men "that any . . . that went out . . . and got drunk would be sent right back to Canada, and he didn't have his back turned hardly till half of them were gone, and he went away and got drunk himself." A month later, Macfie noted that "it has been so wet and miserable all the time, it is almost impossible to dry clothes . . . I have had an awefull sore throat for a week now . . . It is a terror what a lot have died and been planted here since we came." He was correct, for influenza and meningitis had carried off many. Macfie added that hundreds were absent without leave, perhaps because "you could paddle a canoe in the mud some places." Lieutenant Alex Thomson of the 10th Battalion also pointed out that "we couldn't get boots for quite a while . . . the men were walking on the ground but they are all fixed up now." "We cannot get a chance to do any good work," one battalion commanding officer wrote. "I never dreamed of such weather."

The dreadful conditions severely limited opportunities for training. The gunners did not have a chance to fire their eighteen-pounders until the end of January, to cite only one example, and then were able to fire only fifty rounds a gun. The infantry and cavalry had

only a few days of serious training, other than drill, route marches and lectures. Another reorganization ordered by the War Office made the Canadian Division the same as British formations: three brigades each of four battalions and three artillery brigades. (The surplus brigade became the Canadian Training Depot in England.) The divisional establishment was fixed at 610 officers and 17,263 men. The cavalry regiments and the regiment of horse artillery formed a cavalry brigade.

LEFT: Eventually the War Office found rude huts for the Canadians. These huts were marginally warmer than the tents hitherto used. (CWM 19660049-001 P.3B)

By February 1915—most extraordinarily, since its training was so far behind schedule—the War Office deemed the Canadians ready to proceed to France. The 1st Battalion's Roy Macfie was eager and optimistic. "You wouldn't think this was the same bunch of men that were at Valcartier at all, they are getting pretty well tamed down, and more soldierlike, and take more interest in it." Many troublemakers had already been shipped home; still others had deserted and had not yet been rounded up. As for Macfie, he had all the soldierly qualities and was destined to be one of the very few originals of the 1st Battalion (and the Canadian Division) to survive the war. He would receive the Military Medal and Bar for his bravery in action.

The war that Canadians in August 1914 had expected to be a romp had already turned into a brutal struggle for survival. The Germans had smashed a Russian invasion of East Prussia and, with the Austro-Hungarians, were now pressing eastward into Czar Nicholas's territories. In the west, the German armies had rolled through Belgium and into France, slowed by the British at Mons in August, but only being definitively checked on the Marne in front of Paris in bloody fighting in early September. Then there was a race by each side to outflank the other, a sprint marked with sharp actions at Ypres in October. It ended only at the North Sea and on the Swiss border in the south.

Soon a continuous line of trenches, eight hundred kilometres long, extended across the front. The Germans held almost all of Belgium and a large part of industrial northeastern France. Artillery and machine guns ruled the battlefield, destroying thousands of combatants in a single day of action, and men who dared to poke their heads above the trench parapet often fell victim to snipers. The bloody war might have reached a near-stalemate, but the raw Canadian Division, new to the front, still had the optimism and high spirits with which it had left Canada not five months before. Unfortunately, it also had only a little more training.

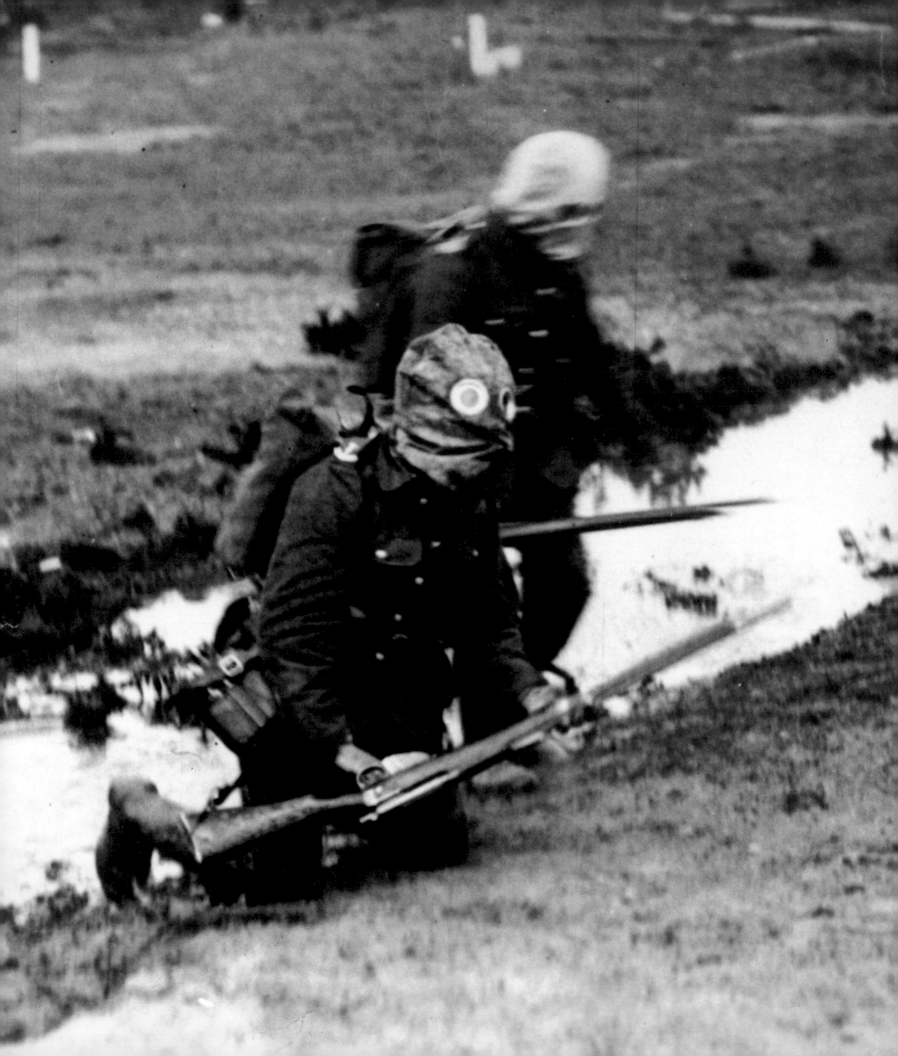

2 | MARCHING OFF TO WAR

"IS THIS A GENERAL RETREAT?" Padre Frederick Scott asked a staff officer as the full weight of the German attack fell on the Canadian Division at Ypres. "Never use such a word out here," the officer replied. "That word must never be mentioned at the front." Scott added that later in the war he would have known to phrase his query differently: "Are we straightening out the line?" or "Are we pinching the salient?" Not wholly reassured by this encounter, Scott soon came across some Canadians from the 16th Battalion moving up to reinforce the line. One said, "The Germans have broken through," and Scott replied, "That's all right, boys. Play the game. I will go with you." A sergeant then asked if the padre knew where they were going. "That depends upon the lives you have led," he riposted. This drew a great laugh from the soldiers, many of whom soon had the opportunity to find out the truth or otherwise of Scott's words. In the maelstrom of explosions and chlorine gas that fell upon the Ypres Salient in April 1915, the men of the Canadian Division discovered the terrible cost of war.

WHEN THE CANADIAN DIVISION arrived at St. Nazaire, France, in February 1915, crowds cheered the Dominion troops and Sam Hughes was there to greet his boys. The division's first duties were trench familiarization operations, as brigades paired up with experienced British formations to learn how the war was being fought. Commissioned and non-commissioned officers and privates worked with their "Tommy" (British) counterparts for two days, and then Canadian platoons took over a stretch of trenches for a day while gunners worked alongside the British artillery. Corporal Jack Finnamore of the 3rd Battalion remembered his "week's indoctrination" in the trenches well, the going "in and out of the

trenches on four day stints." The patrols were not much fun, he said, but "worst of all was the listening posts," as men could be caught in no man's land between the trenches.

Then, on March 3, General E.A.H. Alderson and his men assumed responsibility for about six kilometres of trench line near Armentières, and on March 10, the Canadians provided fire support to an abortive British assault on Neuve Chapelle. The division, hardly in action as yet, already had a hundred casualties, the normal "wastage" for a few days' front-line service.

The division then moved north to the critically sited medieval town of Ypres, Belgium, the heart of a salient sticking like a thorn into the enemy lines. The Germans could fire on the town—and its defenders—from three directions, and "Wipers," whose location made it the gateway to the English Channel and hence of great strategic importance, already had a well-earned reputation as a corner of hell. Six divisions held the line, most British but some French colonial troops as well. Coming into the line in mid-April, the Dominion troops took over shoddy, lice-ridden, filthy trenches—full of shit and unburied dead—from French troops. The war diary of the 10th Battalion was blunt about its position: "We did not see how it could possibly be held if a determined effort was made to take it by a strong force." Fortunately, "things are quiet here," wrote the surgeon attached to the 1st Brigade, Canadian Field Artillery, on April 15. Major John McCrae would see his full share of the action soon enough, for the division was in the midst of deepening the defences as much as the wet ground permitted, and they were putting up barbed wire when the Germans attacked on April 22.

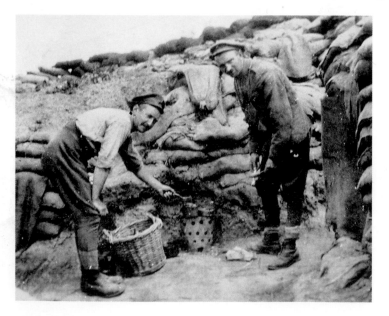

The attack began with an extraordinarily heavy artillery barrage. "The holes made by the seventeen-inch shells with which Ypres was assailed," Padre Frederick Scott wrote later, "were monstrous in size"—thirteen metres across and five metres deep! At the same time, the winds from the northwest at last favourable, the Germans opened the valves on some 5,700 cylinders of chlorine gas that drifted on the breeze towards the 45th Algerian and 85th French Territorial Divisions, sited to the left of the Canadian line. The Germans had used gas once before on the Eastern Front and once, it seems, on the Western.

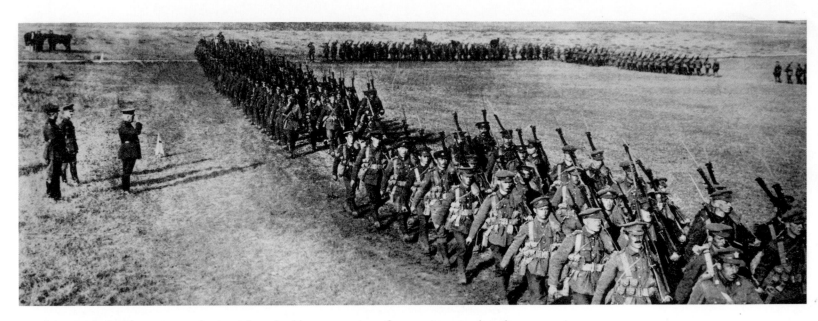

But these trials had been inconclusive. There had been warnings from prisoners that the enemy might use gas in the Ypres fighting, but no one really believed that such a form of warfare was possible. Moreover, gas had been banned by the Hague Convention of 1907. But now Germany was prepared to try its new weapon.

The unprotected Algerian and Senegalese troops, to say nothing of the French reservists caught in the greenish-yellow clouds, choked and died or fled. The chlorine gas attacked the lungs, swelling bronchial membranes and causing fluid to enter them from the bloodstream. As a result, the victims suffocated in their own bodily fluids. Major Andrew McNaughton, commanding a battery of eighteen-pounders, recalled that the Algerians "came running back as if the devil was after them, their eyeballs showing white, and coughing their lungs out—they literally were coughing their lungs out; glue was coming out of their mouths." A huge gap on the Canadians' left flank opened up, and the enemy infantry moved three kilometres forward in its first bound.

Now the Canadians were for it, and for the next three days the fate of Ypres, the British Army and possibly the entire Allied position rested on the new and untried division. The Canadian commanders desperately tried to move their men into the gap while the British also rushed men forward. On the evening of April 22, about 1,500 Canadians of the 3rd Brigade were thrown away in a hasty and ill-prepared attack on Kitcheners Wood that took the objective at heavy cost, the five hundred survivors then being ordered to abandon the hard-won ground. One sergeant in the 10th Battalion, leading the attack with bayonets fixed, later wrote: "We didn't seem to realize what we were up against, but we kept going. The wood seemed to be literally lined with machine guns, and they played those guns on us with terrible effect." Further Canadian counterattacks, just as hastily prepared, slowed the Germans, unsure in the dark of the strength of the opposition. But the costs were terrible. The 1st and 4th Battalions, moving forward "in most perfect order as if on

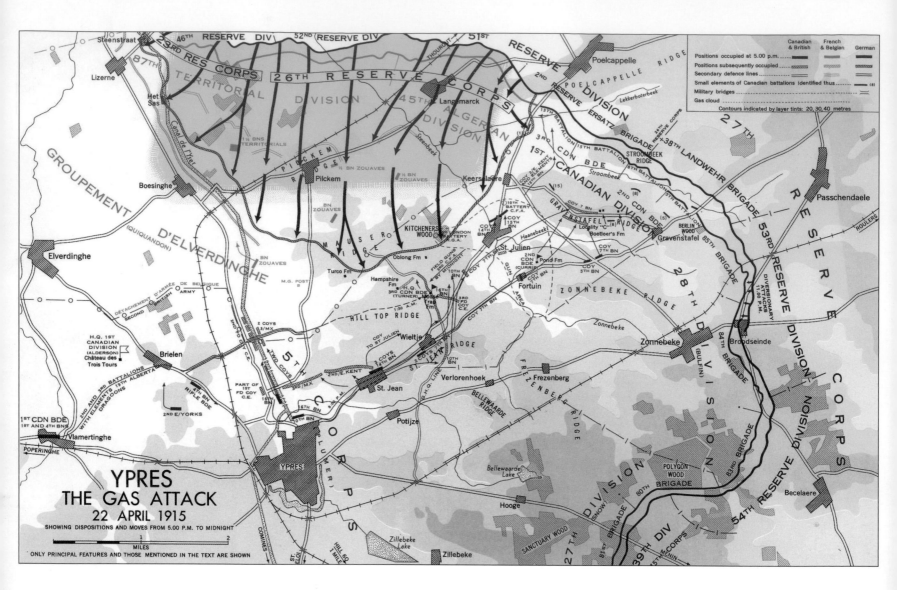

YPRES
THE GAS ATTACK
22 APRIL 1915

SHOWING DISPOSITIONS AND MOVES FROM 5.00 P.M. TO MIDNIGHT

ONLY PRINCIPAL FEATURES AND THOSE MENTIONED IN THE TEXT ARE SHOWN

Courtesy Directorate of History and Heritage, National Defence Headquarters, Ottawa.

parade," each lost more than four hundred men in a daylight attack in the morning of April 23. Enemy machine gunners had a field day destroying the two battalions.

Meanwhile, Major John McCrae, a doctor and sometime poet, not yet famous, wrote later that his guns had been rushed forward at 3:20 AM: "It was fight all the time. We were far up to the front, and to that we owe our effectiveness as well as our losses… The men behaved magnificently… In one 30 hours we fired 3,600 rounds and at one time our brigade had only seven guns able to fire; two of these smoked at every joint and were too hot to touch with the unprotected hand." Rifle bullets, he added, "came over us in clouds. We got the gas again and again."

As McCrae stated, the Germans' gas weapon now was turned against the Canadians, and the enemy's high command assigned a division and three brigades to follow the chlorine cloud. The gas rolled forward onto the 8th and 15th Battalions, and it became the

Canadians' lot to struggle to survive. Advice had come down that there was some protection in urinating on a puttee or handkerchief and holding the wet cloth over one's nose or stuffing it in one's mouth; the ammonia in the urine could partially neutralize the chlorine. This strategy worked, but it was insufficient to stop the choking and gasping of those whose distaste for a urine-soaked cloth on the face was greater than their fear of the gas. Those who deeply inhaled the chlorine gas died either on the spot or, later, in casualty-clearing stations, where medical officers could only watch. The Germans had crude respirators for their *Stinkpionieren,* as they unflatteringly dubbed their gas specialists, but the attacking troops had nothing to provide them with some safety from their own terror weapon. The reluctance of German troops to press forward into the gas clouds likely helped spare some defenders.

Not until the beginning of May did even makeshift respirators reach the Allied troops. Major Agar Adamson of the Princess Patricia's Canadian Light Infantry, then fighting in a British division, wrote on May 2 that "we were all served out with cotton wool with a piece of elastic sewn on to put over the mouth." The instructions, he added, "are to breathe in through the mouth and out through the nose."

Raw courage had helped save the situation at Ypres. Major Harold Mathews of the 8th Battalion from Winnipeg recalled the five-metre-high cloud of gas that rolled onto his position: "the terror and horror spread among us by this filthy loathsome pestilence." The gas moved into the trenches and shell holes, gathering at ground level and forcing men into the open. The wounded, seeking safety on the ground, soon died from the chlorine. But the battalion hung on, its men gasping and puking, desperately fighting off the enemy who were also being machine-gunned from the flanks and shelled by supporting artillery, firing over open sights and killing hundreds. The 15th Battalion, a Toronto unit based on the 48th Highlanders, found itself with no supporting fire and was all but eliminated, losing 647 men, including 257 taken prisoner. Its commanding officer was later discovered well to the rear, either shell-shocked or insensibly drunk. Corporal Jack Finnamore noted that he could see the 15th being overrun, "the Germans running through the village popping off our men. Then they went around. The first thing we knew they were behind us!"

Now the Canadians discovered that the Ross rifles, their magazines holding five rounds, were next to useless in action. "There were some fellers crying in the trenches

BELOW: Gas training was done the army way—"on masks"—with sergeants shouting at men to "look alive." Other trainees watched, hoping that there would be enough masks for them. (CWM 19820103-011 P.66A)

RIGHT: The gas was terrifying to see. This aerial photograph, taken over the Somme battlefields, shows it blowing westward on the wind. (CWM 19700140-077)

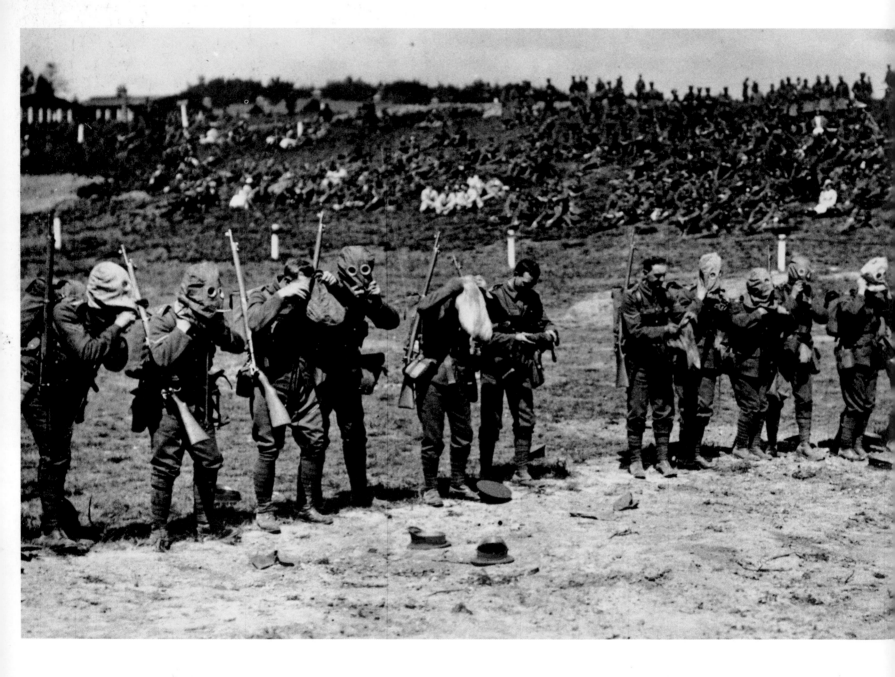

HELL'S CORNER

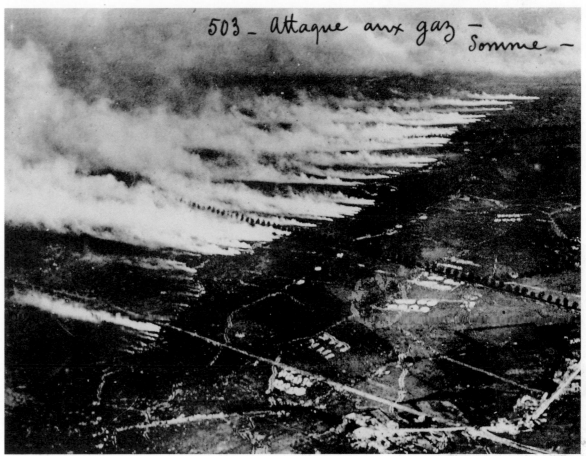

503 - Attaque aux gaz -
Somme -

BELOW: Belgian artist Alfred Bastien, who worked with the Canadians, painted a gas attack in Flanders. (CWM Bastien 8086)
RIGHT: Soldier Arthur Nantel fought at Ypres and was taken prisoner. From his POW camp he painted what he had seen, including the mournful Canadian prisoners moving off to Germany. (CWM Nantel 8620)

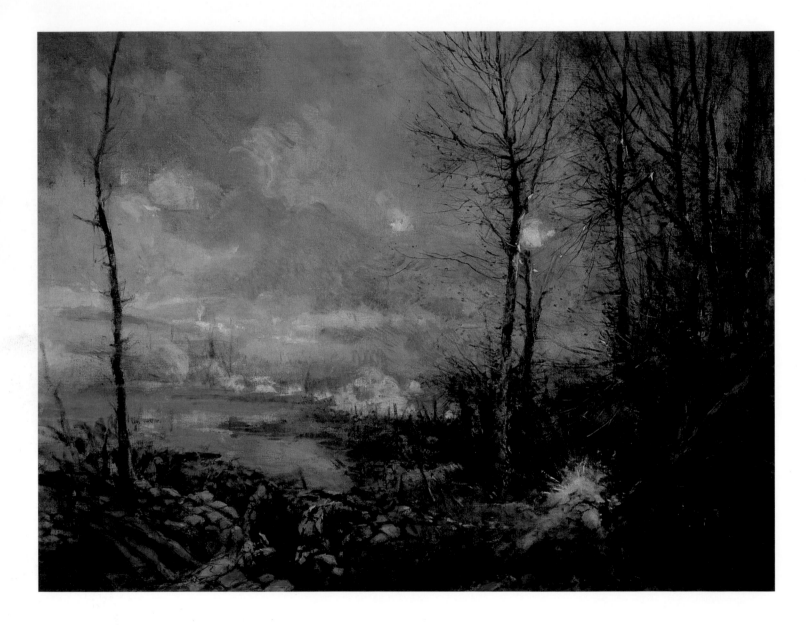

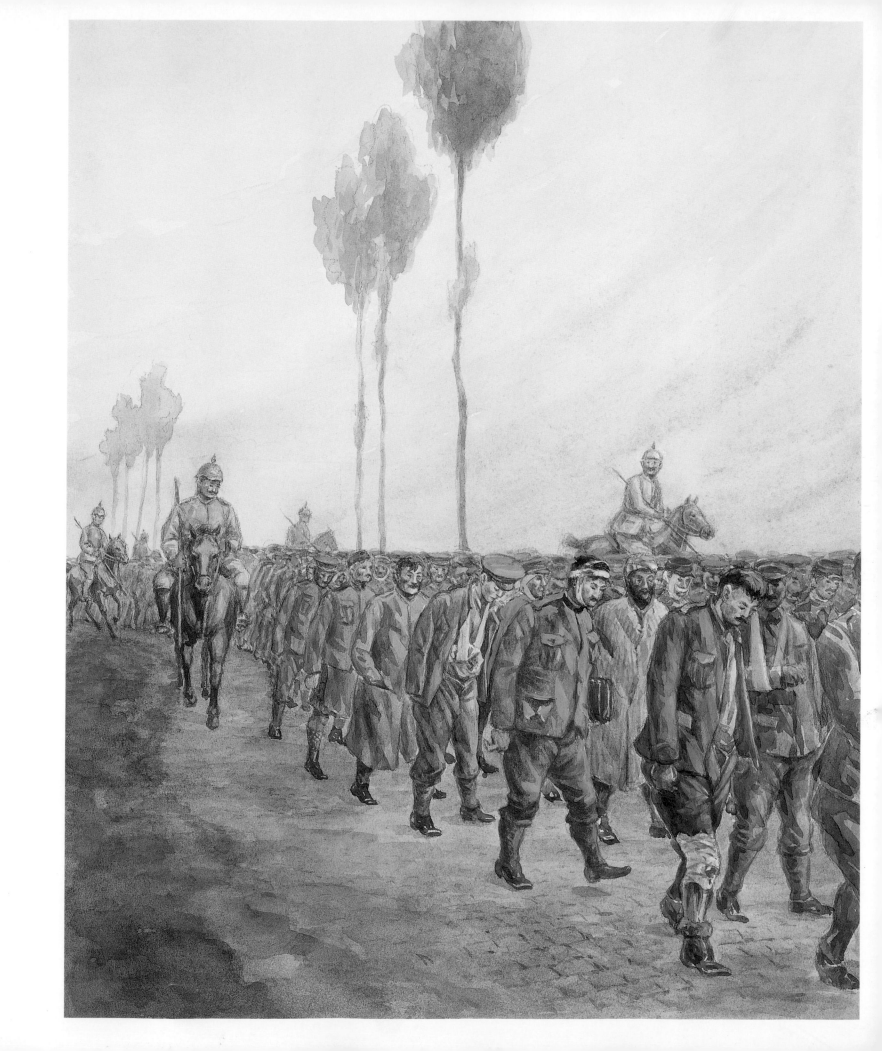

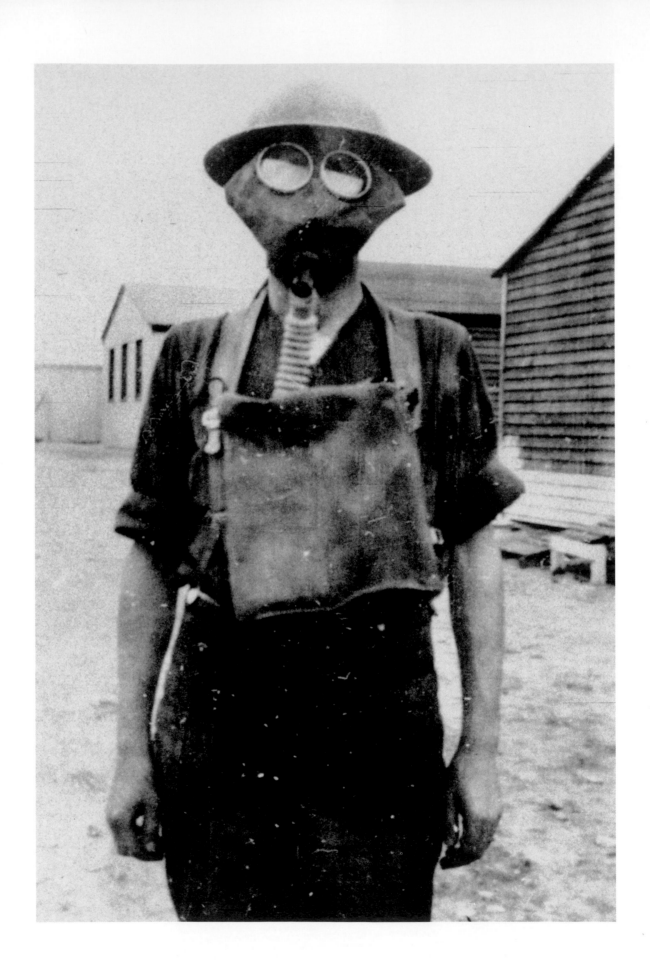

because they couldn't fire their damned rifles," one soldier remembered. The rifles overheated, the bolts jammed and the bayonets fell off. Shouting, swearing soldiers discovered that they had nothing to fight with. The fortunate, throwing away their rifles, picked up Lee-Enfields from British casualties, but hundreds of Canadians died from the failings of their primary weapon. Padre Scott recalled that he carried the rifles of a stretcher party and wondered if one of the loaded weapons might not blow his head off if he stumbled. He was comforted by the unworthy thought that "they were Ross rifles and had probably jammed." Unfortunately, the Ross was no laughing matter.

The spike-helmeted and grey-clad Germans, their belt buckles proclaiming *Gott Mit Uns,* continued to press forward, hitting the 3rd Brigade's lines to the west. The Canadians drove the first infantry back, but accurate, heavy artillery fire soon forced them out of their trenches. It was a fighting retreat, but some companies, and many individuals, were slow and as a result were captured. The key village of St. Julien was now all but surrounded. It fell when the 3rd Brigade commander, Brigadier-General R.E.W. Turner, personally courageous but less than effective as a senior officer, misinterpreted a confused order and failed to reinforce the village's defences. A gap in the line was now open, but the enemy, as confused as were the defenders, failed to seize the opportunity. The fog of war, well mixed with chlorine, was devastating to everyone, not least the all-but-untrained Canadians and their leaders.

Now the enemy's full weight fell on Brigadier-General M.S. Mercer's 1st Brigade. The Ontario brigade drove off five separate attacks on April 24, aided mightily by artillery support and a counter-thrust by two British battalions. Private Frank Ashbourne of the 3rd Battalion said later that his unit had been forced back to the support trenches where the troops lay down and covered their noses and mouths with wet cloths, "waiting for the Germans to come up. They came slowly, thinking we were all dead from their gas, but not so. It drifted slowly over us and showed the Germans about seventy-five yards away. We were suddenly ordered to rapid fire and I don't think that more than a dozen Germans got away alive." Then, Ashbourne said, the 3rd Battalion retook its original line. Nonetheless, the 2nd and 3rd Battalions had been cut to pieces, and Ashbourne's brother was taken prisoner. So too was Major Peter Anderson of the 3rd Battalion. He was one of the few survivors of his company and found himself "surrounded by Germans. I was awfully dazed;

LEFT: Gas masks improved as the war went on, but gas remained a terrifying psychological weapon. (CWM 19910047-050 P.20B)

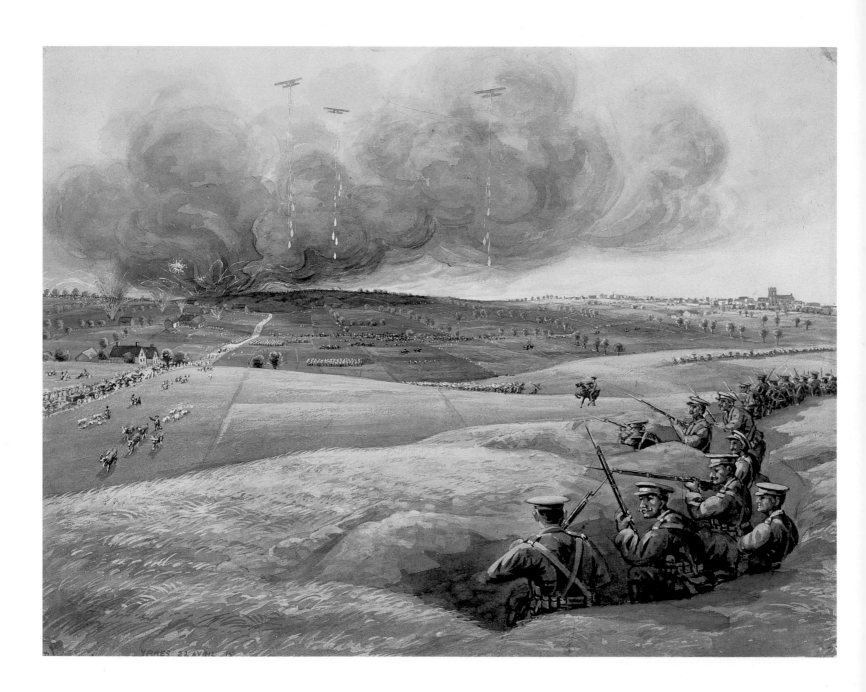

HELL'S CORNER

I have a hazy recollection of a German trying to take my pistol. I would not let him. I had my watch shot on my wrist, bullet holes through my clothes, but I received nary a scratch. I was now a prisoner of war." Anderson added, "What an awful feeling; what a humiliating position to be in."

Arthur Currie's brigade now faced its own Calvary. An attack on the 7th Battalion's position in the morning of April 24 made progress—despite the extraordinary courage of a lieutenant and a sergeant who, struggling to operate often faulty Colt machine guns, drove off repeated assaults. The sergeant was killed and Lieutenant Edward Bellew was wounded, but he kept firing until his ammunition ran out. Then he smashed his gun. In the end, the enemy—fighting with a determination equal to that of the Canadians—took the position and 266 prisoners, including Bellew, who subsequently received the Victoria Cross. Currie's westerners, most notably the 8th Battalion commanded by Lieutenant-Colonel Louis Lipsett, had hung on in the hell of fire and arguably saved the situation until sufficient British reinforcements were in place to check the Germans finally. Currie's 7th and 10th Battalions had been decimated, but his men's grit and the support of the artillery (most notably Major Andrew McNaughton's battery, which expended 1,800 rounds of eighteen-pounder ammunition over open sights to support the 8th Battalion) deserved the laurels they won.

Indeed, so did the whole of the Canadian Division, which was hailed by the British and French. One soldier told Padre Scott that "I was in a blooming old funk for about three days and three nights and now I am told I am a hero. Isn't that fine?" Fine indeed, though the Canadian Division had sustained 6,036 casualties in a few days of battle. Ypres was still held by the Allies, and it would be for the remainder of the war, though the town was all but levelled by continuous heavy shelling. Some Canadian commanders, junior officers, non-commissioned officers and men had proven themselves in action; many had died or were wounded, whereas others inevitably failed their first real test. It was all part of the battlefield learning process, but a hugely costly lesson.

THE CARNAGE AT THE FRONT shook Canadians at home, who pored over the pages of casualty lists in the newspapers. What had happened to the supposed chivalry of the battlefield when poison gas was used? How could there be far more Canadian dead, wounded

and prisoners in a four-day action than there had been in the three years of the South African War, people asked in hushed, fearful voices. Though still in its early stages, the war in France and Flanders already had no comparisons in its bloodletting. The idea of a quick battle on the Franco–German frontiers, followed by a victorious march on Berlin, was gone forever.

But even before April 1915, a Second Canadian Contingent was in formation. Once again Sam Hughes tried to bypass the mobilization plans, directing selected colonels to begin raising battalions. This time, however, Prime Minister Sir Robert Borden demanded that some rationality govern the process and ordered that four battalions be raised in Ontario, one each in the western provinces and in Nova Scotia and New Brunswick, and two in Quebec. One of the latter, the 22nd Battalion, was to be French-speaking. Before the end of 1914, the Second Contingent, shortly to become the 2nd Canadian Division, had the men it required, and just at the time of the Ypres struggle, it embarked for England. There, Major-General R.E.W. Turner, one of the original brigade commanders at Valcartier and Ypres, became its general officer commanding.

Soon after Ypres, moreover, the British and Canadian governments agreed that Canada would send all the men it could, dispatching formed and half-formed units overseas, where they would be shaped into brigades and divisions. By June 1915, the strength of the Canadian Expeditionary Force, the new name for the forces sent overseas, was just over 100,000; six months later it was 218,000. In August 1914, no one in Canada had contemplated that the Dominion would have such an army—no one.

AT THE SAME TIME, Canada's tiny navy was also beginning—without much governmental support—to expand very slowly. Created by legislation in 1910, the Royal Canadian Navy had a strength of just eight hundred officers and ratings in 1911, but even that pathetic total had declined under the Borden government to some 350 in mid-1913. Most of those were British "tars" (sailors) on loan, and by the end of the year only 350 more young Canadians had signed up. There was an admiral, Charles Kingsmill, a Canadian who had transferred from the Royal Navy; the Naval Service Headquarters, in Ottawa; a naval college; two obsolete training cruisers, HMCS *Rainbow* and HMCS *Niobe*; the authorization of the formation of the Royal Canadian Navy Volunteer Reserve in May 1914, and even plans

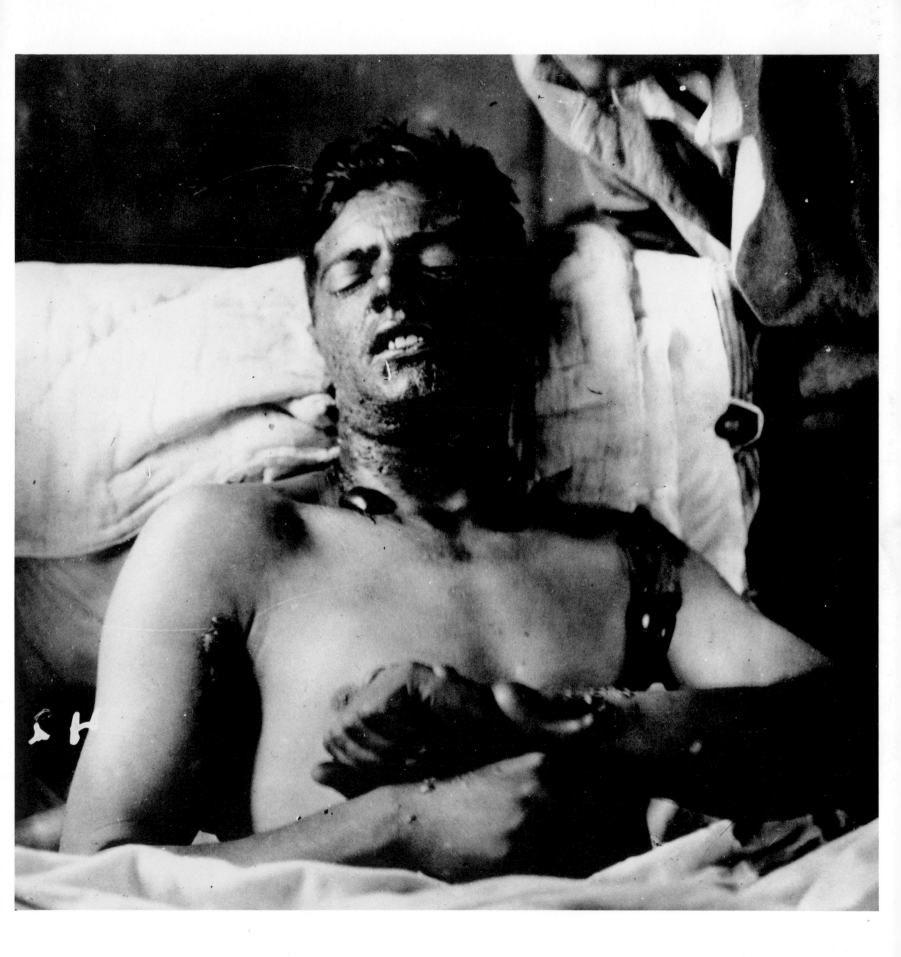

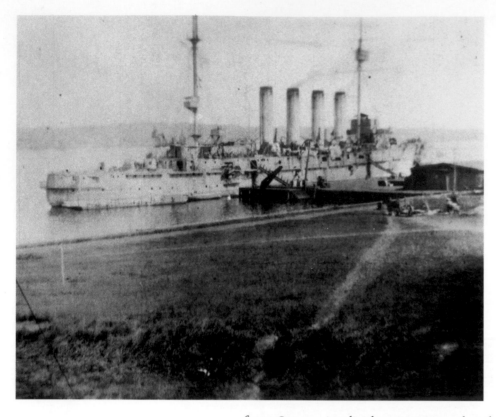

for the defence of Halifax, though no naval vessels to carry it out yet existed. No one could have claimed that Canada was ready to defend its coasts when war erupted.

Its crew largely untrained, the twenty-one-year-old *Rainbow* was nonetheless quick to put to sea from the navy's West Coast base at Esquimalt in August 1914, searching for a German cruiser. "Remember Nelson and the British Navy," Naval Service Headquarters had telegraphed from Ottawa, implicitly recognizing that the Canadian cruiser had no chance in battle against a modern vessel. Moreover, *Rainbow* had no high-explosive shells, only underpowered ones with black gunpowder. One observer, watching the ship depart, noted that few "expected to see her return." Fortunately, *Rainbow* did not encounter the enemy and made it back to port safely.

The utterly defenceless state of the West Coast, however, impelled British Columbia's premier, Sir Richard McBride, to persuade Ottawa to repay the province for two small submarines that were under construction for Chile in a Seattle dockyard. He had hurriedly purchased the subs at the outbreak of war. They were still partly unfinished but were available for $1.15 million because of contract disputes between the shipyard and the Chilean government. Ottawa quickly paid up and, without the benefit of export permits, the submarines slipped away to Canadian waters. Canada had no torpedoes for the submarines and no crews to man them, but somehow the boats' companies were cobbled together. At best, their very existence may have helped deter German raids—if any were even contemplated—but they saw no action. Before long, Britain's ally Japan assumed responsibility for the defence of the North Pacific. *Rainbow* sailed only in inshore waters, unready and unused.

At Halifax, *Niobe*, commissioned in the British Royal Navy in 1898 and transferred to the Royal Canadian Navy in 1910, was in even more decayed condition than her West Coast counterpart as a result of being tied up for two years. The cruiser saw service for

only nine months of war, sailing on patrol off New York City, where some thirty German merchantmen had been caught by the outbreak of war in August 1914. Then *Niobe* was blessedly tied up to rust away as a depot ship. The defence of Canada's main Atlantic port came from the army, which was manning coastal defence batteries, from the Royal Navy, and from a scratch fleet of twenty small Canadian ships requisitioned from government agencies or purchased for local duties. By mid-1915, because it thought the threat of attacks in Canadian waters from U-boats was increasing, the Naval Service began buying and arming large yachts to patrol the Gulf of St. Lawrence. It was still a small-potatoes effort, but for now the response seemed to be sufficient. The country's attention was fixed on the Western Front, not on the sea approaches to Canada.

AFTER YPRES, the Canadian Division had only a short time to lick its wounds. The 4th Brigade that had come to England in the First Contingent, as well as three battalions from home, were broken up to fill the ranks. The newcomers had to be integrated into their platoons and companies, and already commanders were beginning to question if "Major Jones" who had yet to hear a shot fired in anger was fit to command a company at the front, whatever his success with his troops in Canada or England. Battle experience was the key.

The Canadians went into the attack at Festubert in Artois on May 18. Although the gunners fired the then-extraordinary total of 100,000 rounds in just sixty hours, the attacks were unsuccessful. The 3rd Brigade attacked in late afternoon, and the German machine gunners destroyed it after an advance of three hundred metres. The shaken survivors dug in and, joined by the 2nd Brigade, tried again on May 20, once more going over the top in full daylight. Some slight progress was made. The next day, Currie's 2nd Brigade tried once more. German artillery, much more accurate than the Allies' and using shells that almost always exploded—unlike the sloppily made British

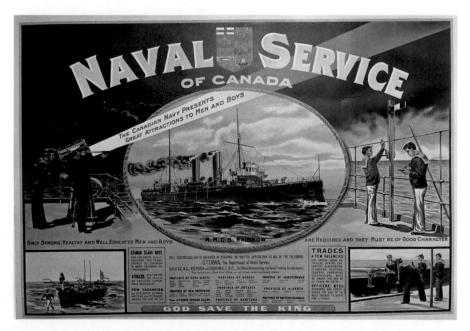

ones—smashed this attack. On May 24, despite Currie's pleas for more time to study the ground and prepare his troops, his weary men tried again. This time they seized their objective, a redoubt known as K5. They had moved the line forward six hundred metres but at a cost of 2,500 casualties. Fifteen hundred men of the Canadian Cavalry Brigade who had volunteered to fight as infantry then struck the Germans on May 25. Though they had only one day's training in the trenches, the new infantrymen tossed gas bombs at the Germans and reported success back to headquarters. Unfortunately, fighting on a bombed-out battlefield with few surviving landmarks and equipped with frequently inaccurate maps, the Canadians missed their objectives.

The Festubert fight was a foretaste of what was to come. Attackers needed a substantial superiority in numbers to stand a chance to prevail, and the Canadians had not had this advantage. Daylight attacks without proper, coordinated artillery support and an element of surprise were doomed to fail. The Germans troops were better trained than their opponents, and their weaponry in 1915 was far superior. Put it all together, and you had Festubert; men died in the hundreds and thousands for a few metres of mud. Confusion reigned. And orders to attack had to be followed, no matter the pleas of subordinate commanders for more time for reconnaissance and preparation. The great unstoppable machine of war simply chewed up the attackers.

The Canadians returned to the offensive on June 15 at Givenchy. At least the ground here was dry, the grass green. This was a far cry from the Ypres battlefield. There was also blessedly some time to ready the troops, and the artillery blasted the enemy's barbed wire and tried to destroy his machine guns. At the same time, Canadian sappers (engineers) dug a tunnel and planted a huge mine under the enemy trenches. The planning was better, but regrettably it was no more successful. The wire was cut in places, a handful of machine guns were destroyed and the mine did blow up a section of German trench. But the explosion killed some of the attackers from the 1st Battalion, and German counter-battery fire blew up the Canadian guns firing at the machine guns. As was their almost invariable habit, the Germans mounted a quick counterattack, well supported by artillery, and drove back the Canadians before they could dig in on the objective and be reinforced. Givenchy was yet another costly debacle. Frank Ashbourne of the 3rd Battalion observed ruefully that his unit of a thousand men had attacked at Festubert "and only five hundred returned.

Again reinforced to one thousand we were cut right down to five hundred and sixty at Givenchy." That was the way the war was fought.

Fortunately, Givenchy was the last major battle the Canadians fought in 1915. The Canadian Division was very different than it had been when it formed up at Valcartier in August and September 1914. The division's infantry of eleven thousand had sustained an incredible 9,413 casualties, and reinforcements outnumbered the old sweats by huge margins. Experience had been hard won, but too many of those who learned how to fight had been swallowed up in the mud of Festubert and the fire of Givenchy. Many of the wounded, however, might be able to return in time.

THE CANADIANS' INTRODUCTION to the Western Front had been brutal. This was no war for gentlemen, only a bloody struggle for dominance and survival. In the maelstrom that was industrialized warfare, only the disciplined and careful could survive. Leaders had to learn what to do and how to do it, equipment had to work properly and supplies had to reach the men and the guns. Without these traits—never before found in great quantity among Canadians in the field—death and defeat were certain. From the shaky beginnings of August 1914 through to the confused but heroic glory of April 1915, the Canadian soldiers had begun the process of learning how to fight and win at war.

The Ypres struggle moved Major John McCrae to write the poem that made the battle live on forever in the consciousness of the world. Moved to the breaking point by the death of a friend on May 2, McCrae looked at the poppies that sprang up in the fields just north of Ypres. Almost without stopping his pencil, he spent twenty minutes writing fifteen lines of poetry. "In Flanders fields the poppies blow," he began, and he ended with a call for perseverance and victory:

Take up our quarrel with the foe:
To you from failing hands we throw
The torch; be yours to hold it high.
If ye break faith with us who die
We shall not sleep, though poppies grow
In Flanders fields.

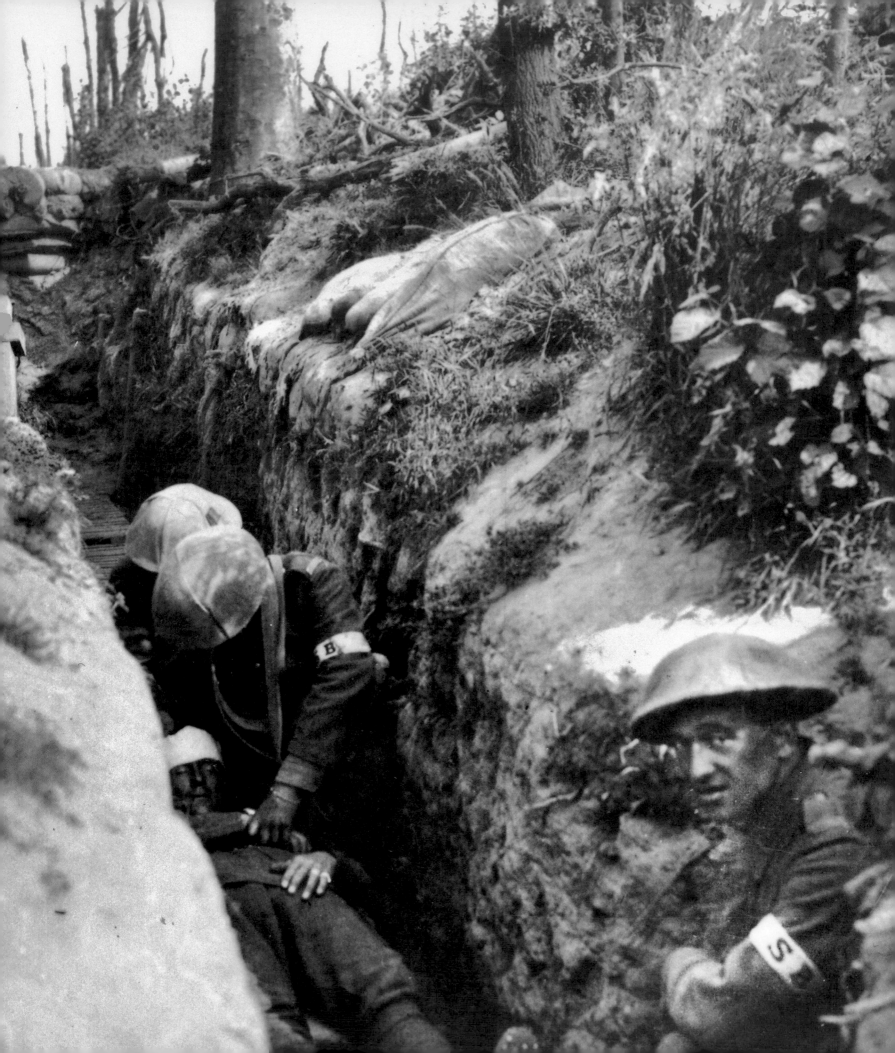

3 | BECOMING SOLDIERS

PRIVATE DONALD FRASER of the 31st Battalion wrote carefully in his journal of his first stint in the trenches. It was October 1, 1915, and the routine for the 6th Brigade of the 2nd Canadian Division, of which Fraser's unit was part, was "two battalions in the front line, support line and strong points for six days, one battalion in and around Kemmel [a village to the rear] for six days and the remaining battalion in reserve . . . We start early," he noted. "We had quite a long march through the trenches, the communication trench going under the name of Regent Street. [Strong point] 9 turned out to be a circular redoubt on slightly elevated ground, with a trench running round it and small trenches, covered in, radiating from the centre. At the eastern end a short trench branched off, at the end of which was a machine gun emplacement."

That night, Fraser and his comrades were introduced to dugout life. "The dugouts," cut into the trench walls, "were small, damp and cold and overrun with rats." Men slept in their clothes for the entire tour in the trenches, and sentries changed every two hours, "so the chances are you get wakened up between the shifts." Then there was every likelihood of a stand-to, "which means you have to hold yourself in readiness for eventualities, in other words you have to be wide awake with equipment on." Add this to the cold and wet, the dirt and rats, the constant enemy rifle fire, the patrols and the possibility of major fighting, and the soldier's life was misery compounded by fear.

THE CANADIAN DIVISION had time to restore itself after Givenchy. Reinforcements could be brought forward, imbued with the battalion's culture and taught their brigade's fighting style. There was time for lectures on hygiene, on the use of the machine gun and on combating gas attacks, the latter a subject on every soldier's mind after Ypres. Officers

took specialized courses to prepare them for higher posts or staff duties. And the respite gave time for Major-General R.E.W. Turner's 2nd Canadian Division to arrive in France and for the Canadian Corps to be born in September 1915. General Alderson became the corps commander, and Arthur Currie took over the original division, now called the 1st Canadian Division.

The war had not ceased just because the Canadians were not in full action continuously. On the Eastern Front, the Germans and Austrians continued to push into Czarist Russia. The Italians joined with the Allies in 1915, and the Austrians began to press through the mountains towards the northern Italian heartland. The British and French, spurred on by the restless mind of Winston Churchill, the First Lord of the Admiralty, launched an amphibious attack at Gallipoli, the object being to force Turkey, Germany's ally, out of the war or at least to pull back troops from the Ottoman Empire's possessions in the Middle East. Gallipoli was an attempt to escape from the stalemate in the trenches in western Europe; it turned into a bloodbath of futility.

For the Canadians, however, the war went on, even though they held a relatively quiet sector of the front. If it was quiet, however, it was not for want of trying. The Princess Patricia's Canadian Light Infantry, a battalion raised largely from men with previous service and initially attached to a British division, had invented trench raiding in February 1915, and the Canadians raised the tactic to an art form. A trench raid aimed to establish Canadian dominance over no man's land, to keep the Germans on edge, to take prisoners and do damage and to oblige the enemy to move reinforcements forward so that carefully planned artillery concentrations could inflict more casualties. Usually, from thirty to 250 men might be involved in a raid, though some could be battalion-sized, and rehearsals and special training were frequently involved. There were men with wire cutters that actually could cut barbed wire—unlike most wire cutters issued to the troops—bombers and riflemen, all working together in a carefully calculated way. The raids could be useful. The first one by the 1st Canadian Division on November 17, 1915, saw thirty casualties inflicted on the enemy and a dozen prisoners taken. The shelling of the enemy reinforcements was also deemed effective.

There was a price to pay for raids, of course. Often the attackers suffered casualties, and by poking a stick into a quiescent hornets' nest the Canadians invariably stirred up the

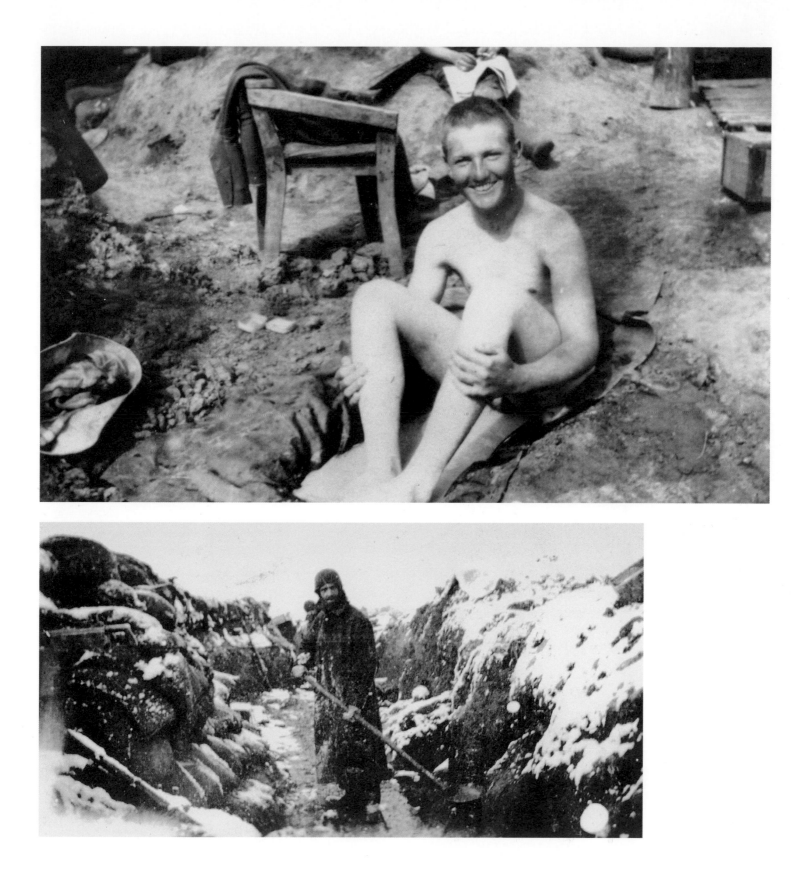

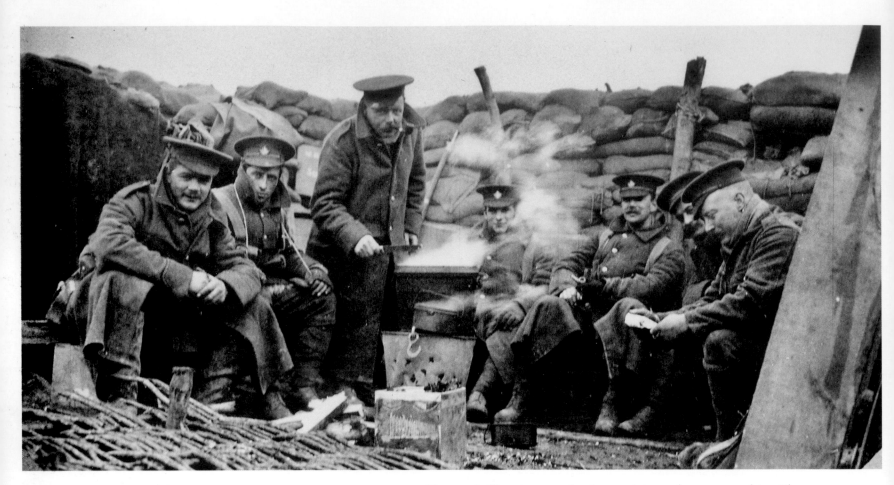

enemy, a guarantee of heavy shelling, increased sniper activity and more casualties. That delighted commanders, who worried that their men too often lacked the offensive spirit; it bothered soldiers, who tended to prefer a "live and let live" policy.

At least raiding countered the boredom of military life. For soldiers of the Great War, much like those of every age, the army was "hurry up and wait." Short stretches of intense activity were followed by endless waiting or make-work projects devised by both commissioned and non-commissioned officers. When the troops were out of the line, there were training courses, parades and "chickenshit"—polishing brass, shining leather, painting rocks. When they were in the trenches, the combatants' dreary, miserable existence in muddy dugouts was punctuated by bursts of excitement and fear. And in the trenches, even in quiet sectors, there was the steady drain of casualties from artillery or small-arms fire. In the first quarter of 1916, for example, the Canadian divisions suffered more than two thousand casualties from enemy fire and an additional third of that number from non-battle injuries, which included those resulting from road accidents, kicks by nervous or frisky horses and self-inflicted wounds.

The men learned to live with the prospect of death. Fear was normal and all shared it, but most soldiers would rather have died than let their friends see how frightened they

were. Frequently that fear began even before men reached the front. Future prime minister John Diefenbaker was an infantry lieutenant training in England when he was declared unfit for service and sent home to Saskatchewan. Diefenbaker said in 1969 that without his medical disqualification, "I wouldn't be here, no possibility; the possibility is so remote. We went overseas with 184 lieutenants and twelve weeks later there were 33 living. Utter slaughter. Young officers going over the top..." His biographer Denis Smith concluded that Diefenbaker was invalided out for depression and psychosomatic symptoms that were "natural reactions—even sane ones, as can now be admitted—and they were widespread."

Another future prime minister, Lester Pearson, had similar experiences. He had enlisted as a private in 1915 and served in a Canadian hospital unit in Salonika, Macedonia. Then he used his father's connections to get sent back to England, where he trained to be an infantry officer and soon was accepted for pilot training. The rest of the story is as unclear as Diefenbaker's, but there seems to have been a plane crash and a bus accident that left Pearson with "neurasthenia," described by biographer John English as a "generalized anxiety syndrome." In effect, Pearson's nerves were shattered, and he too was deemed unfit to fight.

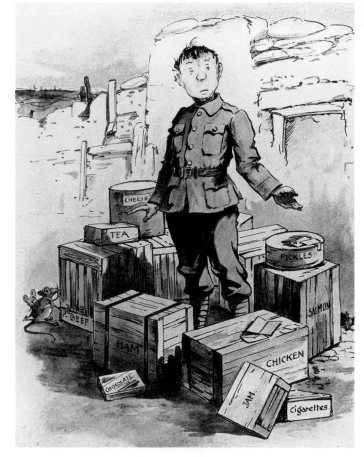

Officers had to lead their men, and this required that they understand both their own and their soldiers' fear. To live in the trenches was difficult enough, even without the enemy's fire. Standing in mud and water, sleeping on the dirt, was not good for fitness or morale. The cold and wet seeped through boots and socks, causing trench foot. This condition wasn't fatal, but it incapacitated a soldier as much as a battle wound did, and officers conducted daily foot inspections, whenever conditions permitted, to ensure that soldiers kept their feet in good condition. There were other diseases, usually lumped together as trench fever, that arose from the foul conditions, the lack of drainage, the human waste and the ever-present lice. ("I feel quite lonely now," one soldier wrote home. "Just had a bath & change of underwear a few days ago & I lost all my friends.") Soldiers developed rheumatism

Soldiers in training soon learned the ways of the army.

BELOW: One major aspect of training was getting comfortable whenever possible. (CWM 19680113-001#1 P.65F)

RIGHT, ABOVE: Kit inspections were regular occurrences; all one's possessions were laid out in a prescribed order. (CWM 19910047-050 P.6B)

RIGHT, BELOW: Digging was a skill to be learned. (CWM 19820103-011 P.66C)

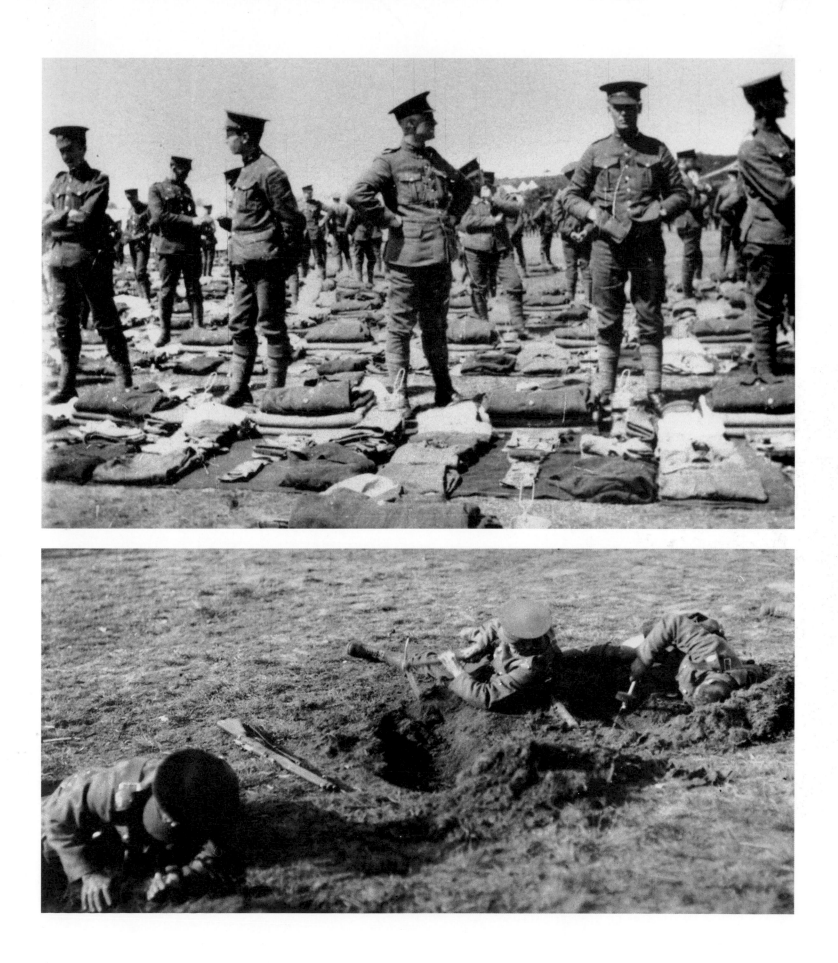

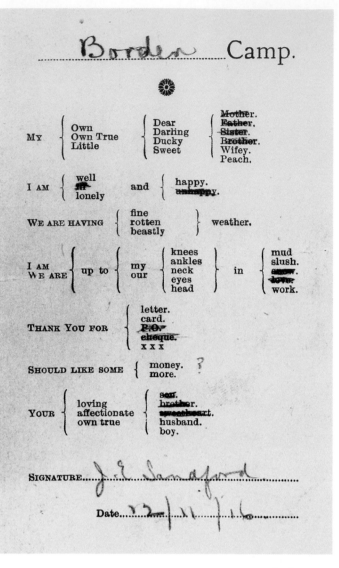

_____ Border _____ Camp.

✿

MY { Own / Own True / Little } { Dear / Darling / Ducky / Sweet } ~~Mother.~~ / ~~Father.~~ / ~~Sister.~~ / ~~Brother.~~ / Wifey. / Peach.

I AM { well / ~~ill~~ / lonely } and { happy. / ~~unhappy.~~ }

WE ARE HAVING { fine / rotten / beastly } weather.

I AM / WE ARE { up to } { my / our } { knees / ankles / neck / eyes / head } in { mud / slush. / ~~snow.~~ / ~~love.~~ / work. }

THANK YOU FOR { letter. / card. / ~~P.O.~~ / ~~cheque.~~ / x x x }

SHOULD LIKE SOME { money. / more. } ?

YOUR { loving / affectionate / own true } { ~~son.~~ / ~~brother.~~ / ~~sweetheart.~~ / husband. / boy. }

SIGNATURE...... _J. E. Sanford_

Date...... 12 / 11 / 16

from wearing wet clothes for long periods, and others contracted tuberculosis, meningitis, influenza or a host of other ailments. And yet, the soldiers' overall health seemed to improve. Except for the shelling and the prevalence of death, army life was relatively healthy.

The food also wasn't too bad. In the trenches, food and water came forward daily, to be divided up by companies, then platoons and then sections. Men cooked their grub over improvised cookers or alcohol burners and ate out of the pot or from mess tins. There was ordinarily plenty of tinned "meat and veg," bread, hard army biscuits, jam and endless cups of strong tea with enough sugar to stand a spoon up straight. Unchlorinated water might be scarce, but the tea leaves seemed to kill most of unpleasant taste. It was all high-calorie foodstuff, aiming to provide the more than three thousand calories a day that men doing hard physical work required. The rations came from British provisioners, not from Canada, but because such a high proportion of the Canadian Corps was British-born and used to unappetizing food, there were fewer complaints than might otherwise have been the case.

Parcels from Canada which, in quiet sectors, could come right up to the trenches, supplemented the issued rations with luxuries like candy, cookies, good cigarettes, canned meats, canned milk and tinned salmon. Private Floyd White of the 87th Battalion wrote to thank his family for the "two big tin boxes, with the fruit cake in" that he had received on December 31, 1916. "Tell Mother her fruit cake keep swell & moist." Naturally, officers received more and better parcels than did most of the men in the ranks. Captain Georges Vanier of the 22nd Battalion wrote his mother in January 1917 that he had received "five or six boxes from you containing nuts, socks (the right kind), candy, maple syrup, chocolate, Woodbury's soap (will you send a few more bars?) and other most useful gifts. I believe most of the packages you send reach me eventually." Like other officers and men, Vanier shared much of what he received with his friends. Officers, unlike their soldiers, could get liquor.

Mail from home mattered a great deal to officers and men alike. Although not all Canadian soldiers were literate, most were, and the inarticulate notes they exchanged with family and friends are heartbreaking in their simplicity and yearning. "I got your nice long letter and the cute little picture, of yourself," Corporal Roy Macfie wrote a girlfriend in October 1915. "Its sweet! Can't you send me some more like that." Many soldiers used the printed cards the army supplied that let them indicate they were well and unwounded, in hospital or not. Too often, however, the mail from home brought bad news of family tragedies, money problems or "Dear John" letters telling a soldier that his wife was leaving him.

Fortunately, there was a daily rum ration in the line, Special Red Demerera that came forward in gallon jugs. It was our "one consolation ... [in] a beastly place," one private wrote. A few teetotal unit commanders refused to permit rum to be doled out to their soldiers, but most recognized its utility in providing some stimulation to men who were frequently cold and wet and some temporary relief for those with private pain. Temperance organizations at home, working for prohibition in Canada, also complained about the rum ration, denouncing the government and the army for turning innocent youngsters into men dependent on alcohol. That the innocent youngsters had to kill or be killed seemed almost immaterial when the baneful influence of demon rum was the issue. Still, the rum ration hung on, and before attacks troops usually received a double shot. After the attacks, the ration came forward, almost always failing to take account of casualties. That the survivors could get drunk was probably unintended but certainly therapeutic.

THE DEAD WERE COLLECTED, identified where possible and buried, initially near their unit lines. After the war, Imperial War Graves Commission cemeteries consolidated the dead, the Canadian government having decided that none of the killed would be returned to Canada. (At least one distraught Toronto mother made her way to France after the war, disinterred her son from a war cemetery and smuggled his remains into Canada for burial in the family plot.)

The wounded received remarkably effective and prompt treatment in an era before antibiotics and helicopter evacuation. First treatment came at the regimental aid post, where a battalion's doctor would set up shop in the support trenches. Stretcher-bearers brought

THE SALVATION ARMY
Military Hostel

For Soldiers on Active Service and Returned Men
(in or out of Uniform.)

CORNER OF KING AND CLARENCE STS.
KINGSTON, ONT.

IT IS A REAL HOME

PRICES:

BEDS—Dormitories, per night - 30c. & 40c.
Semi-private, per night - - - 50c.
SINGLE ROOMS—Per night - - - $1.00
Per week - - - $5.00

The Use of Smoking, Reading, Correspondence, and Lounge Rooms Free.

CALL AND INSPECT THE HOSTEL

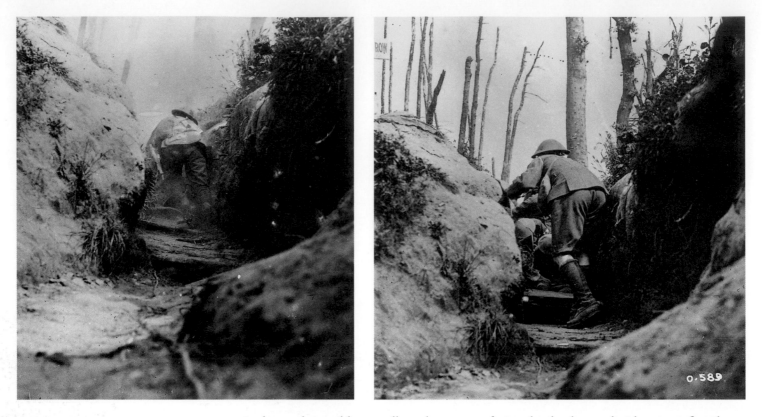

in those who could not walk, and a system of triage let the doctor decide to treat first those who might live. Then casualties began a rearward journey, initially by field ambulance to an advanced dressing station, where morphine might be administered. The wounded then proceeded, sometimes by train, to the casualty clearing station, where surgeons, assisted by nursing sisters, operated. The final stage occurred when the wounded were transferred to stationary or general hospitals, in either France or England, where further surgery might take place. There were then specialized convalescent hospitals in England and, for the lucky, military hospitals in Canada.

The standard of care was impressive, and 876 of every thousand wounded men survived—a miraculously high figure, considering that the men lived and fought in mud and filth, the embodiment of septic conditions. Blood transfusions were used routinely by 1918, and the army also worked ferociously to control disease. Of the more than 600,000 who served, only 6,767 Canadians died of disease during the war.

Occasionally the Germans, either deliberately or in error, attacked hospitals and hospital ships. In one air attack on the Canadian General Hospital at Etaples, France, in May 1918, seven nursing sisters were killed. Fourteen more died when the *Llandovery Castle* was sunk by a U-boat in June 1918. Canadian nurses were officers, and 2,854 enlisted during the course of the war. For the wounded, the presence of women in casualty clearing stations and hospitals was enormously important, and the nursing sisters performed their medical duties at some risk while reading mail and frequently writing letters for the men in their

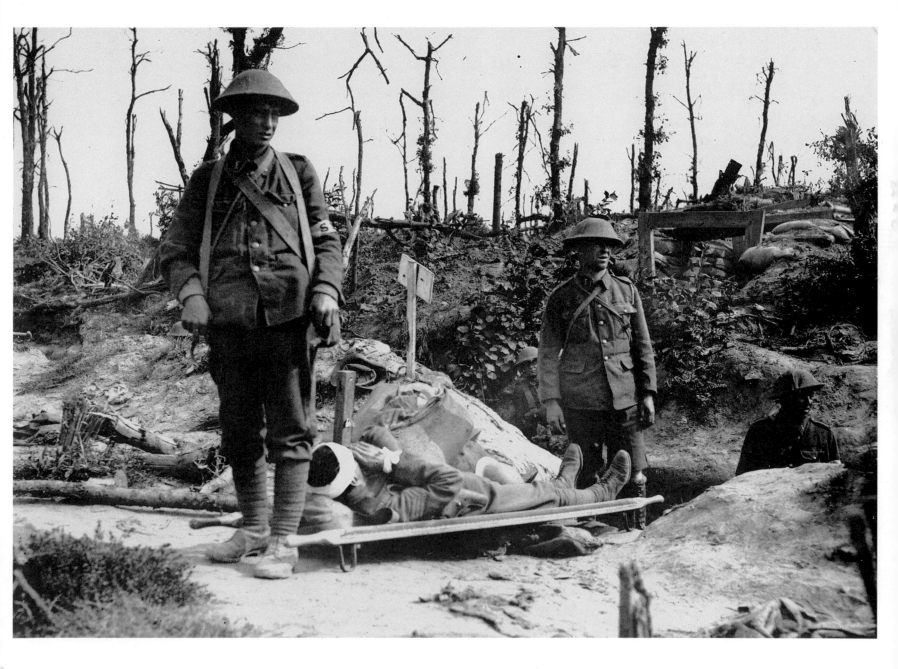

care. One of them, Lieutenant Roberta MacAdams, won election to the Alberta legislature as one of two "soldier candidates" in August 1917. "Give One Vote to the Man of Your Choice," her campaign flyer said, "and the Other to the Sister." Alberta's soldiers listened, and MacAdams, a thirty-seven-year-old dietitian, became only the second woman elected to a legislature in the British Empire. As far as those fighting the war were concerned, nursing sisters shared their hardships and comforted them in their suffering.

ONCE WOUNDED MEN recovered their health, every effort was made to return them to their original unit. Men wanted to serve with their friends, with those from their home town or province. Thus, when Canadian reinforcement training battalions were organized in England, they were grouped regionally. Men fought for many reasons, including patriotism, but they seemed to fight better when they were with their own kind. (Some British historians, bemoaning the fact that the British Army did not group its battalions regionally, attribute "the superior performance" of Canadian and Australian troops to this policy.)

When they came out of the front lines, soldiers could live a little better. There were infrequent passes for other ranks and more regular ones for officers, a cause of much dissension. Men could get from the front to England in a day, and soldiers wearing their foul trench uniforms regularly disembarked at London's railway stations. After a quick wash-up, they were in the pubs or trolling for sex in Piccadilly Circus. Others took leave in France, just behind the lines, where they ate chips and drank harsh *vin ordinaire* in grubby *estaminets*.

They lined up for quick, mechanical sex at British Army–inspected brothels, each marked with a red light. Officers who wished to do so could patronize slightly higher-class brothels, sporting a blue light. Supposedly the lights were a guarantee of protection against venereal disease, which the army took very seriously because it took men out of the line; treatment for syphilis, for example, took some seven weeks. Unfortunately, Canadian soldiers were said to have the highest infection rate of any army on the Western Front—more than five times that of the British Army—a badge of distinction (and sexual naïveté) that was not especially wanted. The commanding officer of the Princess Patricia's Canadian Light Infantry had his medical officer lecture each platoon on VD and on "how

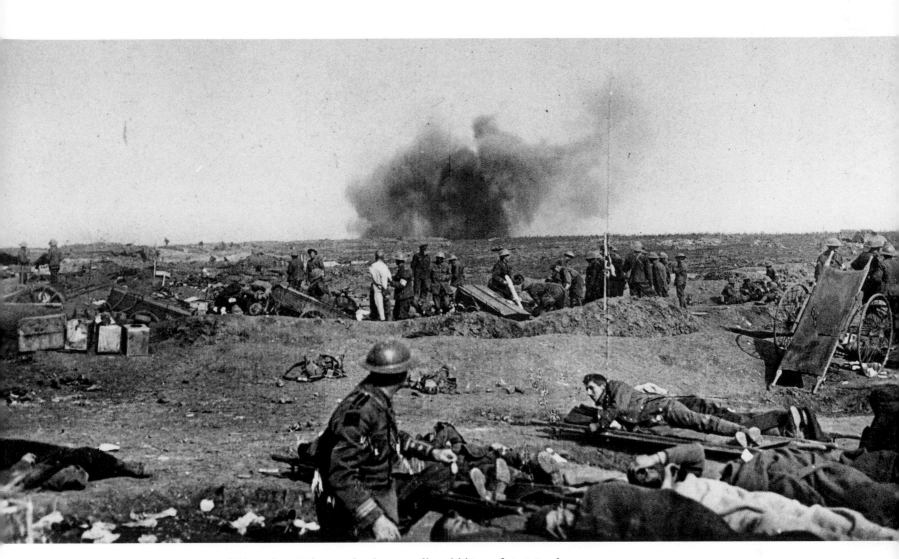

certain precautions could be taken." The results, he proudly told his wife in March 1917, were "most satisfactory" because only two cases occurred. "Some of the other regiments have been most unfortunate."

On longer leaves, there was Paris, where soldiers gawked at the Eiffel Tower, ate and drank in cheap restaurants and patronized the prostitutes who abounded on the city's streets and whose rate of venereal infection was high. For men from a prudish, still-Victorian Canada, France was licentiousness writ large. The Canadians took advantage wherever and whenever they could.

But some, like the religious Georges Vanier, did not wallow in sin. Vanier, a lawyer from Montreal serving with the 22nd Battalion, the Van Doos, travelled extensively in France whenever he could get the opportunity. His letters home recount trips to the Mediterranean coast, pilgrimages to churches and orphanages, discussions with priests, excursions to the opera and visits to the theatre. For him, France was a religious and cultural opportunity, even in wartime.

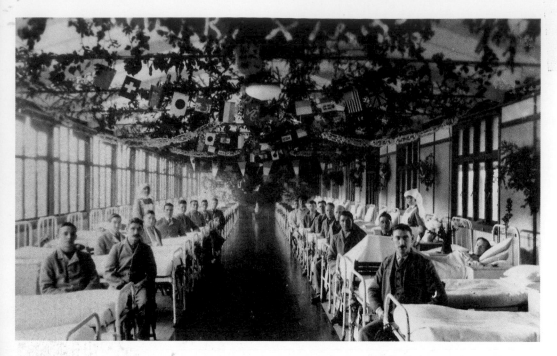

For private soldiers, leave was frequently more regimented. Private Donald Fraser was sent on leave for two weeks in mid-1917—the sole man from his battalion to be selected—and found himself in a rest camp at Wimereux, near Boulogne. The camp was crowded, men slept—or tried to sleep—in tents and there were endless fatigues (non-military duties) that had to be done. "Restrictions as to walks were absurd. We were practically confined to camp. Passes were few and not easy to get." On the other hand, Fraser observed that there were good concerts, movies and sports—"I saw Tom Longboat, the Indian," Fraser wrote, "running and jumping." Canadian battalions organized baseball teams (and in England played against American and the few British teams) and held track meets, with divisional and corps championships. Concert parties were organized by many battalions and divisions, almost all featuring female impersonators. The Dumbells, from the 3rd Canadian Division, became widely known at the front, in England and, after the war, on the stage in Canada. The Comedy Show of the Princess Patricia's Canadian Light Infantry regaled the battalion with "takeoffs" on the officers of the regiment and the corps commander.

Back of the line, padres ran religious services on Sundays, and large numbers of soldiers took communion. The Salvation Army, "Sally Ann," was the soldiers' favourite operator of rest huts, where coffee and a roll and tables to write letters could be found. The YMCA and the Knights of Columbus operated similar establishments. Likely more important than the rest huts was the opportunity to take a communal shower in the big bath units run by the Canadian Corps' rear-area troops. Men washed and scrubbed, deloused themselves and exchanged their filthy clothing for new supplies at the quartermaster's stores. Hot meals were cooked communally, pay records were sorted out, and the mail that sometimes was misdirected reached those waiting for word from Canada.

The corps' operations behind the lines were massive and grew ever more sophisticated as the war went on. Salvage units recovered wrecked equipment, and workshops, some mobile, repaired it. Veterinarians looked after the horses that pulled the artillery and

LEFT: If the wounded made it back to England, they ordinarily found themselves in convalescent hospitals which, while not this well decorated every day, could be cheerful places. (CWM 19910056-001 P.21)

BELOW: The soldiers' feet were one of the officers' main concerns. Trench foot, shown here in a very severe case, could cripple a man forever. (National Archives of Canada PA-149311)

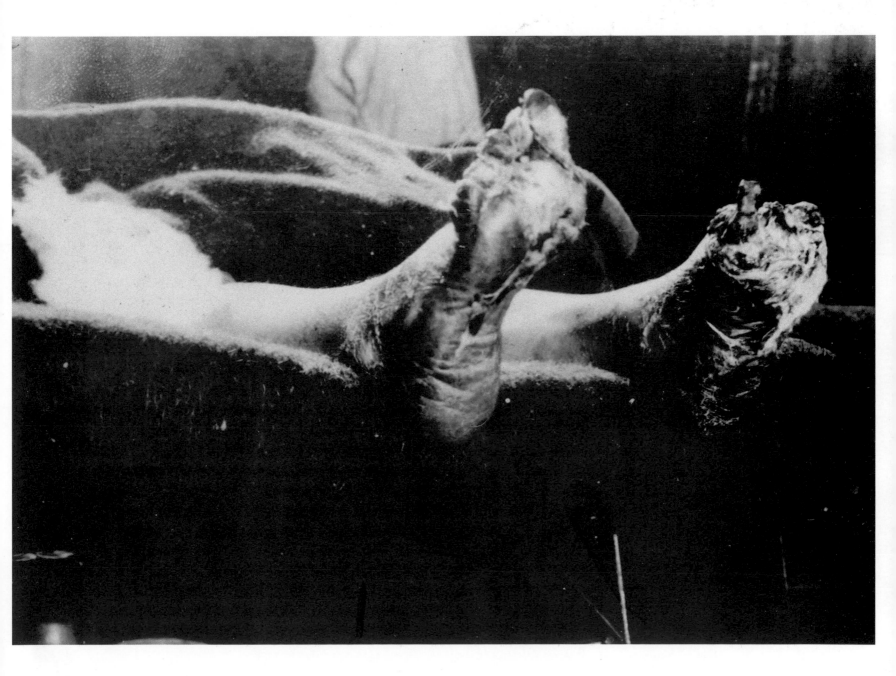

wagons. Service Corps companies operated heavy trucks that carried rations and supplies forward, while railway construction units built railroads from the rear towards the front and forestry units cut down the woods of France. In a real sense, the Canadian Corps had become a great efficient machine handling the needs of all its men and women.

BUT AFTER THIS RELATIVE PEACE, there were the trenches to return to. The trenches ideally were wide enough to allow two or three men to pass each other and deep enough so that only the very tallest of men had to stoop to avoid becoming a sniper's target. The front and rear of a trench received protection from sandbags, and traverses, or sharp bends, occurred at regular intervals to prevent an enemy party from getting into the trench and having clear fields of fire to the right and left. If time and supplies were available, timber and corrugated iron were used to provide overhead shelter in dugouts or for revetments (retaining walls) on the trench sides, which were essential to stop the walls from collapsing in the rain. "Firing steps" were carved into the parapet or front of the trench to allow men to shoot at the enemy. Officers' dugouts were frequently furnished with beds and desks, and they sometimes verged on the comfortable; the men's were crude, cold and usually foul-smelling, with the combination of body odour, tobacco, cooking smells, damp and excrement making the reek memorable.

In front of the trench line were belts of barbed wire. Concertina wire, curling in rolls, was the favoured defence, but every unit worth its salt kept its wire in good shape, sending work parties out each night to ensure that the enemy had not cut routes through it. The Canadians also sent out patrols, so gaps in the wire had to be maintained for their departures and returns. These gaps especially needed to be covered by riflemen.

Work on the wire was not all that soldiers did at the front. Repairs on the trenches were continuous, filling time in the daylight hours. Units dispatched bearer parties to the rear each night to

THE CANADIAN CONVALESCENT HOSPITAL AT BEAR WOOD, WOKINGHAM
(1) Dinner-time. (2) At dinner. (3) Nothing is wasted. (4) Getting into khaki again. (5) The blue suit. (6) Repairs.
(7) A game under difficulties. (8) Writing home.

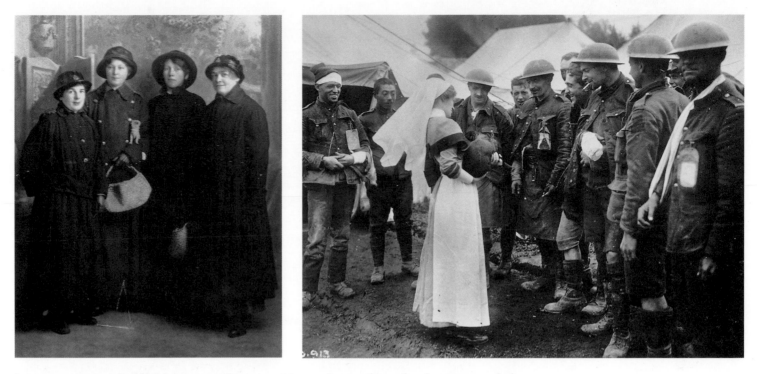

bring up supplies, food and water, mail, ammunition and everything else that men needed to live and fight. The communications trenches, linking the front with the support line, also had to be maintained. And each dawn and dusk, the unit went on stand-to, manning the firing steps and guarding against attack. The Germans liked to attack when there was just enough light to see but also enough darkness to hide movement.

The day was full for the Canadian soldier not only because there was always work to be done, but primarily because the army instinctively believed that idleness was bad. Most soldiers likely understood this because they were frequently bored silly. "This war is getting unbearable," Roy Macfie said after three months without a major Canadian action, "sticking here in one place so long, and the bad weather is setting in again . . . you have no place to go." It hardly seemed like war, he added, "just the same old thing over and over again . . . the only excitement is a few getting picked off now and again. Any kind of change would be welcome no matter how bad it was."

Boredom led to discipline problems. Men fought with their friends, stole from each other or neighbouring units, got drunk in or out of the line, slugged civilians or raped women. Others formed liaisons with Belgian and French women, impregnated them and disclaimed any responsibility. All such trespasses were dealt with by the army's system of military justice. Commanding officers meted out punishment for minor infractions that could extend from restricted leave or pay to extra duties. Serious crimes went to court martials; the most serious offences involved desertion or cowardice.

Even if the army's treatment of battlefield stress, or "shell shock," was unsophisticated, most sensible officers in the Canadian Corps on one level recognized that a soldier's

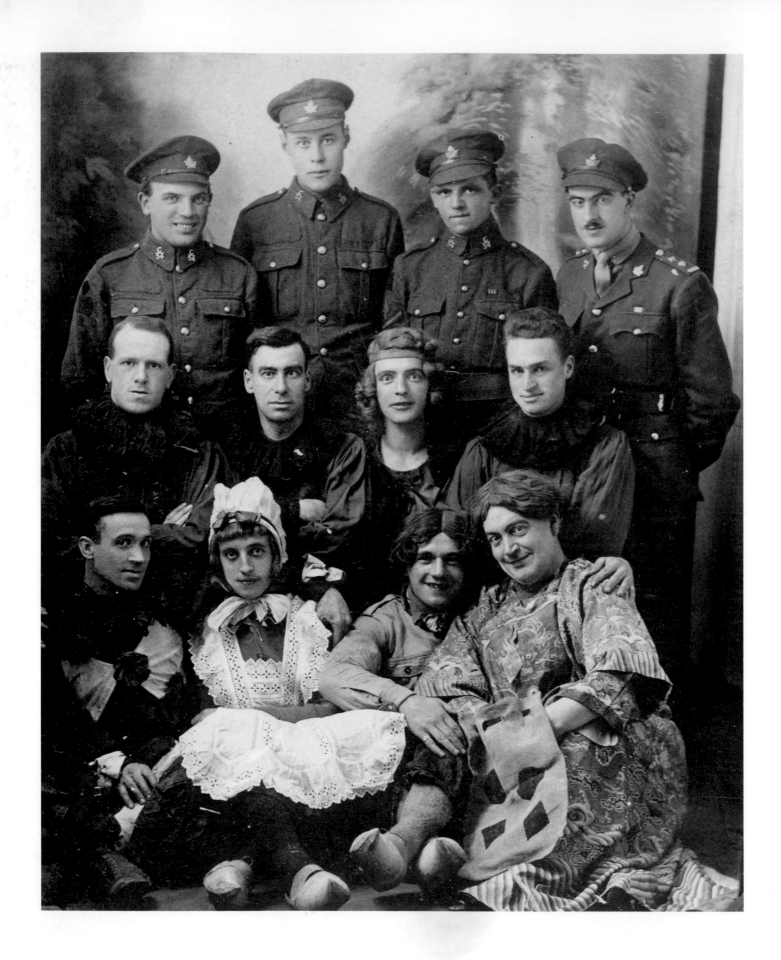

stockpile of courage was not infinite. Sympathetic unit doctors could take men out of the line, and some commanding officers sent soldiers and officers to other jobs in the rear when their condition threatened the lives of those around them. Men fought not for lofty ideals but for their friends, and no soldier wanted to let down the men in his section, to whom he was closer than to his brothers at home. But fear could sap the will, and men fled the battlefield or refused to go into the line, despite the best efforts of their comrades and officers. In the senior officers' view, this could not be tolerated, for if one man could escape his duty and go unpunished, whole units might be next. Thus the punishment for desertion or cowardice could be severe: long terms of imprisonment or death by firing squad.

Twenty-five Canadians were executed by firing squad in the Great War. The 22nd Battalion, the sole francophone unit at the front, executed five of its members, more than any other battalion. The unit's commanding officer, Lieutenant-Colonel Thomas Tremblay, was a stickler for discipline, an officer determined to prove that French-Canadian soldiers were as good as or better than their English-speaking compatriots. Discipline, he believed, had to be enforced. It fell to Captain Georges Vanier to command a firing squad in March 1917. The soldier, Private Arthur Charles Degasse, had deserted thirteen times. Vanier wrote in his diary:

14 March: At 4:30 PM I officially announced to the condemned man that the Court Martial has found him guilty and has sentenced him to death. His attitude was calm and I left him with the Chaplain. I have been put in charge of the troops that will take part at the execution tomorrow morning. A sad task, a sad command.

15 March: Up at 5 AM. The dawn has not yet broken. A platoon from each company, 20 men from Company Headquarters and all the detainees from the guard room lined up on the square in front of the church. In silence, I led them to the site of the execution. At 6:30, the condemned man arrived, his eyes blindfolded . . . The Chaplain recited prayers and I heard the man say "Padre, Padre" twice, then the sharp and clear sounds of the rifle shots, followed by silence. We all filed out past the body.

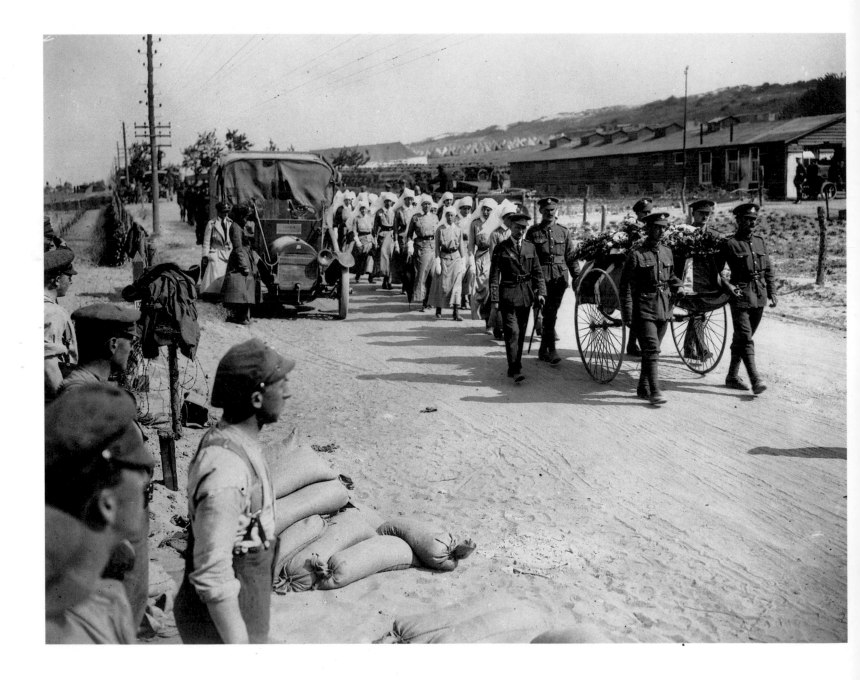

HELL'S CORNER

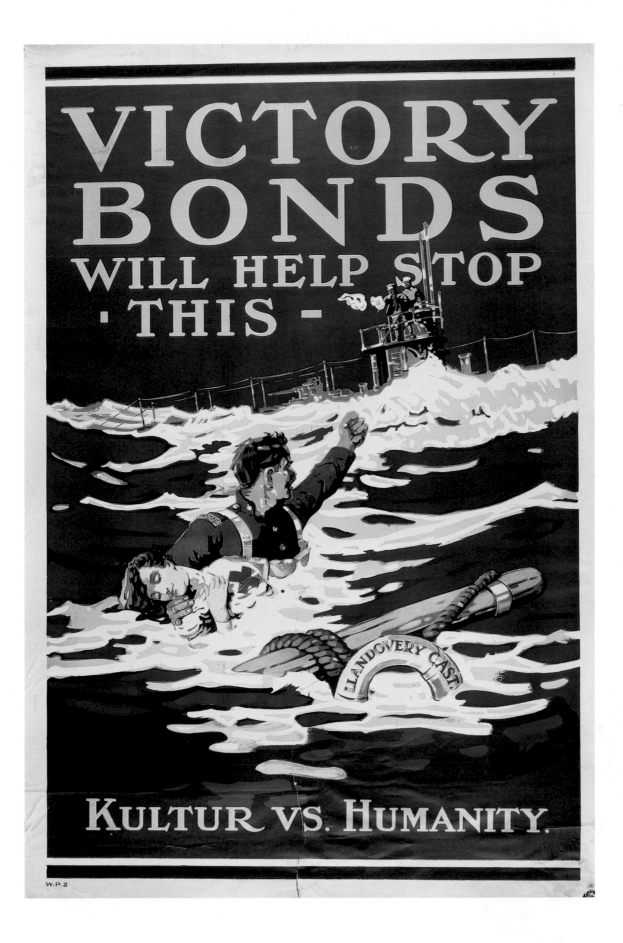

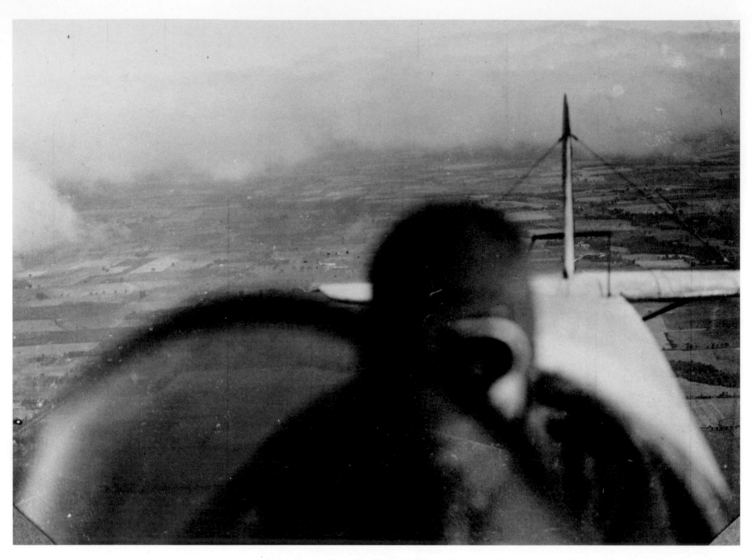

If the firing squad of ten soldiers had not done its work cleanly, the officer in charge had the obligation of applying the *coup de grâce,* a pistol shot to the head. Vanier did not indicate if this morbid task fell to him to administer. What his diary account makes crystal clear, however, was that the primary purpose of the execution was *pour encourager les autres*—to set an example to the other soldiers of what might happen to them if they failed to do their duty. Whether fear of harsh discipline was successful in motivating soldiers to fight remains unclear. During the Great War, however, Canadian commanders had no doubt that it did.

An execution was only another death in a war overflowing with death. Soldiers wanted to live, but many seemed to lose their fear as they saw death all around them. One officer, just advised of his brother's death in the Royal Flying Corps, wrote home: "It is much easier for anyone here, Father, as you would understand if you were here, to take what comes to them. You look forward to certain things as inevitable . . . Death," he added,

"has no horrors for anyone here, at least for those who have been here a few weeks or more." The officer, Ramsey Morris of the 38th Battalion, went on to say that "it is a man's work here and not anything else. It is something to have come out here and done what is expected of you, and those who haven't come don't come into the matter at all. This is a matter purely among men and the men are here." Whether that letter provided much comfort to his parents is unclear, but it certainly reflected a widespread view at the front. The war was horrible, but it had to be fought and won.

FOR SOLDIERS AT THE FRONT and in the rear, the sky above was full of miracles and dangers. They saw aircraft—most had never seen one before the war—as thrilling, and they contrasted their earthbound existence to the apparent freedom of the pilots. They could understand the dangers—to the pilots and to themselves—but the terms soldiers used to describe dogfights were revealing. "I watched one of the prettiest fights I have ever seen," one Alberta officer wrote, "watched them dip and turn, each trying to jockey for position ... they twisted, dived, climbed and slipped."

Powered flight had begun only in 1903, when the Wright brothers managed to get their aircraft off the ground at Kitty Hawk, North Carolina. J.A.D. McCurdy was the first Canadian to fly, six years later, when he took the *Silver Dart* into the air, and a Canadian Aviation Corps, with one already obsolete craft, was at Valcartier in September 1914 with a strength of two officers. The plane never flew, and the corps soon ceased to exist.

But Canadians were in the air. The Allies and the Germans used aircraft in reconnaissance roles in the opening battles of the frontiers, and some give credit to the pilots' reports for putting a stop to the Germans at the Marne. Soon, observers carried rifles or grenades into the cockpits, spotted for the artillery or operated cameras. The troops on the ground, realizing the threat from the air, began to shoot at the enemy craft, and the pilots began to engage in dogfights and the strafing of troops and vehicles. It was only a matter of time before the aircraft became faster and were equipped with machine guns that could fire through a whirling propeller without damaging it. The war speeded up the development of aviation dramatically, and young Canadians, most of them adventurous but some seeking an escape from the grinding fatigue and horror of the trenches, joined the British Royal Flying Corps (RFC) or the Royal Naval Air Service overseas.

LEFT: The sense of speed and joy of flight are captured in this snapshot taken from the pilot's seat. (CWM 19850166-005 P.59)

The excitement of flying, the sheer beauty of flight, mesmerized
Canadians during the war. Two artists who later became prominent
in the Group of Seven graphically portrayed this new sense of freedom.
BELOW: Frederick Varley portrays air combat in his sketch *The Young
Man's Element, the Air* in 1917. (CWM Varley 8918)
RIGHT: Franz Johnston's superb painting of a Curtiss JN-4 trainer
looping over southern Ontario in 1918 captured the joy of flight.
(CWM Johnston 8269)

THE SOPWITH CAMEL AT BEAMSVILLE DOING 4 LOOP

Billy Bishop, the Canadian ace of aces, recalled that he joined the RFC because of the mud at Shorncliffe Camp in England: "I had succeeded in getting myself mired to the knees when suddenly, from somewhere out of the storm, appeared a trim little aeroplane ... I knew there was only one place to be on such a day—up above the clouds and in the summer sunshine." Lieutenant Basil Morris joined the RFC in January 1917 because, he said (sounding much like Bishop): "I was awfully fed up on the trenches, the mud and slush and everything." The air let one be an individual, pilots thought, not just an unthinking cog living a miserable existence in a giant ground-based machine. Moreover, it was exciting. "I am going to get on a fighting machine," Charles Hendershot wrote from his pilot training course in May 1917, "not one of those observing planes ... They can go 140 per hr and on a nose dive a thousand feet in two seconds."

Even so, flying required great skill and strength, and the aircraft, made of fabric stretched over wood frames, remained fairly primitive. Lieutenant John Brophy of Ottawa kept a diary in which he recorded his first flight in a BE2B in England in February 1916:

I took this aircraft over to hop a few times. There were two men over in the field somewhere in front of me. As soon as I got up in the air I lost sight of them and didn't care to land for fear they should be where I landed, which would make a mess of them, so I went on a piece farther and then couldn't come down for fear of landing on a group of officers. They scattered like a school of fish as I passed, wobbling, over their heads about 30 ft. up. I almost passed away laughing at the antics of the machine which did several odd tricks and terrified the ones on the ground. I had very little room to land in and almost decided to do a circuit, only I was afraid I'd get strafed [reprimanded] for it so I landed, and landed just in time to avoid tearing through a hedge. The officers ... begged me to "have a heart" in the English equivalent. I did five more hops without doing murder in any degree ...

"Everyone hates the 2B," he said, "and fervently hopes for its demise." After service in France, Brophy died when his aircraft failed to pull out of a spiral during an anti-Zeppelin patrol over England on Christmas Eve, 1916.

Neither the sky nor the ground was a place of safety. German Zeppelins, which essentially were giant manned gas bags, operated over Britain from May 1915 onward, dropping bombs indiscriminately on civilian targets. The first Zeppelin was shot down in flames the next year, but the Germans soon diverted their long-range efforts to Gotha bombers, resuming their attacks and killing hundreds. The Allies countered by developing their own bomber forces and carrying the war to German cities. Each side also bombed the other's airfields. Lieutenant Harold Price, a Canadian in the RFC fighting against the Turks and their German allies in Mesopotamia, wrote in his diary in December 1917 that "Fritz bombed us again tonight. He was miles out. It is a downright nuisance being hauled out of one's bed about 2:00 in the morning, slipping on shoes and a flying coat, and running into the funk hole. I wish we only did daylight bombing." The next day, Price's squadron did

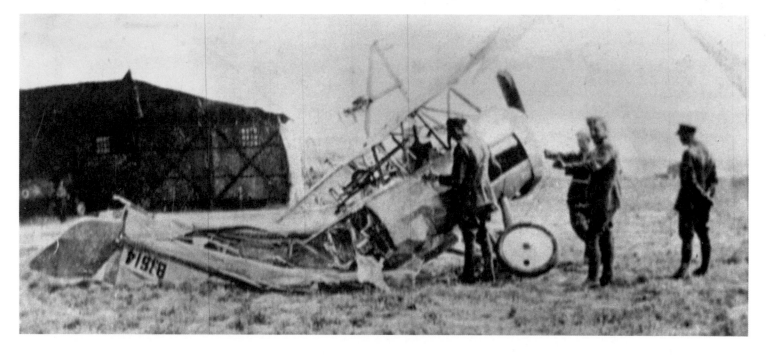

just that and carried out its own raid. Price then recorded: "Intelligence reported 73 casualties. We dropped over 50 bombs altogether, and the shooting was good. I could watch mine all the way down."

Over the front, the enemy fighters were better than Allied aircraft until late in the war, and RFC pilot casualties were high. In early 1917, for example, the average lifespan of a pilot in action was forty-five days, and in April 1917, No. 60 Squadron of the RFC, based near Arras, France, suffered a 110 per cent casualty rate with thirteen of eighteen of the original pilots shot down, along with seven replacements. The RFC in a five-day period before the Vimy Ridge battle lost seventy-five aircraft to enemy fighters and fifty-six to accidents. Basil Morris told his mother that flying "is no more dangerous than my last job," which may well have been true, for trench warfare killed far more Canadians than enemy aircraft did. Morris, however, understood the risks of aerial combat; he was killed when his plane was shot down on St. Patrick's Day, 1917. Another pilot, Warren Hendershot of Kingsville, Ontario, wrote home that "while you are more or less afraid all the time, yet you are not what you would call 'frightened.' When you see Huns, all you think about is getting at the devils. You always think you are better than they are." That was a mistake. For much of the war, the enemy maintained air superiority—and certainly the Canadian divisions fighting at Passchendaele in October and November 1917 were strafed and bombed regularly and complained about the absence of RFC aircraft overhead.

What was clear, however, was that Canadians seemed to have an aptitude for flying, and the British in late 1916 created the Royal Flying Corps, Canada, to recruit and train pilots in Canada. The Imperial Munitions Board secured land for airfields, arranged for the construction of hangars and barracks, and established Canadian Aeroplanes Limited to manufacture Curtiss JN-4 "Jenny" aircraft for training. The instruction after more than two years of war was more sophisticated than it had been initially in Britain and now emphasized map reading, meteorology, engine mechanics, aerodynamics, gunnery and pilot training, and it quickly separated those with an aptitude for flight from the rest. Accidents were common, both because of the eager inexperience of the trainees and because the reliability and airworthiness of the aircraft were often dubious. Engines lost exhaust valves in flight, and the fuel supply often failed. As a consequence, cadets died in substantial numbers as a result of crashing their aircraft. A pilot trainee wrote from Camp Borden in

June 1917 that a cadet and an officer "got in a spinning nose dive and crashed into the side of a hill." The officer was killed, the cadet seriously injured. The same trainee the next month told his parents about one of his comrades, who was struck by lightning "about 2,000 ft in the air and when he hit the ground there wasn't a bone that wasn't broken in his body." Another cadet flying a Jenny tried to crash-land on an Oshawa, Ontario, main street in April 1918; the aircraft became caught in telephone wires and was pinned near the top of a large store front. Those who survived their initial flight training, more than 2,500 in all, proceeded to Britain for advanced flying training and then were posted to squadrons in France.

For most, combat was a brief experience, the untried fliers easily falling victim to experienced enemy pilots in better aircraft. Many of them died horrible deaths, burnt offerings to the sky gods; the lucky ones were killed by gunfire before their planes crashed

and burned. In all, 1,388 Canadian pilots died in action or as a result of injuries resulting from accidents.

But some survived and learned, and some like Billy Bishop and Billy Barker proved to be highly skilled fliers with a deadly shooting eye. A wild youth, Bishop had been an indifferent student in constant trouble at Kingston's Royal Military College. He joined the Mississauga Horse in 1914 and crossed to England in June 1915 with the 7th Canadian Mounted Rifles. Before his unit went to France, Bishop transferred to the RFC, initially as an observer. He did one tour in France before being injured in a crash. Then he trained as a pilot, returned to France in March 1917 and turned out to be deadly—a calculating, aggressive killer whose ability to control his fear appeared to some as complete fearlessness and whose devotion to his score of "kills" was total (encouraging debunkers who have pored over Bishop's record endlessly, seeking to discredit his successes). Like other great fighter aces, "Bishop was an expert deflection shot, a skill he maintained by constant practice," the Canadian official history observed. "His tactics . . . were built around surprise," and, seeking every possible opportunity to get into the air to kill the enemy, he threw his fighter aircraft "about with complete abandon and a rare tactical sense." He earned every decoration the British could award, including the Victoria Cross for a single-handed attack on an enemy airfield. With seventy-two victories credited to his name, Bishop arguably became the best-known Canadian hero of the Great War.

Billy Barker scored fewer kills than his countryman, but was likely a better flier than Bishop and an equally deadly shot. His initial experience too was as an observer and gunner, flying behind the pilot, but when became a pilot he proved peerless. Barker mastered air-to-ground communication, frequently spotting for the artillery. He strafed enemy troops frequently, and he appeared to relish dogfights against Baron von Richthofen's "flying circus," the most formidable enemy squadron. He won the Victoria Cross for his exploits on October 27, 1918, when he put his Sopwith Snipe, the newest and likely the best British fighter plane of the war, against some sixty Fokkers and shot down four, though he himself was wounded repeatedly and almost died. The dogfight was watched from the Canadian trenches below by, among others, the commander of the Canadian Corps Heavy Artillery, Brigadier-General Andrew McNaughton. "The hoarse shout, or rather the prolonged roar, which greeted the triumph of the British fighter, and which echoed across the

battle front, was never matched... on any other occasion," he wrote. Major Barker himself, sounding more British than a twenty-three-year-old from Dauphin, Manitoba, should, proclaimed: "By Jove, I was a foolish boy, but anyhow I taught them a lesson." He had destroyed fifty enemy aircraft in all.

To the naïve public, the air war was the last preserve of chivalry in a war of utmost horror. Sometimes it was true. Henry Botterell, who died in 2003 at the age of 106 as the last Canadian pilot (and likely the last pilot in any nation) of the Great War, told how he had shot down a German observation balloon. Flying a Sopwith Camel of No. 208 Squadron, Royal Air Force, on August 29, 1918, over Vitry, France, he was returning from a bombing mission against a rail station when he saw a tethered German observation balloon. He fired four hundred rounds at the balloon, whose handlers were frantically trying to lower it to the ground. It burst into flame, and the observer jumped from three hundred metres, hoping his parachute might open. Botterell banked to avoid the observer, but was close enough to see his frightened look as the German thought Botterell was going to machine gun him. Instead, gallantly, Botterell saluted the enemy and flew home to his airfield.

Such an act was very rare, certainly after 1916. "Callousness and a hard-boiled and unsympathetic attitude were the best friends of a successful ace," said Bogert Rogers, an American who learned to fly in Canada. Raymond Collishaw, born in Nanaimo, B.C., and the Royal Naval Air Service's most successful pilot of the war, echoed Rogers: "Anything goes in the air." Billy Bishop, no sentimentalist, added his mite. To bring down an aircraft, you had to "hit the man... with a concentrated fire in some vital spot. You must hit him in the head or the upper part of the body with a concentrated fire of bullets." Air combat, just as much as the war at sea or on the ground, was about killing, and unsuccessful fliers died from machine gun fire in the air or in flames when their aircraft smashed into the ground. A pilot you failed to kill today might be the one who brought you down tomorrow.

In all, some seven thousand Canadians flew with the Royal Flying Corps (RFC), the Royal Naval Air Service (RNAS) and, after April 1918, the Royal Air Force (RAF). Estimates are that as many as a third of all RAF aircrew were Canadians, an extraordinary contribution. Towards the very end of the war, Ottawa authorized the creation of the Canadian Air Force (CAF) with two squadrons. Before they saw action, the armistice led to the disbanding of the CAF.

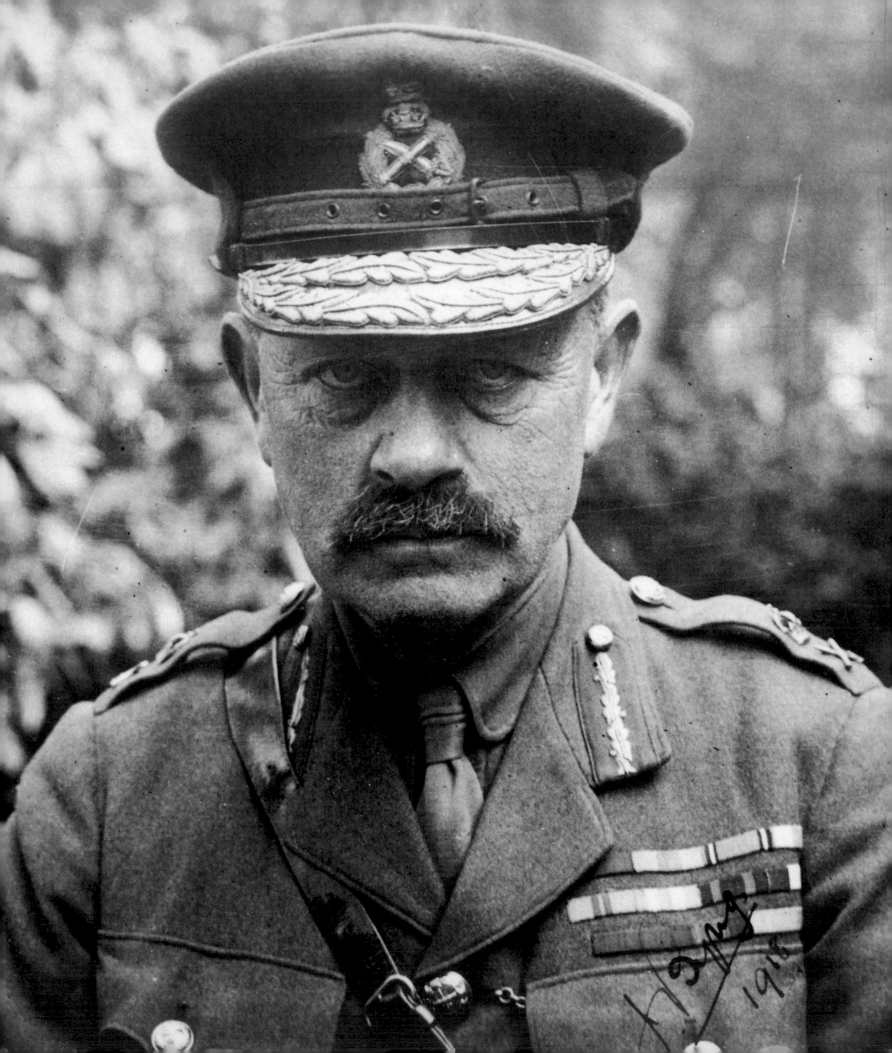

4 | MASTERING TRENCH WARFARE

"GHASTLY WERE THE STORIES which we heard from time to time," Padre Frederick Scott wrote of the Somme battle in the autumn of 1916. "One man told me that he had counted three hundred bodies hanging on the wire which we had failed to cut in preparation for the attack." Mistakes such as that cost soldiers' lives and, in learning to function effectively on the battlefield, the Canadian Corps under General Sir Julian Byng began to master the process of avoiding such errors.

AWAY FROM the hard fighting for almost nine months, the Canadians returned to battle in March 1916. Under General R.E.W. Turner, the 2nd Division was to receive its first test—and fail. The scene was St. Eloi, south of Ypres and north of Messines, and the British high command hoped to relieve pressure on the French, engaged in a titanic struggle at Verdun, by forcing the Germans to divert resources. The battle at St. Eloi was almost medieval, the main fight initially pitting tunnellers against each other. Shafts were dug under the enemy lines and huge mines planted there. Each side struggled to hear the noises of the sappers and to strike at them, while the commanders timed their infantry assaults to follow directly on the detonation of the mines. At St. Eloi, the British placed six mines with fifteen thousand kilograms of ammonal, hoping to utterly eliminate a six-hundred-metre stretch of the German trench line. The plan called for the attack to go in on March 27, and the 2nd Division was charged with taking over from a British division a few days after it took its objective.

Initially, everything worked as planned. The mine explosions vaporized two companies of German infantry, and the British attack progressed well in what was now a lunar

landscape. The Canadians, wearing steel helmets for the first time and equipped with Mills bombs—effective hand grenades—took over the British line on the night of April 3–4 in the face of stubborn resistance. The Dominion troops found no trench line, no workable communication trenches, and the impassable muddy obstacles created by the mine craters. Private Donald Fraser of the 31st Battalion wrote that "the English Tommies we relieved could furnish us with no information about the whereabouts of the enemy or our immediate connections."

The men did what they could to remove the dead British soldiers from their lines and to improve their defences, but the Germans, clever in their tactics, were more effective than the still-raw Canadians. A terrifying artillery barrage hit the division's lines and smashed the 27th Battalion of Brigadier-General H.D.B. Ketchen's 6th Brigade. Fraser noted that "Cpl Hunter, one of our finest men, was twice buried. L/Cpl Wood had four rifles, three having been buried or smashed." When the 2nd Division tried to relieve the survivors overnight on April 5–6, a German attack retook two of the mine craters. A Canadian counterattack got lost and went to craters further north, the success signal nonetheless going to headquarters. The Canadians were hopelessly confused: bad weather made aerial reconnaissance impossible, maps became useless in the morass and communications from front to rear were hopelessly snarled. Not until April 16 did Turner's headquarters realize the situation, and the division lost 1,373 men. Fraser's battalion, he recorded, had 180 casualties, and the 27th Battalion suffered 217 killed, wounded or missing.

St. Eloi was a lesson, historian Tim Cook wrote, "on how not to engage the enemy . . . A squalid affair in which the Canadians were trounced by both German commanders and troops." This was failure, and officers lost their jobs. The corps commander, General E.A.H. Alderson, demanded that Turner fire Ketchen. Turner refused, so Alderson went to the British general officer commanding-in-chief, Sir Douglas Haig, and asked that Turner, who had mismanaged the battle, be sacked. Fearing that an anti-British sentiment was developing among the Canadians and likely fearful that Sam Hughes, a Turner supporter, would cause trouble, Haig refused. Still, someone had to pay for the St. Eloi fiasco, so

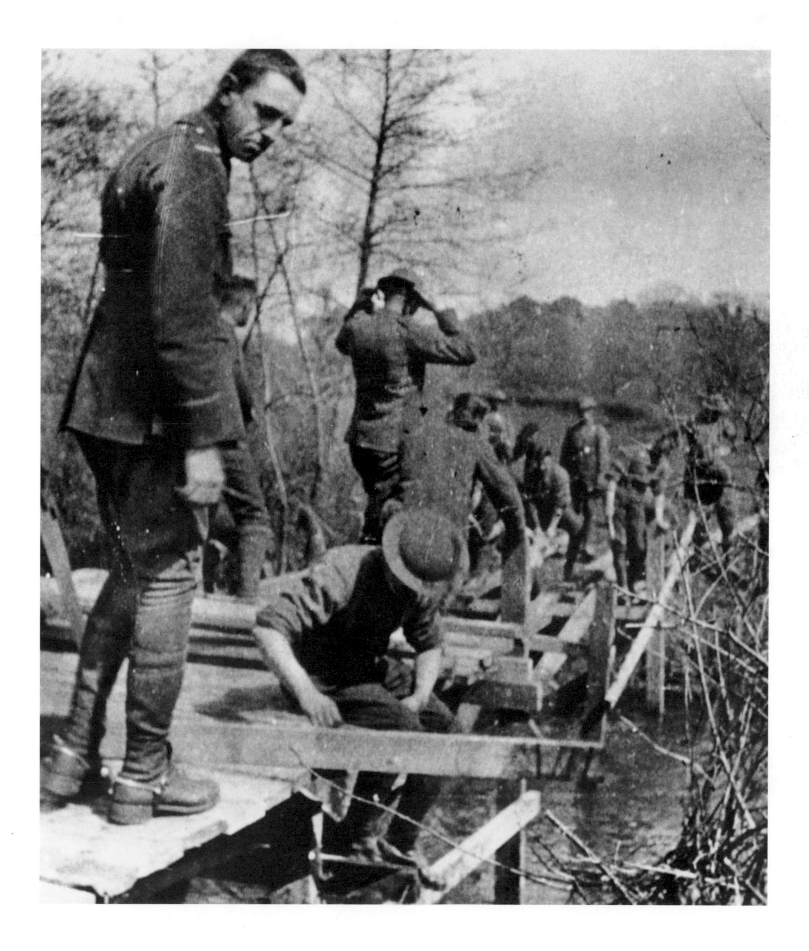

BELOW AND RIGHT: Trench life in 1916 was not a vast improvement over the situation in 1915. Soldiers had steel helmets now, but they still lived in a hole in a trench wall and slept where and when they could. (*below:* CWM 19760346-018 P.14B, *right:* Sir Alexander Galt Museum & Archives, Lethbridge)

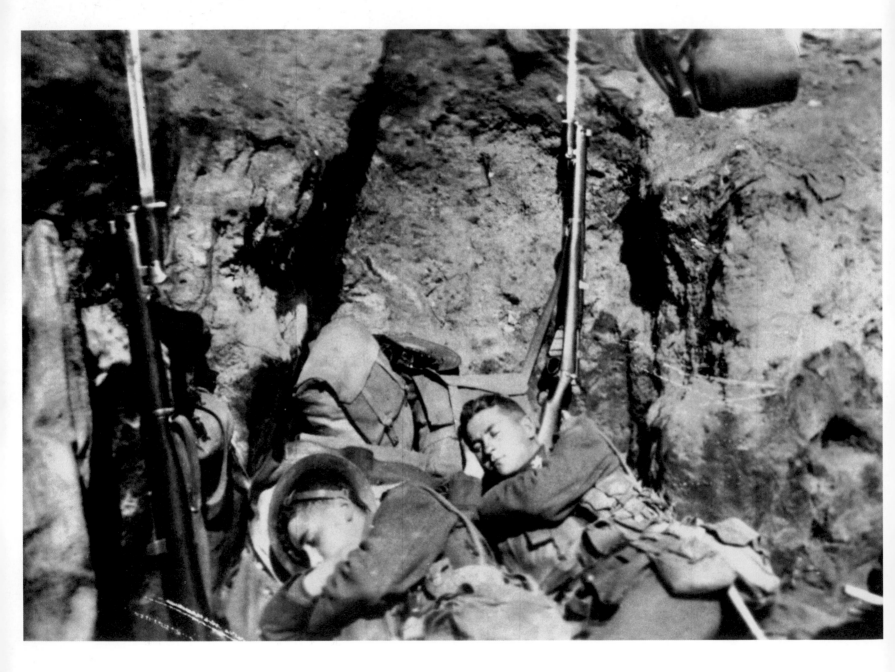

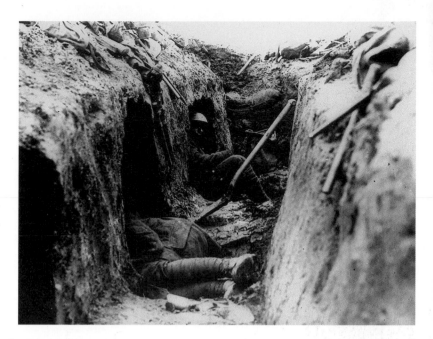

Alderson was dismissed. Poor Alderson, no Napoleon, had done the best he could with the Canadians; once Hughes left as minister in November 1916, Turner became inspector-general of Canadians in Britain, with a promise that he might, someday, be considered for command of the Canadian Corps. To replace Alderson, Haig selected Lieutenant-General Sir Julian Byng, a competent British cavalry officer with a common touch who had served in France and at Gallipoli. Byng was not amused—he knew nothing of Canadians and didn't want to. But he did what he was told, and he built the Canadian Corps into the great fighting machine it became.

IN CANADA AND IN BRITAIN, the army's recruiting and training machine lurched from disaster to disaster. The government and at least some of the Canadian people understood the gravity of the situation overseas, and Sir Robert Borden in June 1915 had set the ceiling of the Canadian Expeditionary Force at 150,000. In October, he raised it to 250,000, and on New Year's Day 1916 doubled it to a half-million men. This pledge, made without consulting anyone, became binding as soon as it was uttered—a huge effort for a country of only eight million people. But as 1915 turned into 1916, few doubted that such numbers could be achieved. By mid-1916, in fact, Canada had enlisted 312,000 men and sent 150,000 overseas.

Complicating matters was the minister of militia and defence, Sir Sam Hughes. Hughes appointed cronies to raise battalions in Canada, and he named other friends to run the army in England. He also tried to get his acolytes named to key positions at the front, but here at least he could not always get his way. At the front, efficiency mattered. It took months, indeed years, to sort out matters for the Canadians in Britain.

In one area, Hughes's attitudes worsened matters significantly. An Orangeman, a militant Protestant, the minister had no understanding of French Canada and, indeed, no belief that French-speaking Catholics could make good soldiers in a "British" army. Other than the 22nd Battalion, raised in 1915, no other Québécois battalion managed to fill its ranks and to go overseas to fight as a unit. Data in 1917 suggested that only 14,100 French-speaking soldiers had joined up after more than two years of war, with just 8,200 from Quebec.

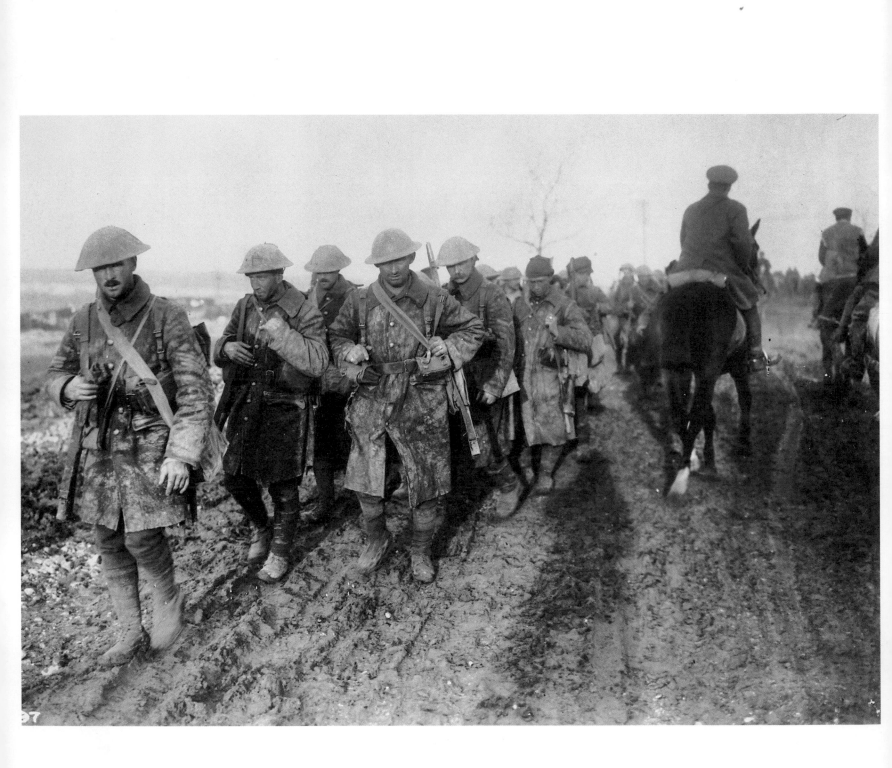

HELL'S CORNER

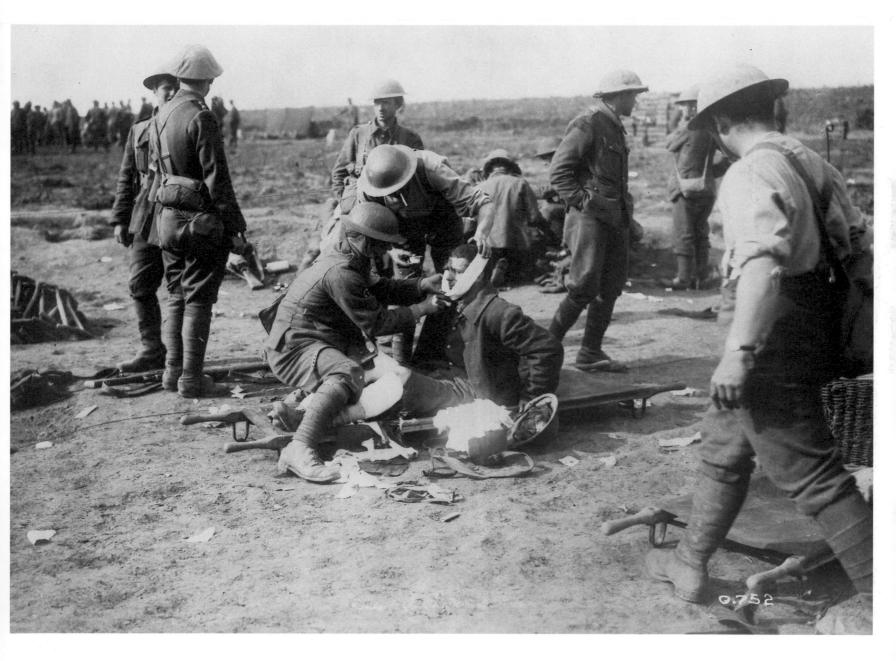

Known or suspected for months, these facts (perhaps softer than they seemed) enraged francophobes across Canada, and charges of Quebec's cowardice were hurled in the press and in Parliament. French Canadians responded with charges of their own, complaining about Ontario's discriminatory school legislation, about Hughes, about linguistic discrimination in the army.

Recruiting in English Canada similarly was becoming more difficult. Long casualty lists and the slow return of badly wounded men to their home towns, horror stories about warfare in the mud, and the continuing political infighting at home did little to encourage men to come forward. As in August 1914, the British-born were the most eager to join up and native-born Canadians required persuasion. Still, everyone in Canada did their part to recruit men. Clergymen preached ferocious sermons on sacrifice and duty; soldiers' wives and mothers pinned white feathers on men who, they believed, looked fit enough for service overseas; parades, bands and recruiting rallies filled the streets and parks, and Sam Hughes authorized more colonels to form battalions. The 124th Battalion, recruiting in Toronto in December 1915, like many other units made a special appeal to churches, lodges and clubs. Why shouldn't "men who are friends . . . serve together during their enlistment . . . [and] make their term of service much more congenial"? The commanding officer wrote that it was his wish that "the Battalion shall be recruited, not so much by those who individually enlist at random, but by parties or groups of young men, who being friends, or members of Church, Mercantile, or other organizations can chum together." Such appeals ordinarily failed, perhaps because word invariably got out that units frequently shuffled and reshuffled their ranks. Private Graham Adam of the 56th Battalion, in training at Sarcee Camp in Alberta in December 1915, complained bitterly about the breakup of his company: "I feel quite lost this week. They have divided the Draft Company up among all the other companies in the battalion, which is a scandalous thing to do. Just imagine," he went on, "we have all been together for practically 6 mo[nth]s . . . also our officers know us. Then suddenly we are all broken up and put among strangers."

In all, 265 battalions won the minister's go-ahead to recruit, and 179 were led by local notables, almost none of whom had any military experience; neither did most of the majors, captains, lieutenants and sergeants these commanders named from among their friends. In a very civilian society, this was hardly surprising, but Hughes stupidly guaran-

teed that the officers and non-commissioned officers (NCOs) could take their units overseas and hold their positions. But who in the corps in France now wanted untrained, unskilled officers and NCOs at the front? This was a brutal war, not playing soldiers at summer camps in pre-war Canada. After training at hastily constructed camps in Canada, the still-raw battalions reached England, and the best-trained (or sometimes the best-connected) went into the 3rd and 4th Divisions being readied there. Usually, however, the Canadian Expeditionary Force (CEF) staff in Britain broke the units up and, while the men eventually reached France as reinforcements, the officers and senior NCOs faced a hard choice. They could revert to junior officer status and go to the front, or they could keep their ranks and stay in England. Perhaps that was not such a hard choice, for most chose to hold their positions in England and complained to everyone about the unfairness of their treatment. Sam Hughes's chaotic lack of system and organization had created a costly mess.

A cautious, stubborn man, Prime Minister Borden slowly and reluctantly tried to impose order. Hughes predictably and unfortunately would not listen to suggestions, so in August 1916 Borden took control of recruiting from his hands. The government appointed a businessman as director general of national service, a position charged with controlling the recruiting of men for the forces but with due regard for the needs of industry and agriculture. This was progress, as was National Service's decision to conduct a registration of Canada's manpower.

But Borden understood by late 1916 that nothing could truly be changed if Sam Hughes remained in the Cabinet. Hughes gave his leader the opportunity he sought when he disobeyed the Cabinet's explicit orders by creating the Acting Sub-Militia Council for Overseas Canadians, and appointing a friend at its head, to handle all army matters in Britain. Borden responded by establishing the Ministry of Overseas Military Forces of Canada with Sir George Perley, Canada's high commissioner in London, as the minister. Recruiting in Canada had been wrested from Hughes's grasp; now control over the CEF in England was gone as well. In a rage, Hughes exploded in fury and vituperation at his chief, and Borden demanded his resignation.

On November 11, 1916, Sam Hughes at last left the government—to the cheers of the men in the field. This was the minister who had foisted the Ross rifle on them, the minister who had tried and often succeeded in putting incompetents in charge of battalions,

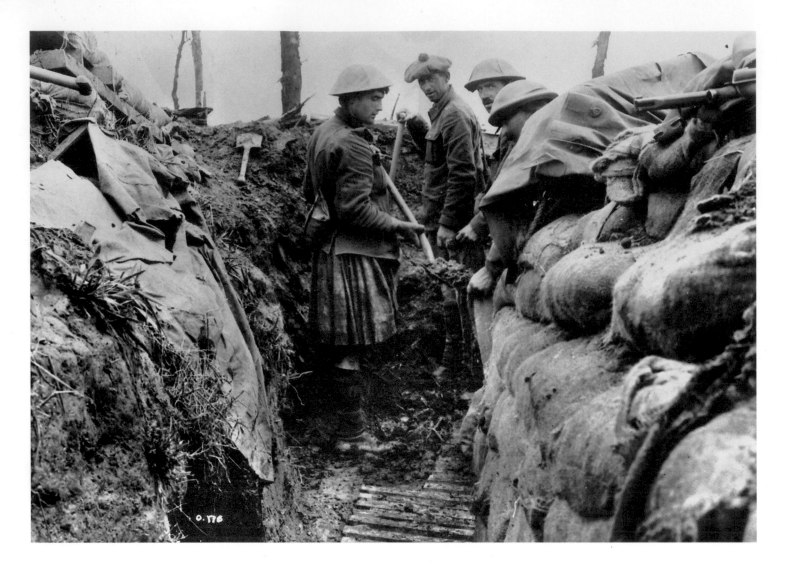

brigades and divisions. One artillery colonel wrote in his diary when he learned of Hughes's departure, "The Mad Mullah of Canada has been deposed . . . The greatest soldier since Napoleon has gone to his gassy Elba, and the greatest block to the successful termination of the war has been removed. Joy. Oh Joy!"

Slowly, order took hold of the recruiting system in Canada and the training, reinforcement and convalescent organizations in Britain. Patronage and politics had not been vanquished for the rest of the war, but at least they were under control. Sam Hughes, however, remained in Parliament, fulminating at his enemies, who were legion. The government and the CEF could not rest easy.

AFTER ST. ELOI, the Canadians licked their wounds. The 3rd Canadian Division was commanded by Major-General M.S. Mercer, one of the original brigade commanders at Valcartier, and the division included the Princess Patricia's Canadian Light Infantry, repatriated

from service with the British 27th Division, and the Royal Canadian Regiment, returned from its ministerial-imposed exile in Bermuda. The fresh division was in the Canadian Corps' line when it fought its next battle, its first under Byng, at Mount Sorrel in June 1916.

Once again, with unerring intelligence and skill, the Germans focused their attention on the new 3rd Division. They had aimed at the 2nd at St. Eloi, and now the weight of their guns pointed at the 8th Brigade. General Mercer, the 3rd's commander, and Brigadier-General Victor Williams, the brigade commander, were inspecting the trenches of the 4th Canadian Mounted Rifles, a cavalry regiment converted to infantry, on the morning of June 2, when the enemy gunfire began. In a bombardment that observers believed to be the heaviest thus far in the war, the regiment was crushed, losing an incredible nine tenths of its strength in a few moments. Mercer fell wounded three times and subsequently died; Williams was wounded and taken prisoner, the highest-ranking Canadian to fall into German hands. At a stroke, the division commander and the brigade commander were gone, and there was a large hole in the line.

The Germans preceded their assault by blowing mines, and four hours after the shelling had begun, they sent six battalions at the shaken Canadian brigade. Two battalions of Canadian Mounted Rifles dissolved, the enemy employing flamethrowers to destroy any pockets of resistance. Although they had huge gains in their grasp, the Germans dug in after an advance of seven hundred metres. Late in the day, the 8th Brigade could muster only seven hundred men.

A counterattack was necessary, and Major Agar Adamson of the Princess Patricia's Canadian Light Infantry wrote his wife an account of it:

> At 10 PM we moved off and after considerable casualties we got them formed for attack and attacked, driving the Germans out of the Right Sector and straightening out the line. Some of the troops were not satisfactory and for reasons which cannot be put down entirely to funk, failed to push with the vigour that is required to do the job properly, stopped to attend to wounded men, only themselves being wounded and reducing the force and numbers of the assault.

The riposte was slow to get going and badly organized, four battalions attacking one after the other in daylight rather than together under cover of darkness. The losses were heavy.

The battle of the Somme in late 1916 devoured armies wholesale.
BELOW: This photograph shows the terrain after the battle.
(CWM 19910162-009 P.83)
RIGHT: These soldiers are coming out of the line; the one in the
centre of the photo looks remarkably fresh-faced. (National
Archives of Canada PA-000914)

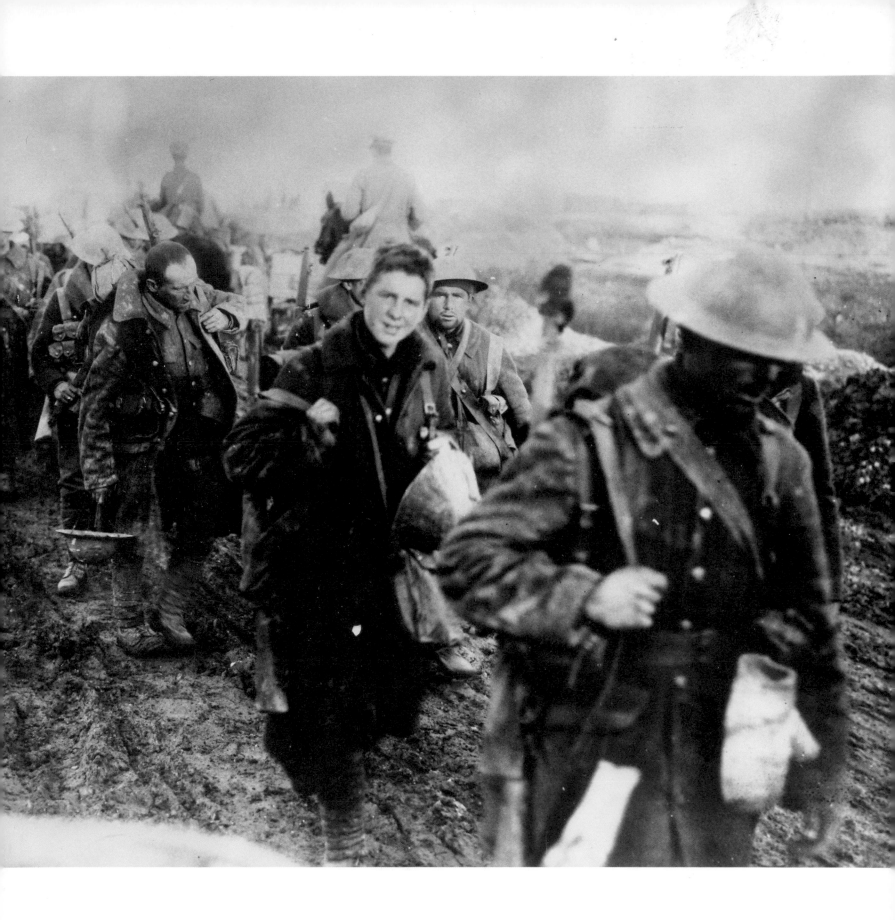

Byng's corps now received all the artillery backing it could ask for, and the Germans took a pummelling. But before a major counterattack could go in to seize back the lost ground, the Germans surprised the Canadians by attacking once more. Again they exploded mines under the 6th Brigade of the 2nd Division at Hooge and redoubled the artillery concentration they had used so successfully on June 2. The 28th Battalion was hit very hard—an entire company was wiped out by the exploding mines—but the rest of the brigade rallied to fill the gap. Private Donald Fraser of the 31st Battalion, taking the brunt of the enemy assault, noted that "notwithstanding the difficulties we were in, encumbered with the dead and wounded, the firing step smashed in many places; in mud and wet; rifles half clogged; and though dazed and crazed we pull ourselves together, line the serviceable parapets of the trench and blaze into the advancing enemy, who recoil in confusion."

Byng now ordered Arthur Currie's 1st Division to stage a careful attack at Mount Sorrel. The division moved into the line on June 11–12, and on June 13, Currie orchestrated a brilliant stroke. Using clouds of smoke to shield his men and employing a perfectly planned barrage that his infantry closely followed, the division got into the enemy trenches before the defenders could get out of their bunkers. In one hour of battle, the Germans were pushed back to their June 2 starting point. The enemy still held the ruins of Hooge, however, and Fraser recorded the British complaints that "we did not hold the ground turned over to us... it ill befits those patriots to talk so loosely and loudly about the Canadians never losing a trench." Fraser was correct.

Mount Sorrel and Hooge were perfect examples of Western Front warfare in mid-1916. New divisions, like the 3rd Canadian, took time to master trench warfare and simply were unable to withstand German professionalism. The 1st Division, by then experienced and well led, could and did defeat the enemy. The losses—almost 8,500 Canadian and likely an equal number of enemy—were horrid for a few metres of worthless ground. Whole battalions were all but eliminated. The Princess Patricia's Canadian Light Infantry, for example, lost 230 killed and 170 wounded in two days of battle, and Agar Adamson later told his wife that he had received drafts of 24, 199, 80 and 253 reinforcements in a twenty-four-hour time span. To rebuild the regiment out of those men would take time.

The Canadians still fought with more dogged courage than skill, and the slow process of feeding new divisions into the corps meant there were always weak spots for the enemy

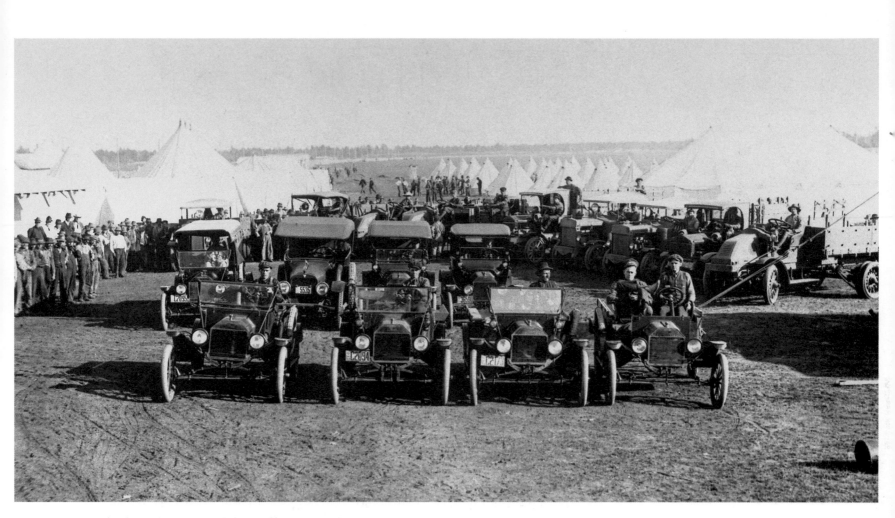

to hit. But the men and their officers were learning, though the price in lives was high. Some 32,000 Canadians had been killed, wounded or taken prisoner in only fifteen months of fighting.

If there was one ray of hope, it was that Currie's strategy on June 13 had been perfectly executed, using smoke, guns and fighting skill. If General Byng saw a future of success for his Canadian Corps, the 1st Division had provided it.

Now the 3rd Division needed a new commander. Sam Hughes, still the minister in mid-June 1916, was quick off the mark, suggesting that his son Garnet should get the nod. Lieutenant-General Sir Julian Byng, however, named Brigadier-General Louis Lipsett, a pre-war British regular, to the post. When Sam Hughes protested, the corps commander stated that "there was a better man available for the post and the better man would get it." Privately, Byng said his Canadians were "too good to be led by politicians and dollar magnates."

For good measure—what did he have to lose from Sam Hughes's wrath?—Byng also gave orders to scrap the minister's beloved Ross rifle and the Colt machine gun. The Lee-Enfield became the Canadians' rifle, and the more reliable British Vickers and a light

machine gun, the Lewis, replaced the Colt. All the Canadian divisions now received Mills grenades and three-inch Stokes mortars. Every soldier now wore a steel helmet as well. The war was serious business, and militia amateurism, Sam Hughes–style enthusiastic meddling and foolish decisions, had no place in it.

THE CANADIAN CORPS did not return to action until September 1916. Only good luck kept the Dominion troops out of the opening stages of the battle of the Somme, where General Sir Douglas Haig threw tens of thousands of men against German machine guns. On July 1, the British lost 57,470 men, and the Newfoundland Regiment, part of Britain's 29th Division, was slaughtered at Beaumont Hamel. Haig continued the fight into August, his losses now over a quarter-million, and his gains at the greatest were just seven thousand metres.

At last, it was Canada's turn in the charnel house, and the corps went into the line at Pozières Ridge, some thirty kilometres east of Amiens. Their attack was to go in on September 15, and Byng had a few innovations to throw at the enemy. First was the tank, the British invention that aimed to deal with the mud, wire and machine guns that dominated the Western Front. This armoured and tracked vehicle could crawl forward at six kilometres per hour over all types of ground—when it worked. Armed with cannon or machine guns, tanks terrified the first enemy who saw them, but they were few in number and hugely prone to mechanical failure. More useful was Byng's reliance on the creeping barrage, first tried by Currie at Mount Sorrel. The guns advanced their fire in timed hundred-metre steps while the infantry kept pace, advancing as close to the barrage as they could. This let the infantry catch the Germans in their dugouts, where they could be dispatched with grenades. The Canadians also adopted the practice of moving in bounds, a tactic in which the first wave of attackers took its objective and consolidated its position there; the second wave—and sometimes a third and a fourth wave—then moved through the first to take the next objectives. Byng and his men were learning.

But not too many of the soldiers underestimated the risks. Lieutenant Hart Leech of the 61st Battalion wrote to his mother to say, "I am 'going over the parapet,' and the chances of a 'sub[altern]' getting back alive are about nix." He added that many were writing "post mortem letters and kind of half ashamed of themselves for doing it. As one

of our officers said: 'If I mail it and come through the show, I'll be a joke. If I tear it up and get killed, I'll be sorry I didn't send it.'" Leech's premonitions were unhappily all too accurate, and he was killed in the assault.

The Canadian attack went in at first light on September 15, Turner's 2nd Division attacking the defences before the village of Courcelette. The first line fell in fifteen minutes, and the 4th and 6th Brigades were on their objectives by 7:30 that morning. The six tanks supporting the advance had a major shock effect on the Germans. Private Donald Fraser of the 31st Battalion again was on the scene, and he recorded how his battalion attack, gallantly launched, was stopped by concentrated enemy fire. Then "a strange and curious sight appeared":

Away to my left rear, a huge gray object reared itself into view, and slowly, very slowly, it crawled along like a gigantic toad, feeling its way across the shell-stricken field. It was a tank, the "Crème de Menthe," the latest invention of destruction and the first of its kind to be employed . . . I watched it coming towards our direction. How painfully slow it travelled. Down and up the shell holes it clambered . . . moving relentlessly forward. Suddenly men from the ground looked up, rose as if from the dead, and running from the flanks to behind it, followed in the rear as if to be in on the kill.

In the tank's wake, Fraser made his way to the German trench and found it empty. "Down the trench about a hundred yards, several Huns, minus rifles and equipment, got out of their trench and were beating it back over the open, terrified . . . There was not a single German capable of offering fight." Fraser added that he and his comrades then spent some time looting the bodies of dead Germans, searching for Iron Crosses, pistols, money and papers. To the victors belonged the spoils of war, and the Canadians became well known both as victors and looters.

The Canadian attacks continued on a two-brigade front. The 22nd and 25th Battalions struck at the town of Courcelette, while the 26th mopped up Germans holding out in ruined buildings. To their left, the 45th Battalion sent its men forward in four lines on a

NOTHING is to be written on this side except the date and signature of the sender. Sentences not required may be erased. If anything else is added the post card will be destroyed.

I am quite well.

I have been admitted into hospital.

{ sick } and am going on well.
{ wounded } and hope to be discharged soon.

I am being sent down to the base.

I have received your { letter dated _____
{ telegram ,, _____
{ parcel ,, _____

Letter follows at first opportunity.

I have received no letter from you
{ lately.
{ for a long time.

Signature } Vanallan
only.

Date Dec 11 - 1916.

[Postage must be prepaid on any letter or post card addressed to the sender of this card.]

(92683) Wt. W3497-293 2,000m. 9/15 J. J. K. & Co., Ltd.

frontage of eight hundred metres. The men moved forward through German artillery fire "as though they were on a General Inspection Parade," the after-action report noted, and they took their objective after an advance of 2,200 metres. The two battalions in Courcelette faced repeated counterattacks, the Van Doos alone driving off seven enemy assaults in vicious hand-to-hand fighting on the first night and thirteen in all by September 17. Their commanding officer, Lieutenant-Colonel Thomas Tremblay, a fierce officer, said the Québécois "fight like lions." But, he added, "If hell is as horrible as what I saw there, I wouldn't wish it on my worst enemy." More than three hundred Van Doos were killed or wounded in the Courcelette struggle. A soldier from the 31st Battalion, Private W.H. Gilday, echoed that sentiment. "You know how anxious I was to get to the front line," he wrote his sister. "Well, now I am just as anxious to be far away. I am afraid my nerves won't stand many battles."

Private Frank Maheux, an Ottawa Valley logger serving in the 21st Battalion, which attacked Courcelette's sugar factory, wrote to his wife that it had been "the worst fighting here since the war started; we took all kinds of prisoners but God we lost heavy, all my camarades are killed or wounded we are only a few left…" He had gone through all the fights without a scratch, but "same as if I was making logs I baynetted some, killed others. I was caught in one place with a chum of mine he was killed beside me when I saw he was killed I saw red … the Germans when they saw they were beaten put up their hands but dear wife it was to late …" Promoted to sergeant, Maheux was awarded the Military Medal for his service at Courcelette.

At the same time as the fight for Courcelette raged, the 3rd Division attacked a heavily defended German redoubt system known as the Fabeck Graben, a long, costly ordeal marked by initial success and then a hard letdown when the enemy recaptured the ground on September 20. Another Canadian effort almost won back the trenches, but the Germans' counterattack finally left them masters of the field. The Canadians' three-thousand-metre gains on Pozières Ridge had cost 7,320 killed and wounded, or more than two men a metre.

There was little rest, however. The next objective, attacked on September 26 by the 1st, 2nd and 3rd Divisions with the support of eight hundred guns, was dubbed Regina Trench. This trench line, a kilometre beyond Courcelette on the Thiepval Ridge, was strongly

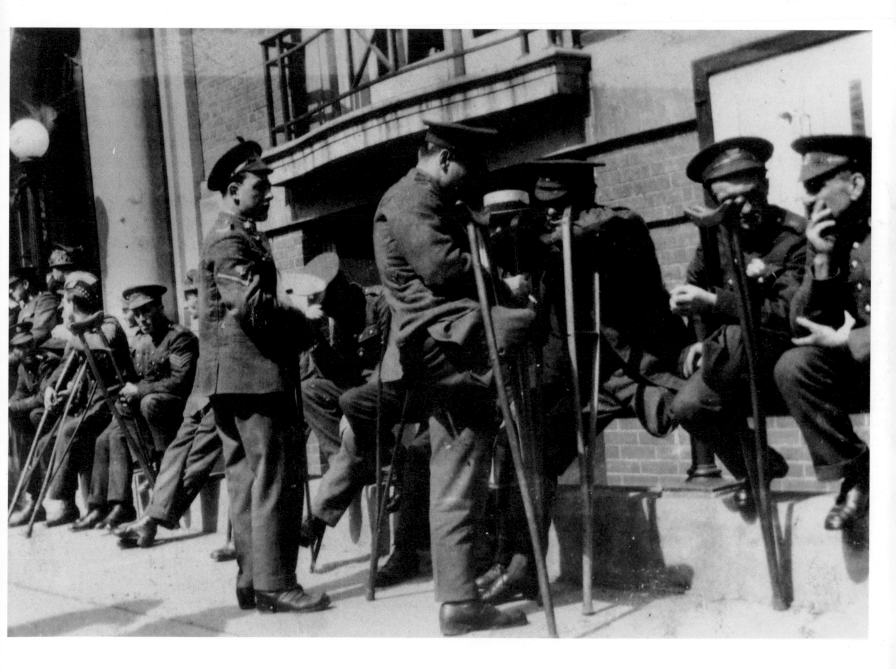

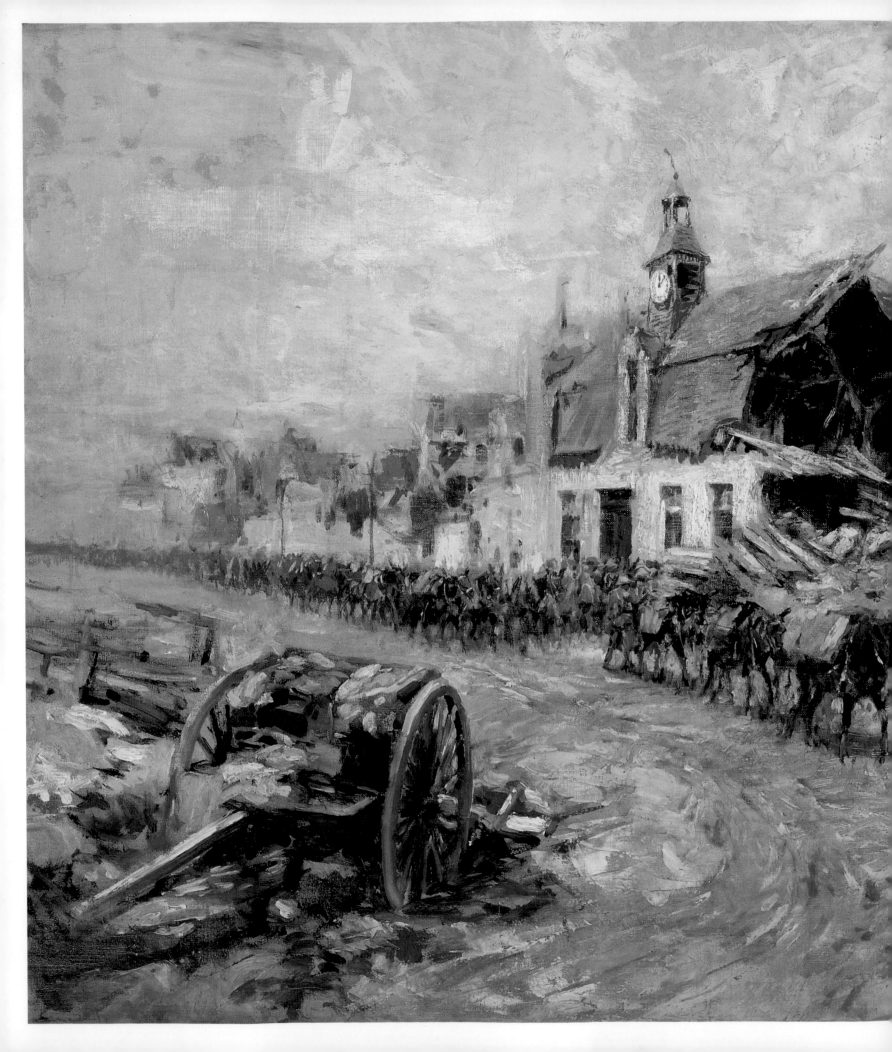

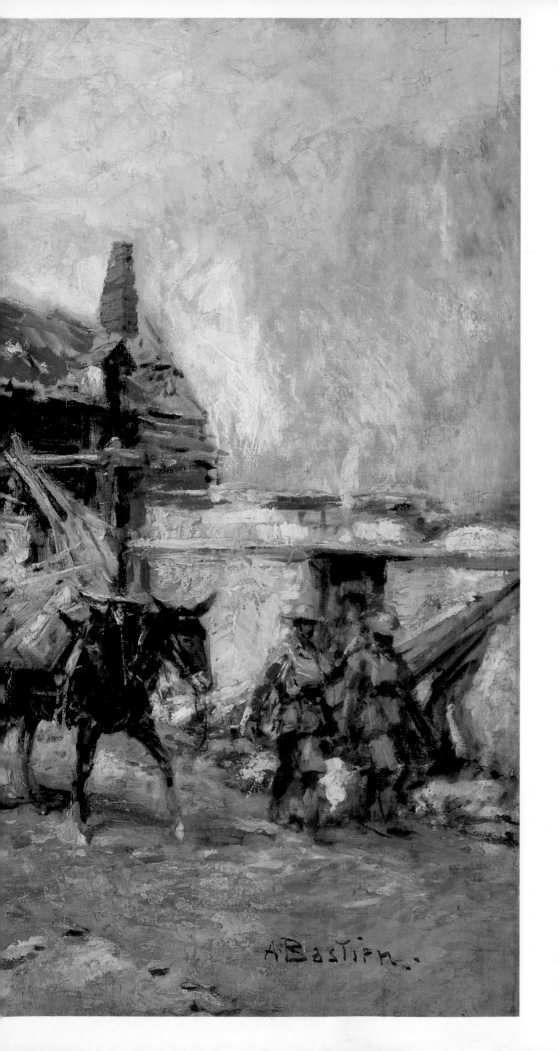

War artists tried to capture both the exciting and the mundane. Alfred Bastien's oil painting shows pack mules moving towards the front. (CWM Bastien 8099)

91

defended, and the Canadians were driven back. A company commander with the 5th Canadian Mounted Rifles of the 3rd Division, Lieutenant George Pearkes, led his battalion's attack, kept gathering men together from other companies and battalions to keep it going, and led parties out of the trenches and onto the parapet to throw hand grenades down at the enemy, still clinging to their positions. But it was all for naught, Pearkes wrote: "Our men hung on . . . until two of our machine guns had been put out of action and the supply of bombs exhausted. At 7 AM the position became untenable and our men retired in good order, bringing the majority of wounded out." He himself had been wounded in the leg. His battalion lost 224 men killed or wounded, almost half its strength in the line.

Padre Frederick Scott spent the night of September 26 at a dressing station near Courcelette. He wrote about the dead and the wounded, including German prisoners, and about how the German shelling pounded the area. "There was no room in the dugout for any but those who were actually being treated by the doctor," he said, "so the wounded had to wait up above . . . It was a trying experience for them, and it was hard to make them forget the danger they were in. Scott gave one wounded officer Communion and brought him some water. Then a shell burst, and there was a loud crack by the wounded soldier's side. "Oh, they have got my other leg," he cried. Using a shielded flashlight, Scott looked and saw a shattered rum jar beside the stretcher. "I told him he owed his salvation to a rum jar. He was quite relieved . . ."

On October 1, the 2nd and 3rd Divisions returned to the charge against Regina Trench. With heavy supporting fire, a few battalions made it to their parts of the overall objective, though the German wire entanglements proved almost impervious to attempts to cut them; again casualties were terrible because the Germans, following their usual practice, counterattacked at once and in strength, using their artillery to pound the Canadians. The Allied armies did not yet have an effective way of neutralizing the enemy's guns; so long as they did not, the enemy's effective gunfire on carefully plotted targets regularly smashed initial Allied successes. Aircraft, however, were now photographing German positions and, late in September, Lieutenant Billy Barker, then flying as an observer, took a series of photos that proved very valuable to the attacking troops on the Somme. That he and his pilot had to fight off six enemy fighters in the process won him the Military Cross, the first of his array of decorations. The next month, Barker used his aircraft's wireless to call

down artillery fire on a German troop train with great effect. The technology of aerial reconnaissance and air-to-ground co-operation was advancing at high speed.

On October 8, the 1st and 3rd Divisions tried yet again and failed for the third time to take the enemy position. One artilleryman who had previously served in Edmonton's 49th Battalion saw the unit coming out of the line. "How did you make out, boys?" he called. "We went in 600 strong," came the reply, "and there are not 150 of us coming back." The Canadian Corps at last had had enough, and the three battered divisions were withdrawn from the Somme front. This was to be the corps' last failure of the Great War.

The 4th Canadian Division, which had arrived in France in August for its initiation into the trenches, now went into the line to finish the job its comrades had left for it at Regina Trench. Led by Major-General David Watson, a Quebec City newspaperman and militia stalwart who had gone overseas as the commanding officer of the 2nd Battalion and commanded the 5th Brigade successfully, the 4th Division had experienced brigadiers. One was Sam Hughes's brother W. St. Pierre Hughes, which must have caused a few palpitations at division and corps headquarters. Astonishingly, the raw division proved itself in action, taking Regina Trench and the German line beyond it—dubbed "Desire Trench"—by November 18. Private Victor Wheeler of the 50th Battalion wrote in his diary that "the Deutschlanders' guns continued to level us as effectively as our Massey-Harris binders back home flattened the golden wheat." Success came at a high cost. As Wheeler put it, "The price-tag on individual lives was falling by the hour."

Nonetheless, the division held the ground it had won. General Watson had ordered that the rear platoon in each attacking company carry the supplies needed to consolidate on and hold captured ground. Thus each man had a pick or shovel and barbed wire and stakes. Learning from the experiences of the three by-now experienced divisions, the 4th ensured that communications trenches were dug quickly to let reinforcements and supplies come forward, wire was strung to protect captured trenches as soon as it could be done, and Watson's battalions took special care in sighting their Lewis guns to ensure overlapping fields of fire on likely enemy counterattack approaches. Each man carried extra ammunition for the Lewis guns, and many had a Stokes mortar bomb as well. Although the infantryman's load was heavy, there were reasons for this: extra ammunition, wire and shovels were essential tools for beating back enemy counterattacks.

HANDS ACROSS THE SEA

WOVEN IN SILK.

H.M.T. EMPRESS OF BRITAIN.

The Great War's battlefields were brutal, but it was possible to learn to overcome some of the aspects that made losses so high. The 4th Division's casualties at Regina and Desire Trenches were *only* 1,250 officers and men—dreadful enough, but startlingly light when contrasted to the corps' total butcher's bill on the Somme of more than 24,000. That total casualty list, about one quarter of the Canadian Corps' strength, fell heaviest on the infantry, as it always did; the infantry lost more than a third of its men. Casualties could not be eliminated in any war, but a smart commander who trained his troops well, who learned what worked and what did not, could minimize losses and achieve the objectives.

The 87th Battalion, Montreal's Canadian Grenadier Guards, had been part of the 4th Division's attack on Regina Trench, and one of the dead was Captain Henry Scott, killed instantly by a bullet in the head on October 21. He had been hastily buried in an unmarked grave, though a cross had been placed there by one of his non-commissioned officers before the battalion left the line. Padre Frederick Scott, his father, set out as soon as he could to find his son's body. Incredibly, he succeeded, scraping the mud off a hand to identify a signet ring. The body, however, could not be recovered because fighting was still underway. All that Scott could do was to read a service and to mark the grave as best he could. Later that bitter year, Henry Scott's body was properly buried.

THE CANADIAN CORPS, soon joined by the victorious 4th Division, now took up position in the trenches in front of Lens, a barren, industrial part of France where the Germans had anchored their defences on the heights of Vimy. In his clear but ungrammatical prose, Corporal Roy Macfie wrote home in late October 1916 to say that his battalion "just got into permanent billets yesterday . . . from all accounts this is a very quiet place, the boys in the trenches will be grateful for that, they have had a year of bad places almost steady. I don't suppose we'll have this very long," he added with a soldier's fatal cynicism. "It's too good." But happily, Macfie was wrong. In the trenches in front of Vimy, the troops passed a relatively quiet winter, once again integrating hundreds of new men into the battalions that had been hammered on the Somme. There they and their commanders assimilated the lessons learned. And there the Canadian Corps prepared for its victories to come.

5 | THE HOME FRONT

"ARE WE TO BE BRITISH INDEED and remove a greater enemy than the Hun from our midst?" asked an advertisement demanding the prohibition of alcohol in British Columbia in 1916. "Is the sacrifice made by our soldiers for us on the battlefield to be the only sacrifice? The Bar or the War? That is the Question of the hour!"

For the opponents of alcohol—men and women who had been fighting without much success for years—the Great War offered the best of opportunities. Opposition to booze in Canada had always been equated with godliness; now, however, it was godliness plus patriotism. This combination proved to be unbeatable. The hothouse effect of the war, the way the conflict allowed reform movements, social issues, public likes and dislikes to reach fruition with speed, had changed everything in Canada.

THE WAR HAD A HUGE IMPACT on the lives of all Canadians. The wives and children of soldiers, their parents and siblings and friends, were affected by the life and death of their boys overseas. As the economy struggled to produce munitions for the war and to feed the soldiers and Canada's allies, every Canadian had to grapple with shortages, higher prices and eventually rationing. War industries recruited tens of thousands, competing with the army for manpower. Women and the grown children of farmers joined the urban work force, making farm labour a scarce commodity and speeding the depopulation of rural Canada. Children studied the war in school and collected scrap iron on those days when they were not in class. Preachers called for sacrifice, newspapers propagandized against the enemy without let, and Canadians became divided on the utility of conscription as the way to fight the war.

The Great War mattered to Canadians. It consumed their sons overseas and their minds and hours at home. The war changed everything.

THE FIRST THING TO CHANGE in Canada in the summer of 1914 was politics. The government had gone to war automatically upon Britain's declaration, but no one objected. The opposition Liberal Party, led by Sir Wilfrid Laurier since 1887, had supported participation wholeheartedly. After all, had not Laurier as prime minister earlier declared that when Britain was at war, Canada was at war? The Liberal chief declared a political cessation of hostilities, promising that his party would do everything necessary to assist the war effort.

In Quebec, *nationaliste* leader Henri Bourassa initially took the same attitude. Bourassa had been in Germany when the war erupted, and he had narrowly escaped internment as a British subject in a German camp. His brush with imprisonment led him initially to support the war, although he had long been a crusader against British imperialism, militarism and any policy of Canada acquiring armaments. His compatriots in Quebec seemed to agree in August 1914; crowds turned out in front of newspaper offices to read the posted bulletins and to cheer the militia units parading their men through the streets of Montreal, Quebec City, Sherbrooke Falls and other towns. No one knew what war could bring, and in tough economic times Canadians hoped that it might provide work and wages.

And the times were tough. From 1896 onward, Canada was in a great boom, flooded with immigrants, factories producing at full tilt and railway construction, mining and farming enjoying great days. But the boom ended abruptly in 1913 as a sharp depression gripped the economy. British investors had begun to withdraw their funds that financed Canadian expansion, and this caused a sharp spike in unemployment as industry cut back. At the outbreak of war, however, Britain agreed to

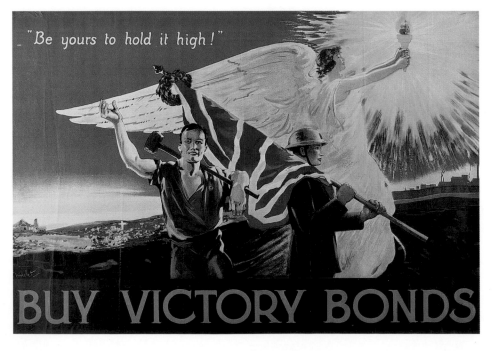

"Be yours to hold it high!"

BUY VICTORY BONDS

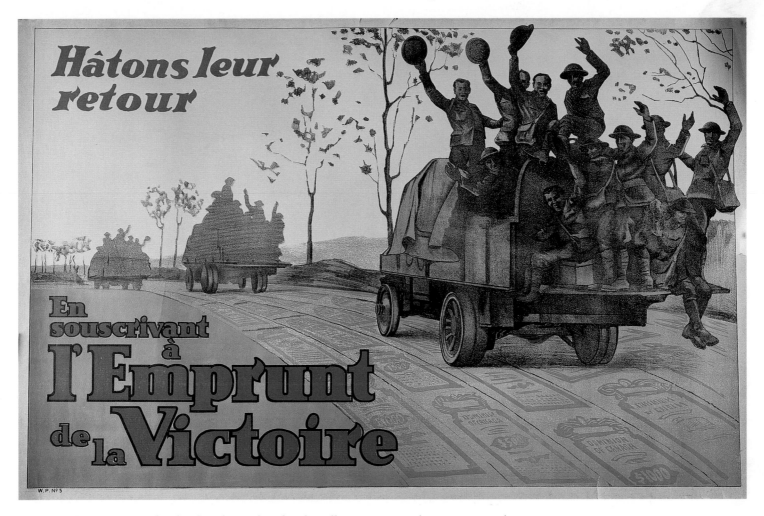

Hâtons leur retour

En souscrivant à l'Emprunt de la Victoire

W. P. Nº 5

pay Canada's war costs for food and supplies for the Allies. "We were leaning upon the British Treasury," said Finance Minister Sir Thomas White, for "our war expenditures in England, but also in Canada, and for part of our public works and railway expenditure as well." In a short war, that might have worked, but the war dragged on, and Britain's finances by late 1914 had started to suffer from the demands made on them. By 1915, White had been forced to turn to the United States' financial markets to raise money—a first for the Dominion and a portent of things to come. Later that year, in an equally unprecedented move, White asked Canadians to support a war loan, and the public did so massively. There would be successive and ever larger Victory Bond campaigns as the war continued.

But politics quickly reared its head. Laurier and the Liberals had hoped to remain supportive of the government's war efforts, but Sam Hughes soon made that impossible. The scandals over the equipment for the First Contingent were bad enough, but what infuriated the Opposition was the mess Hughes's friends had created in the manufacturing of munitions. When the war began, Canada had only one factory capable of producing artillery shells, at a rate of seventy-five a day. Battles on the Western Front soon were consuming

BELOW: War industries, especially the production of shells, boomed during the war. This factory was one of many working to feed the insatiable demands of the artillery. (CWM 19740490-001 P.43)

RIGHT: Farmers, as illustrated in this cartoon from *The Grain Growers' Guide* in early 1915, believed they were carrying the weight of the war on their shoulders—while capitalists profiteered. (*The Grain Growers' Guide*, Winnipeg, February 3, 1915)

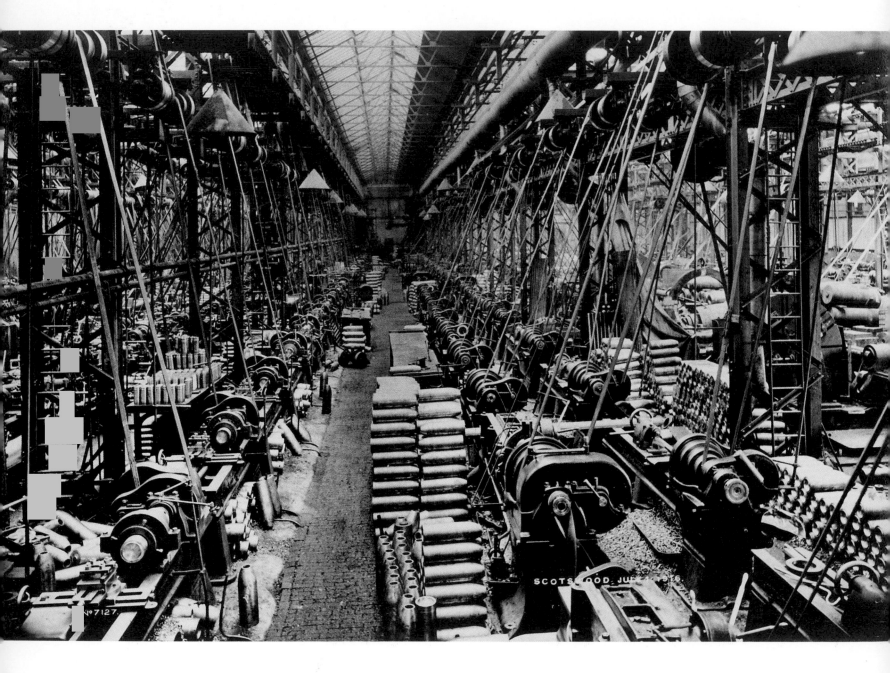

100,000 shells a day. Britain asked Canada to produce all the shells it could and established a committee with representatives of Canadian manufacturing to direct the tooling-up process. Shell-making required skilled workers, but Canada's metal manufacturers were eager to accept the challenge—and the rich contracts. Rumours quickly began to fly about huge profits, sloppy workmanship and shady deals, and too many of those involved proved to be friends of the militia minister. The government resolved the mess by establishing the Imperial Munitions Board (IMB), headed by meat-packing baron Sir Joseph Flavelle, and the scandals disappeared as production soared. Flavelle led the IMB into the construction of a range of armaments—aircraft and ships, guns and engines—and he used government factories to produce the goods that private firms were unwilling to make.

Most Canadian production went to and initially was paid for by Britain. As the United Kingdom's finances buckled under the strain, however, London pressed Canada to absorb an ever-larger portion of the costs of shells and foodstuffs, and Ottawa did. The alternative, even more unacceptable, was to cease exports to Britain. But so huge was the United Kingdom's war expenditure that the United States, once it came into the war in April 1917, had to be begged for a loan to Britain, and Canada asked for and won $15 million a month of this money to cover the country's shortfall of U.S. dollars, a consequence of ever-increasing imports from the south. Sales of armaments to the United States, a potential source of American dollars, were also pressed, though the war ended before Canadian manufacturers and the IMB could gain much. The war had markedly increased Canadian—and British—dependence on the United States.

The United States, very soon after it entered the war, imposed rationing on its citizens and industries and forced Canada to act. If the Americans were to ration Pennsylvania anthracite coal, for example, how could Canada get the fuel it needed to heat its homes and run its steel plants unless it had equivalent controls in place? The result was that Canada implemented controls to regulate the prices and distribution of scarce commodities. In effect, Canada was trying to ensure its access to a share of U.S. output and to allow the sending of as much of that output as possible overseas. Householders put cardboard placards

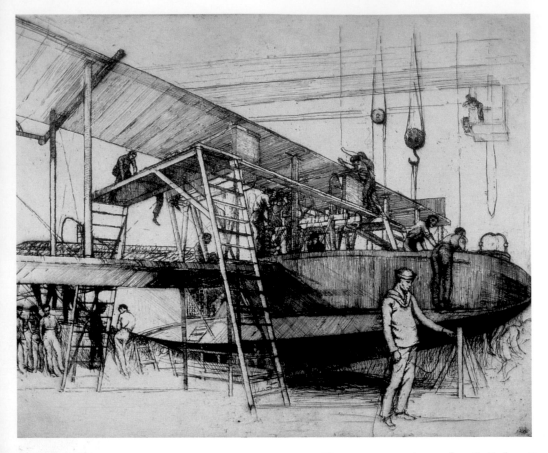

in their windows, pledging "to carry out conscientiously the advice and directions of the Food Controller." Restaurants urged customers "in ordering their food to consider the needs of great Britain, the Allies and the armies for wheat, beef and bacon . . . to do everything in their power to make these commodities available for export by eating as little as possible of them, by using substitutes and by avoiding waste." It wasn't quite compulsion, nor was it complete voluntarism; in fact, it was almost exactly in the characteristic Canadian middle.

There was some irony that Sir Robert Borden, who had come to power in the reciprocity election of 1911 by saying "No truck or trade with the Yankees," had to implement controls on scarce resources primarily to impress the Americans that Canada, fighting for two and a half years before the Americans joined in, was serious about the war. But without U.S. assistance in seeing that the Dominion received its share of food and fuel, for example, Canada could hardly continue to wage war. In effect, Canada became an American region, much like the northeastern or southwestern United States. So significant was this shift that Sir Thomas White told the Treasury secretary in Washington that "our people are very much alike and understand each other better than any other two peoples in the world today." Canadians and Americans were almost the same, the message now was. The war had truly changed everything.

Flavelle's enterprises employed thousands of workers, both men and women; other industries employed many thousands more. Women had not been wholly absent from the shop floor before the war, but the shortages of labour that had developed by late 1915, as the army and manufacturing industries competed for workers, sped women's integration into the work force in heavy industry. By 1916, thirty thousand women were working in armaments factories and shipyards, much to the chagrin of the country's trade unions, who feared a loss of control. The new workers soon proved to be as hardworking as the

War artist Dorothy Stevens went into the factories to sketch the industrial war effort.

LEFT: Stevens's sketch of a flying-boat plant. (CWM Stevens 8825)

BELOW: A heavy-shell factory, with men and women working on the line. (CWM Stevens 8827)

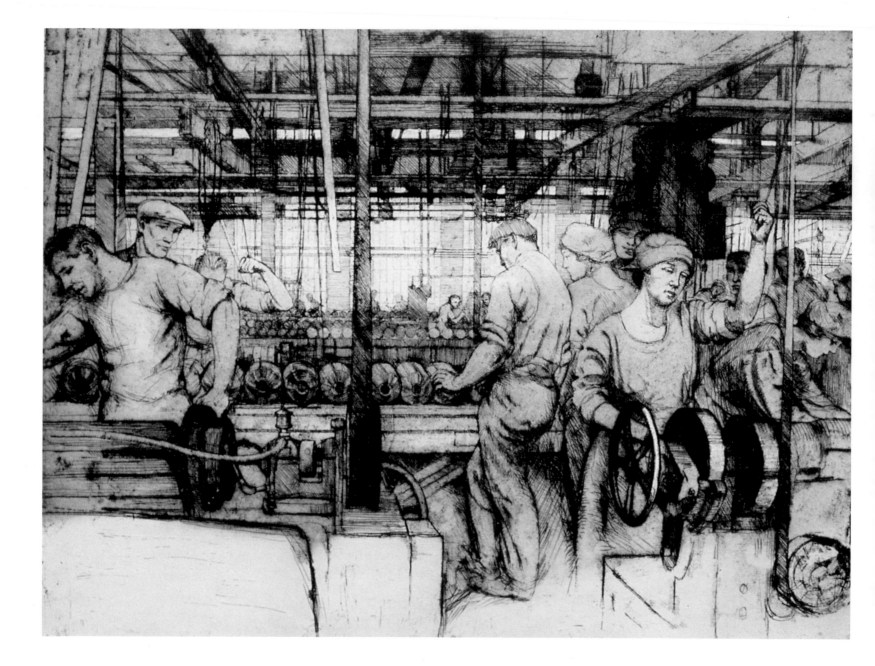

men, though their wages were always substantially lower, despite government efforts in mid-1918 to demand equal pay for work of equal value. Their bosses, moreover, offered few concessions to make the jobs easier—no daycare, terrible sanitary facilities and a clear understanding that their employment was an emergency measure, that there were to be no jobs for women after the war.

But women came to the factories and to other jobs where men were in short supply because the pay was good and because wartime employment was patriotic. In Kingston, Ontario, for example, starting in October 1917, women became streetcar conductors. Their wages were $2.25 for a ten-hour day and, the streetcar company proudly stated, double pay for overtime. Some of the "conductorettes" made $19 a week. Women also took jobs as farm labourers, so severe was the shortage of hired hands. Others picked fruit; the Ontario government sent 1,200 women to the fruit-growing districts in 1917. Women tried to reduce kitchen garbage by using more of the food they bought; they cooked (at least, newspapers urged them to cook) more stews with tougher beef. "Food *must* be conserved," the *Win-the-War Suggestions and Recipes* exhorted, "the Government *must* have our money; women *must* sacrifice their vanity, their mean self-indulgence and criminal selfishness on the altar of their country's safety." Tens of thousands did just that.

Male workers were just as patriotic as the women at home and in the factories, and there was nothing improper about workers organizing to better their lot. Unions tried to use the war as an opportunity to improve working conditions, which could be terrible in factories. The growing shortages of labour in general and of skilled workers in particular led businessmen to heed the call for improvements. Many manufacturers had to raise wages, but others were adamantly opposed to recognizing trade unions, and no legislation obliged them to do so. The result often was strikes, bitter disputes that sometimes turned ugly, until in July 1918, the government prohibited strikes and lockouts for the duration of the war. Even so, the war had shown that the power balance in factories could fluctuate: if owners feared their profit margins might be cut by rising wages, workers feared the loss of their jobs and cuts in real wages. The latter concern, as wartime inflation beginning in 1916 and accelerating the next year drove up the cost of everyday goods and rents, was serious. The average family's weekly budget, $7.96 in November 1914, was $13.49 four years later.

NOTHING WAS AS PATRIOTIC as joining the army, of course. In some parts of Canada, so many men joined up that normal life all but ceased. One Pembroke, Ontario, woman recalled that the middle classes still "went to their cottages, and there were still tennis parties," but the players now "were mostly young women." In coastal British Columbia, some communities saw every man—except for the too young, the too old, and the physically unfit—enlist. Women had to go into the work force to keep towns functioning. On the Prairies, as well, especially where recent British immigrants had congregated, there were labour shortages in the cities and a desperate need for farm labour. In heavily ethnic and francophone communities, however, where enlistment rates were very low, there was no such labour shortage. As wheat prices began to soar and as factory workers received higher wages, the resentment that "aliens" or French Canadians were getting "rich" while "good Britishers" were dying fuelled rampant xenophobia.

Canadians also feared that enemy agents were afoot in Canada, and when the Parliament Buildings burned in the winter of 1916, German spies were widely believed to have done the deed. The neutral United States had accepted tens of thousands of German immigrants in the past few decades, and the malign influence of the German embassy in Washington was much feared. At times, organized attacks from south of the border by German Americans were anticipated, and, until the United States entered the war, Ottawa kept substantial numbers of troops in Canada to meet such an eventuality. Paranoia was everywhere, and people sought to prove their patriotism. Berlin, Ontario, the heart of a German-speaking area that saw riots early in the war, had its name changed to Kitchener—after the British war minister who had drowned at sea—as a direct result of the war's high feeling.

Politicians and the press made elaborate calculations to show that this or that group was doing less than its share of providing men for the army. Few bothered to look at general health, early marriage ages or numbers of children, all of which were factors that tended to keep Quebec enlistments low. If they thought of such things at all, English Canadians tended to dismiss the data with a contemptuous saying: "They breed and we bleed." Quebec's high birth rate (and Roman Catholicism) were threats to the dominance of English Canada, which believed, with ample justification, that it was fighting the war and sacrificing its sons at the front. John W. Dafoe of the *Manitoba Free* Press wrote to one

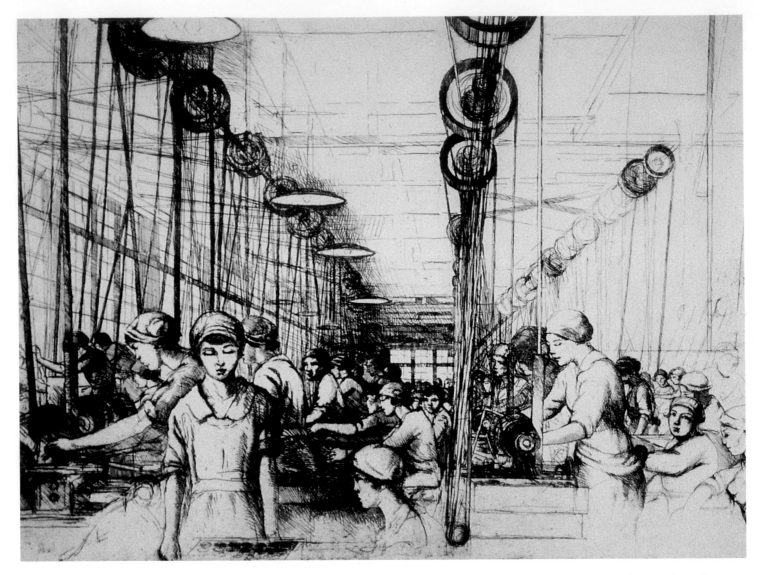

Quebec friend in 1917 that the trouble in Canada was because "French Canadians have refused to play their part in this war—being the only known race of white men to quit." Québécois excused themselves, Dafoe went on, by saying they had domestic grievances which "if true, would be contemptible. In the face of any emergency like this, domestic questions have to stand." There was substantial truth in the editor's terribly harsh words. In French Canada, the public pressure was not to enlist, and men who did join the army had to overcome opposition at home, in church and on the streets. That many did enlist was remarkable.

The pressures in the rest of the country were precisely the opposite. Fit men or conscientious objectors constantly had to justify themselves before those who asked why they were not in service. Some wore badges to show that they had in fact tried to join the forces. In December 1915, the 123rd Battalion in Toronto published an extraordinary letter

urging women to do their duty by pressing men into service. "You entertain their wretched apologies in your homes. You accept their donations, their theatre tickets, their flowers, their cars. You go with them to watch the troops parade. You foully wrong their manhood by encouraging them to perform their parlour tricks while Europe is burning up . . . For the love of Heaven," the battalion urged, "if they won't be men, then you be women . . . bar out the able-bodied man who has no obligations, show that you despise him." Shaming might work, but some men proved impervious. Not all women, of course, wanted their men to enlist.

Curiously, that it was the British-born who had enlisted first and in the largest numbers did not matter to the public, it seemed—not when Anglo-Canadians all appeared to think of themselves as British. Consider the poem, "To Our Heroes" published in the Toronto *Globe* in May 1917:

> True men, farewell!
> True hearts, adieu!
> You sleep Death's sleep
> For the Red, White and Blue . . .
> "Be British!" your dying Captain cried
> So willingly you died . . .

Doggerel it was, but unquestionably sincere. That the British-stock Canadians in the Maritimes and eastern Ontario, for example, were slow to sign up scarcely entered the public consciousness. "Our" record was better than "theirs." "Our" glory was supreme.

The government worked to systematize and streamline recruiting with some effect. But the high and continuing casualties in France and Flanders could swallow a half-division in a day. By the beginning of 1916, Prime Minister Borden had committed the nation to providing a half-million men for the army. But the simple truth was that enlistment was slowing, especially as 1917

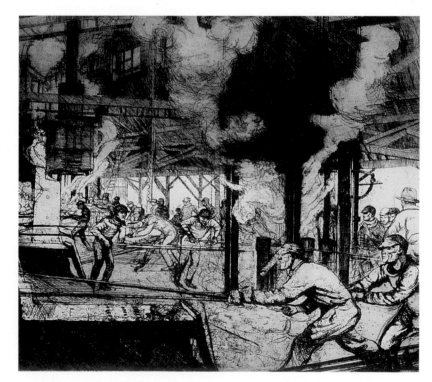

began. Two and a half years of war had taken the willing to the front, and the energy now expended to secure a few volunteers could have raised a battalion in early 1915. A victory overseas might cause a blip in the statistics at home, but the monthly trends showed that casualties were outpacing enlistments.

To some, the only answer to the need for soldiers was conscription, the compulsory enlistment of men into the army. Borden had made earlier promises against compulsory service, directing his remarks at organized labour, farmers and francophones, three groups whose enthusiasm for war was not unbounded. But the prime minister also understood that casualties weakened the battalions serving at the front, and if four hundred survivors were ordered to take a trench that one thousand might have assaulted the day before, the certain result was still higher casualties. Did Canada not owe the soldiers every support, every reinforcement needed to keep the ranks filled? Was this not a war for freedom and democracy?

To Borden, to the elites in English Canada, the answer was clear. To others on the political left and to workers, however, the issue was muddy. Too many friends of the government were getting rich on contracts and corruption, and the state took nothing away from them in income taxes, nor did it impose controls on profits. Why was it only the workers and soldiers who had to sacrifice their blood at the front, while bloated capitalists fattened on the spoils of war? The government tried to counter this argument by introducing a business profits tax in 1916 and income taxes in 1917, but the rates on both forms of taxation were low. Most workers did not earn enough to pay tax; in 1918, only 31,130 Canadians had to pay income tax. Amazingly, occasionally the critics made it into the mainstream press. One anonymous poet published "A Soldier's Testament" in the *Globe* in May 1917:

If after I am dead
On goes the same old game,
With Monarchs seeing red,
and Ministers aflame,
And nations drowning deep
In quarrels not their own

And peoples called to reap
The woes they have not sown …
Why, then, by God! We're sold!
Cheated and wronged! Betrayed!

In Quebec, the argument against compulsory service was different. Was the war not simply a British imperialist plot? Why did Canada send its sons overseas to serve London's interests? And were English Canadians not oppressing francophones in Canada in 1917 as they had ever since the Battle of the Plains of Abraham in 1759? In Ontario, school regulations blocked education in French—a great injustice in the eyes of those who believed that the French language was the bulwark of *la survivance*. The army, moreover, discriminated against francophones. Why was there not a brigade of French Canadians? Where were the French-speaking generals? Everyone had an argument against conscription. But to Bor-

<div style="float:right">

Conscription was the most divisive political issue of the war, and French Canada united to oppose it.

LEFT: This cartoon in Quebec City's *Le Soleil* appeared just days after Borden told Parliament the Canadian Expeditionary Force needed more men. Borden's Union Government promised to exempt farmers from conscription during the 1917 election, but after the great German offensives of 1918 it withdrew the pledge. (*Le Soleil*, Quebec, May 26, 1917)

BELOW: *The Grain Growers' Guide* in May 1918 expressed the agriculturalists' anger at the Borden government's broken promise. (*The Grain Growers' Guide*, Winnipeg, May 22, 1918)

</div>

den, who believed that his duty, Canada's duty, was to support the soldiers who were fighting for their lives and their country, these complaints didn't wash. As he told a friend, "We have more than two and a half million French Canadians in Canada and I realize the feeling between them and the English people is very bitter at present. The vision of the French Canadian is very limited," he went on. "He is not well informed and he is in a condition of extreme exasperation by reason of fancied wrongs supposed to be inflicted upon his compatriots in other provinces …"

By May 1917, after travelling to London to attend the Imperial War Conference and visiting the front, Borden had determined to proceed with compulsory military service, Quebec's concerns notwithstanding. The United States had entered the war, but it would be months before the Americans could send substantial numbers of trained men overseas. In the meantime, Russia was teetering on the brink of revolution and defeat, and Germany was winning the war. Borden knew the storm that conscription would unleash, and he tried to bring Wilfrid Laurier into a coalition

government to enforce compulsion. After difficult negotiations, Laurier refused, fearing that he would destroy his standing in Quebec if he joined the prime minister. Borden then introduced the Military Service Bill in Parliament in June and, after its passage, set out to create a Union Government. In the fall, after much difficulty both within and outside his own party, he succeeded. "Impressed by the urgent necessity of putting aside all minor considerations, of sinking all party differences and of presenting a united front," Borden said on October 5 when he announced the new Cabinet, a strong group of men "have come together in the service of the national interest." The prime minister drew Liberals from the provinces into his government, but he could secure only two French Canadians willing to serve in a conscriptionist government. Neither would survive the election of December 1917.

That election, pitting Laurier's loyalists and Bourassa's *nationalistes* against a powerful English-speaking Unionist coalition, was more viciously racist than any election in Canadian history. Anyone against conscription, the Union propagandists charged, was for Kaiser Wilhelm and Germany. If Laurier won, one newspaper blared, he would do so by leading the cockroaches of Canada to victory. Sir George Foster, a prominent Conservative, shouted that "every alien enemy sympathizer, every man of alien blood born in an alien country with few exceptions, is with Sir Wilfrid Laurier, and every Hun sympathizer from Berlin to the trenches . . . wishes success to Laurier . . ." The *Manitoba Free Press*, a week before the vote, ran this banner headline: "Shall Quebec, which will neither fight nor pay, rule?" In the Quebec media and on the hustings, Borden and English Canada's blood lust and desire to crush the aspirations of Quebec made the running. "Why have the Tories imposed conscription?" asked Laurier loyalist Rodolphe Lemieux. "To create a precedent, in order that Canada may become for England a reservoir of men for the wars of the future." It was a battle of numbers, however, and English Canada had the votes. Laurier swept French Canada, and Borden took almost all the English-speaking votes, more than enough to give him a substantial majority, 153 to 82 seats.

The military vote went overwhelmingly to the Union Government's candidates, swinging a number of seats away from the Liberals. Some officers pressured their men to vote the right way, and even some soldiers who voted for conscription thought the tactics "rotten"— or so Brooke Claxton, a non-commissioned officer in an artillery unit training

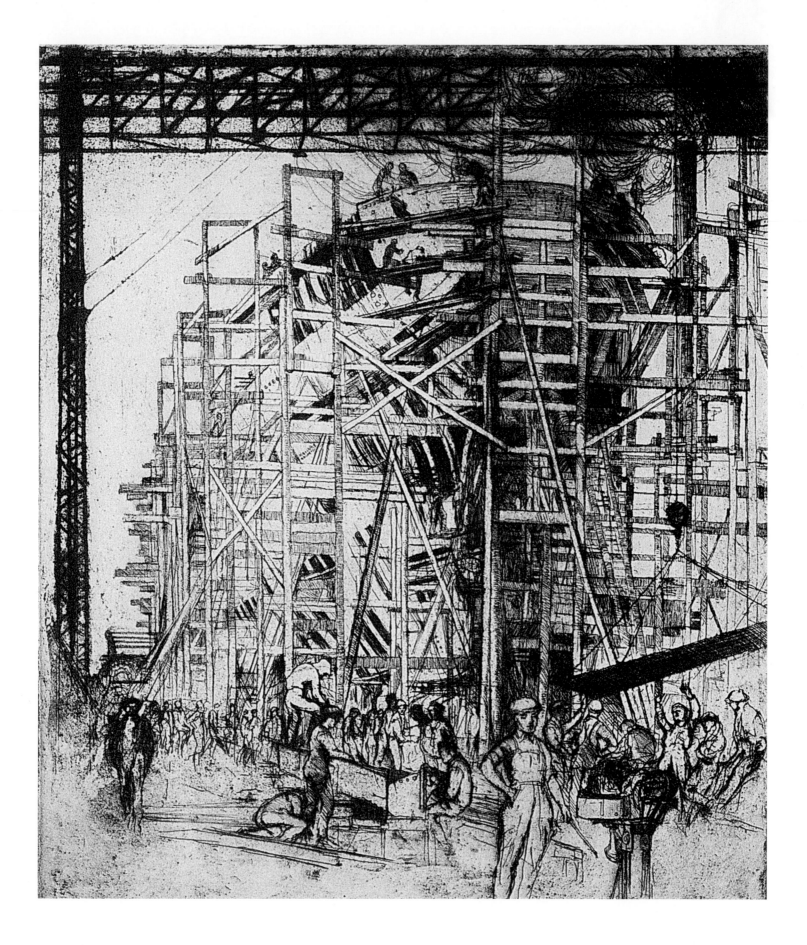

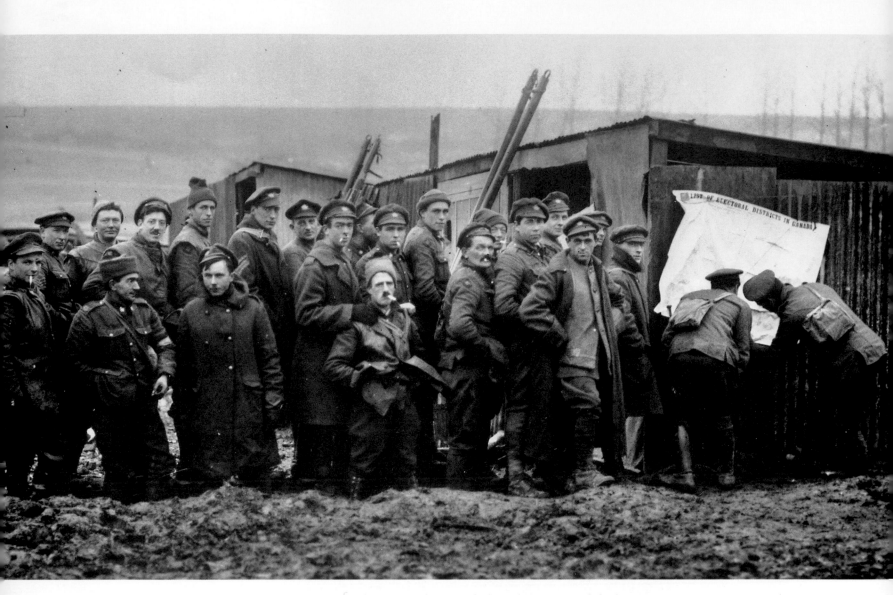

in England in December 1917, believed. But in truth little pressure was necessary to have soldiers support the Union Government. Private Arthur Macfie, recuperating from wounds in England, wrote home on December 2 that "I suppose in every part there are some ready to help the Kaiser . . . I think that any man with a conscience that would vote" against the Union Government "will be ashamed to let any one know." If conscription lost, he concluded, "Canada will be looked upon much like we do Russia today." As quitters, in other words. Jane Walters, a volunteer in a military hospital in London, recalled that "everyone wanted conscription, naturally. When you had your own there voluntarily, you hated all those others sitting around having a nice time." Soldiers, everyone from General Sir Arthur Currie down to the private soldiers, seemed gratified at the election result: "a message of confidence in, and determination to stand by, the Corps," Currie declared to a friend.

Celebrating Borden's victory, Dafoe's *Manitoba Free Press* crowed that Laurier had been "Swept Aside by Patriotic Canada." Patriotism had many variants, but the Union Government had managed to make support for conscription the issue of the day. A wartime election permitted scandals to be forgotten; a wartime election made support for the troops the central issue.

THE WARTIME ELECTION also let Borden put conscription into effect. Men began to be called up for service in January after a complex process that saw more than 90 per cent seek an exemption from service. Farmers could claim exemption (an election promise), as could conscientious objectors, doctors in training, seminarians and sole supporters of families. Borden's goal was 100,000 men; by November 1918 he had secured that number, though only a quarter had made their way to France before the Armistice. But it had been a struggle. In the spring of 1918, efforts by the police to track down defaulters in Quebec had led to major riots in Quebec City. The government had been forced to call in troops from Ontario to restore order. At roughly the same time, the great German offensives against the Allied lines frightened the Dominion government, and the Cabinet decided to cancel all exemptions. Farmers were outraged—they had voted for the Union Government because of a pledge that they would be spared from compulsory service. Now, just as planting was getting underway, the government was taking away their sons!

A tough man, Borden was unmoved. If Germany won the war, all would be lost. If the government did not back up the Canadian Corps, struggling to survive in the hell of the trenches, the men who came home would wreak a terrible vengeance on those who had let them down. Borden had decided that he would back the needs of the front above all. It was a courageous decision, but it was one that left Quebec aggrieved for years to come, and farmers became absolutely convinced that the federal government paid no heed to the imperative needs of agriculture.

THE EXTRAORDINARY EFFORTS of the Canadian Corps overseas played their part in advancing Canada's status in the world. A colony in law in 1914, Canada emerged from the war with enough autonomy that it could credibly join the League of Nations in its own right. This new status was not easily captured. The British government tended to look on

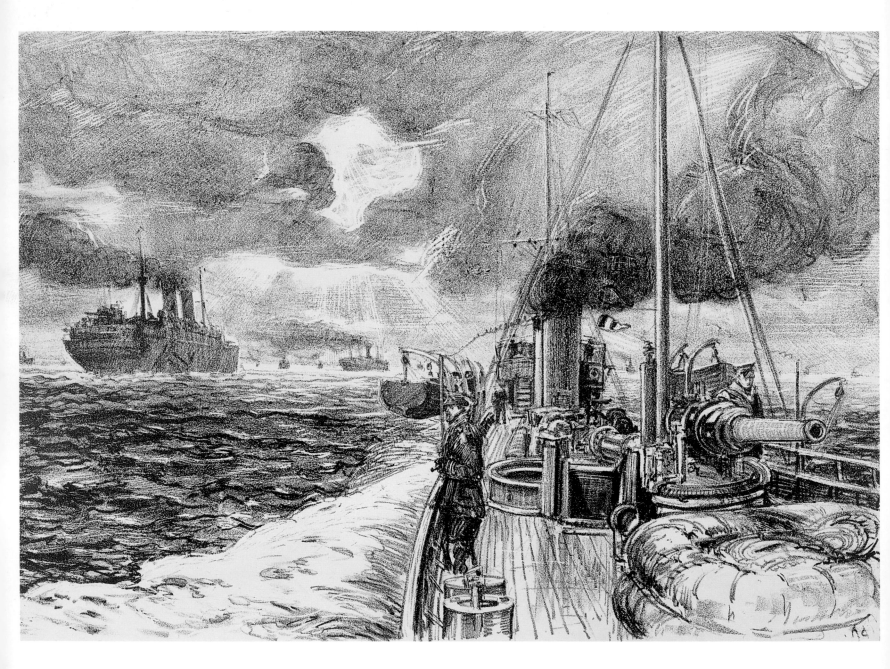

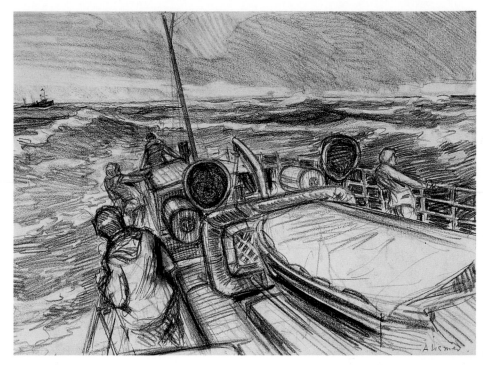

the Dominions as sources of troops, not as partners. But Prime Minister Borden, frequently infuriated by bumbling, incompetent British generalship and political fumbling, pressed his Imperial colleagues hard at meetings in London. His nation had sent a half-million men to fight, he roared at one point, and if there were more slaughters as there had been at Passchendaele, not another soldier would leave Canada's shores. "Canada will fight it out to the end," he said at a prime ministers' meeting in 1918. "But earnestness must be expressed in organization, foresight, preparation . . . For God's sake let us get down to earnest endeavour and hold this line."

Such tough talk reinforced British prime minister David Lloyd George's desire to control his generals, and there was some gratitude towards Borden. This may have helped get the Dominion a greater say in its own and Imperial foreign policy, a position won even more by Canada's huge contribution in men and materials. Resolution IX of the Imperial War Conference formalized it: the Dominions had the right "to an adequate voice in foreign policy and foreign relations." The Canada that emerged from the fires of 1914–18 had a standing in the eyes of the world very different from its position in 1914.

CURIOUSLY, ART HELPED improve Canada's standing. The Dominion was the first of the warring Allies to establish an official war art program to document the national effort. Begun by Max Aitken—soon to be created Lord Beaverbrook, who was handling a variety of chores for Sir Robert Borden's government in London—the Canadian War Memorials Fund commissioned its first painting in late 1916. Soon a number of British and Canadian artists had been commissioned to do paintings, and Ottawa began to accumulate vivid renderings of the war.

The result was that many of Canada's best artists—Maurice Cullen, Fred Varley, A.Y. Jackson, Arthur Lismer, David Milne—painted a substantial array of canvases covering all aspects of the war on land, at sea and in the air. Unofficially, some soldiers painted in their off-duty hours; others had been taken prisoner and sketched in their prisoner-of-war camps. At home, artists also painted women in the munitions factories or portrayed the

The terrible Halifax explosion in December 1917 devastated large tracts of the city and killed or injured thousands. The collision of two ships had precipitated the disaster. This photo, picking out the *Imo's* final resting place, shows the carnage at water's edge. (CWM 19980023-006 P.10)

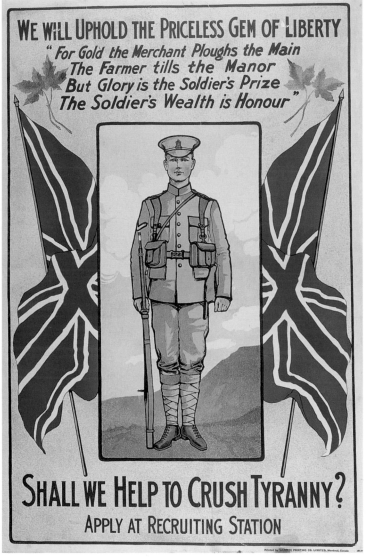

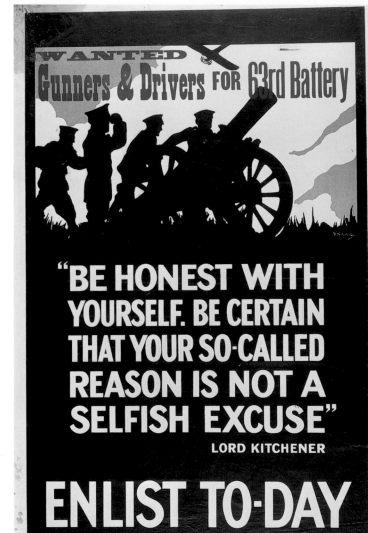

RIGHT: Arthur Lismer's drawings are among the best examples of
Canadian war art, careful in their realism and faithfully reproducing
the ships and aircraft used on the East Coast. (CWM Lismer 8378)

making of aircraft and the building of ships. Much of this art was superb, its range vast; the record of Canada at war was at once inspiring and horrific in its graphic revelations.

Beaverbrook used the war art to raise the understanding of Canada's role in the war (and money for Canadian war charities) through exhibitions in Britain. But his hope was that the art might provide the foundation for a national war memorial and gallery in Ottawa. Plans for a grand building were prepared, but it was not to be. Penny-pinching governments combined forces with post-war disillusionment to stall the project and, eventually, to inter it completely. Canada's war art, unquestionably among the best in the world, was put into storage. Some of the huge canvases, rolled up and mouldering away, remained unseen for more than eighty years.

SOME CANADIANS looked at the impact of the war, looked at those who were fighting and those who weren't, and decided that society had to change. The war was vicious and all-consuming, but didn't Canadians deserve a better country as their reward? The progressive forces in Canada combined a sense of grievance with a moralizing fervour, and during and immediately after the war they made their mark.

The prohibitionists, the "ban the bar" forces, were quick to take advantage of the war's needs. Alcohol was needed for war production, and wheat was essential to feed the soldiers and civilians overseas. What justification could there be for turning rye into whisky? What rationale was there for permitting workers to get drunk when labour was a scarce wartime commodity? In Manitoba in 1916, a plebiscite—limited only to adult males—voted in favour of prohibition by almost a two-to-one majority. Each of the other provinces, pressured by articulate middle-class men and women and by the churches, soon imposed prohibition, and Ottawa did the same. Canada was dry as a bone for the duration of the war.

Another area where pressure built up in wartime was that of women's rights. After all, women were running farms and producing munitions. Should they not also have the right to vote? The suffragist movement had existed before 1914, spearheaded by women like E. Cora Hind, a journalist, and Nellie McClung, a successful novelist. Organizations such as the Women's Christian Temperance Union and the National Council of Women of Canada had been in place for decades. The war provided the opportunity to move the

agenda forward, and one by one the provinces gave women the vote. By 1917, all four western provinces and Ontario were aboard the unstoppable train, and in that year, Ottawa gave women relatives of soldiers the franchise.

By every indication, women relatives of soldiers heavily supported Borden's candidates. Grace Morris, organizing the women voters of Pembroke, Ontario, sent letters to each potential elector explaining bluntly that "the only way they could hope to see their men again was to vote for the Union Government and conscription." This, she added, "was our way of helping to win the war."

That Sir Robert Borden's federal government at the same time took the vote away from recently naturalized immigrants from "enemy" countries, and that it created a system that encouraged corruption in the allocation of the

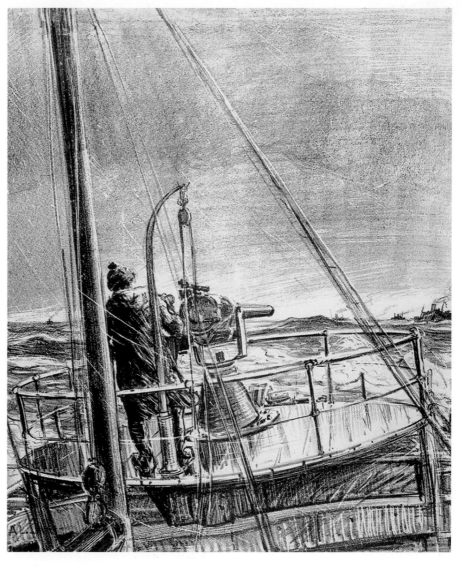

military vote, did not matter. Those were regrettable aberrations carried out in time of war. Few women leaders objected; few seemed to understand that the partial extension of the federal franchise was intended to win the election more than to expand women's rights. Even so, in 1918, the federal government extended the vote to all women. Some provinces had already done this in their sphere, though it would be 1940 before Quebec, the last to act, followed suit.

None of these changes was sufficient for farmers who had long been upset that the government was run by lawyers for the corporations, especially corporations in the Montreal and Toronto areas. Farmers produced the food Canada needed, the food the world wanted. Surely they were entitled to more say in running their own country? In 1916, the Canadian Council of Agriculture had issued *The Farmers' Platform*, soon to be known as "The New National Policy," which called for lower tariffs, free trade with the United States,

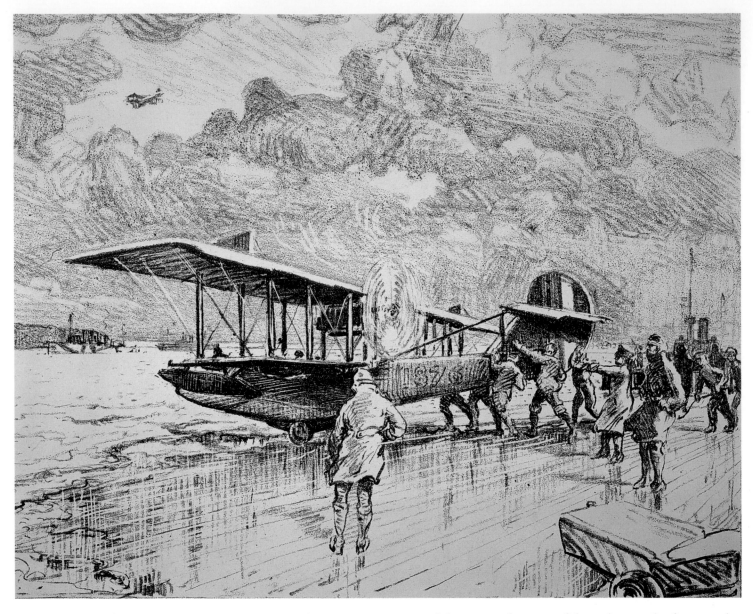

income and corporation taxes and the nationalization of the railways. The farmers also wanted political reform and an end to patronage.

After the ending of exemptions for farmers' sons in spring 1918, the hostility to the Union Government was profound. This mistrust was matched by a deep mistrust of Laurier's Liberals as just another old-style political party subject to party discipline and rule by the "interests." The farmers were in revolt, and they began looking for ways to take over the provincial governments, calling at the same time for members of Parliament to protect the interests of their constituents. Strongest on the Prairies and in Ontario, the Progressives, as they came to be called, were a harbinger of change in Canada, a test for the old party system.

BY LATE 1916, Canada's navy had begun to fear attacks by German submarines against East Coast shipping and against Canadian freighters carrying supplies to Britain. The government initially proved unwilling to pay the costs of defence, though all understood that the answer was patrol vessels and aircraft. In the spring of 1917, the introduction of convoys from Halifax and Sydney, Nova Scotia, designed to use anti-submarine ships to escort groups of merchantmen across the North Atlantic, raised the stakes. For the Royal Canadian Navy (RCN), the need for patrol vessels now was critical. So too was the need to establish that the RCN was in charge at Halifax, and in 1918 a vice-admiral took command of the dockyard, conveniently outranking the senior Royal Navy officer there.

Britain recommended that the RCN provide at least thirty ships for U-boat patrols, but all Canada could find was five. With some reluctance, the government then ordered a dozen forty-metre steel anti-submarine trawlers, and the Admiralty in London soon asked for an additional sixty trawlers and a hundred wooden drifters, all to be built at British expense. These slow and poorly armed ships could not be ready until the spring of 1918, and the submarine chasers, all named after the battles fought by the Canadian Corps, were not very successful designs. With a maximum speed of ten knots, they could not catch U-boats, and if by chance they had come across one, their sole twelve-pounder gun likely would have done little damage. Worse yet, the RCN, which enrolled only some seven thousand sailors in the course of the war, had no trained crews to man them. They did, however, give a huge fillip to the Canadian shipbuilding industry, and they helped make the convoy system work just by being there.

Canada's appeals to London for anti-submarine aircraft prompted only the answer that Canada ought to build and operate the craft itself. Despite the best efforts of the small naval staff under Admiral Charles Kingsmill—who in 1917 had been promoted to the equivalent rank of a full general, or one step higher than Currie, who merely commanded the Canadian

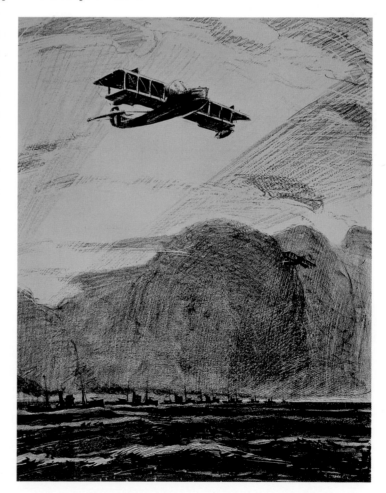

Corps—the Cabinet found this impossible, given the demands on Canadian industry. Little was done. When the threat of U-boat attacks became a reality in the second half of 1918, the result was near-panic in the Maritimes and in Ottawa.

Sinkings, the German capture of ships and their instant conversion to raiders, and the threat of U-boat–laid mines beginning in July alerted the authorities to the presence of U-boats in Canadian waters. The United States Navy (USN), as well as the RCN, organized to fight back. Troop convoys, carrying American and Canadian soldiers, as well as supply ships, were now at risk. The USN sent six sub chasers and promised flying boats—the first time organized units of the American services were based on Canadian soil. The RCN, Royal Navy, and USN began extensive co-operation, allocating their forces to meet the needs and generally working well together at all levels. (There was, however, at least one riot in Sydney, between Canadian and American sailors.) At the same time, blackout regulations darkened the Nova Scotia coast, although one captain asked what use these were at Sydney "when the glare from the steel plant, when slag is being poured, can be observed up to thirty-five miles at sea?"

The Americans' Curtiss HS2L seaplanes arrived at Sydney in August 1918. Operations began the next month, two aircraft flying for two and a half hours to provide air cover for a convoy. The RCN, however, had begun planning for dirigibles, escort-towed observation balloons, and for a new Royal Canadian Naval Air Service to begin operation in 1919, when, it was feared, U-boats would strike in even greater force. The end of the war in November 1918 brought these efforts to a close. The war had come to Canadian waters, and Canada and its navy had struggled to meet the challenge. It was almost certainly fortunate that no RCN vessel met the enemy in action.

THE WAR ALSO CAME to Halifax's civilians with a terrible vengeance. The great harbour had never been busier than it was in the Great War, when troop ships, supply vessels and battleships all used the natural harbour. On December 6, 1917, while all Canada was absorbed in the general election campaign, a French vessel, the *Mont Blanc,* carrying some three thousand tonnes of picric acid, TNT and gun cotton, steamed into the harbour towards Bedford Basin. The Belgian ship *Imo* struck the French freighter in the Narrows off the northwest part of the city, where most of Halifax's poor people lived. The *Mont Blanc*

began to burn, its crew hastily abandoned ship and the drifting vessel floated toward shore. Just after 9 AM, it exploded in one of the largest man-made explosions to that time. The explosion was heard 320 kilometres away, and the force of the blast levelled huge tracts ashore. Windows in the Learment Hotel in Truro, 100 kilometres away, were shattered, so strong was the detonation. Bert Griffiths, a sailor on HMCS *Niobe*, tied up at the naval dockyard, wrote his wife that he had seen the *Mont Blanc* vanish. "I was hurled on the deck & there was an awful noise going on. I got to my feet & ran with a whole lot of fellows. My one fixed idea was to get below." Griffiths soon got ashore "& finding I was unhurt I started in to assist the wounded ... By this time all the houses around the dockyard were on fire."

So was much of the city. More than 1,600 men, women and children died in the blast or subsequent fires, 9,000 were injured and thousands more were left homeless. Parents searched for their children, and Halifax's *Morning Chronicle,* putting the tragedy in personal terms, reported that two sailors who had lived on Hanover Street found "nothing but ruins" and no trace of their families. The newspaper gave the sailors a list of temporary shelters and hospitals, but the men had no success. "Nothing is more terrible than the suspense," the *Chronicle* wrote, "and, strong men as they were, their faces showed the strain." "There is not a single pane of glass in Halifax," Able Seaman Griffiths said, and "the dead are just laid out anywhere. I saw a basket on the jetty this morning & in it was a little baby, quite dead." A heavy snowstorm the day after the disaster made rescue work more difficult but helped to put out the fires.

Aid poured in from Canada and "the Boston States." Prime Minister Borden, a Nova Scotian himself, cut short his campaigning and rushed to Halifax to promise money to rebuild the city. Citizens and servicemen at home now shared fully in the tragedy of the war, and a shaken Able Seaman Griffiths urged his wife to write "to your lucky old Lofty. Every minute I thought I was dead."

Inevitably, a search for scapegoats began at once, and the finger of suspicion pointed at the RCN. The federal government had long been aware of the dangers of a collision in Halifax harbour but had done nothing. Most unfairly, one mid-level naval officer was saddled with the blame, and the RCN suffered widespread vilification in its home station. The real cause, however, was the war. No longer could any Canadians escape its effects.

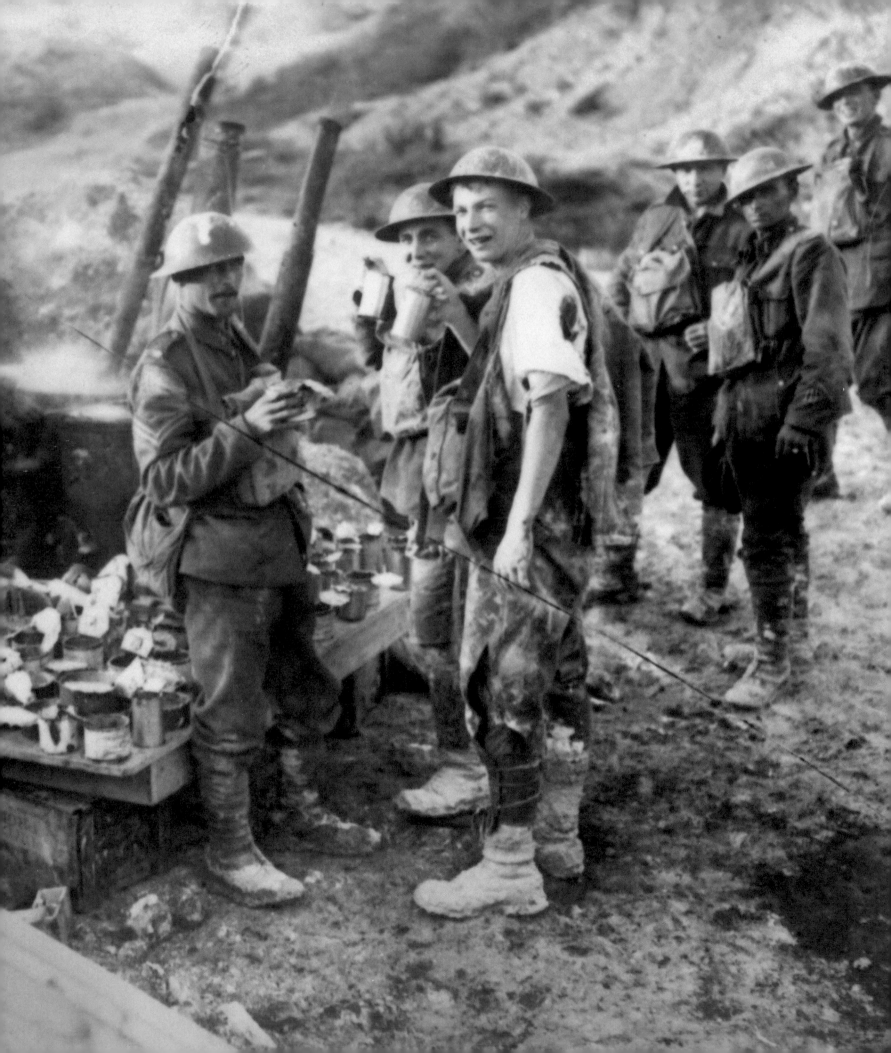

6 | TRIUMPH AND HORROR:
VIMY RIDGE AND PASSCHENDAELE

"THE CONDITION of the ground beggars description," Lieutenant-Colonel Agar Adamson wrote to his wife on October 23, 1917, from the Princess Patricia's Canadian Light Infantry (PPCLI) lines in the Ypres salient. "Just one mass of shell holes all full of water. The strongest and youngest men cannot navigate without falling down." Soldiers reported that "men drowned in shell holes for want of strength to pull themselves out when dog tired." Adamson was right to be full of foreboding. When the PPCLI went into the attack at Passchendaele on October 30, the regiment lost 363 of the 600 men who went over the top.

AFTER THE GREAT BLOODLETTING on the Somme, the Canadian Corps bound up its wounds and prepared itself for the struggles that lay ahead. There was much to do. The battles in the autumn of 1916 had demonstrated that sending men into battle laden with packs and supplies to consolidate captured ground was ineffective. The soldiers simply could not move with forty kilograms of bombs, wire and ammunition on their backs. The answer the corps' thinkers came up with was to send the first wave of attackers forward relatively unencumbered; the second and subsequent waves could carry the equipment, drop it off and proceed to their own objectives. The men in the first wave, however, needed bombs, or hand grenades, in profusion. Without them, the enemy trenches could not be cleared.

At the same time, the Canadians had learned the German tactics as well as their own. The enemy almost invariably counterattacked at once in an effort to retake lost ground. The Germans used their effective artillery to pound the positions they had ceded, and the

positions were precisely plotted. Their men brought forward machine guns and bombs, and they too knew where they were going. To resist such counterattacks, the Canadian artillery had to be ready to hit at the Germans, and the ammunition, machine guns, mortars and grenades had to be in the hands of the soldiers preparing to meet each and every counterattack. Also critical was good communications. Every method had been tried, from pigeons to signal lamps, from reconnaissance aircraft to flags. Telephones worked, but the first wave of attackers could not lay telephone cable, and gunfire frequently cut the wires when they did. A runner carrying a message was still the best way of passing information—a testimony to the terrible problem facing a commander trying to exercise control on the battlefield in an era before reliable wireless communications.

German artillery was a mighty weapon. German guns had a long range, and their shells were powerful and more reliable than those of the British and Canadians. How could the artillery be countered most effectively? Led by Lieutenant-Colonel Andrew McNaughton, from the beginning of 1917 the Canadian Corps' counter-battery staff officer,

General Sir Julian Byng's divisions began to put science to their service. McNaughton was an engineer in civilian life, and he used every tool he could think of to try to neutralize the German guns. He had balloons tethered above the front to spot the flash of German guns and placed microphones for sound-ranging in carefully surveyed positions. If two or more balloons or aircraft picked up a flash, the position could be accurately triangulated. The microphones picked up the bang of the gun, and the interval between firing and explosion let the position be found. In ideal conditions, McNaughton's counter-battery specialists could find a gun in under three minutes. Within a few months, the corps' counter-battery work was the best on the Western Front, and the Germans' war-winning weapon was on the way to being neutralized.

What else could be done to increase the chances of success? The answer came from the 1st Division's commander, Major-General Arthur Currie, who had been sent by the corps commander to visit the French and study their tactics. Currie learned that the great ally emphasized the value of reconnaissance by putting every man who was going to attack

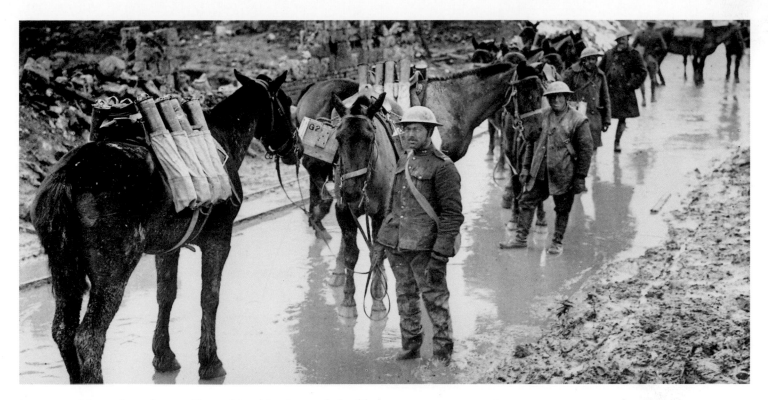

into a position where he could see his objective and the likely enemy strong points. France's aircraft took extensive photographs, and the army distributed these photographs to the officers of each attacking unit, who used them to brief their troops. The objectives were not grid references but recognizable features such as a rail line, and the French believed in rehearsals, running practice attacks on patches of ground similar to those to be attacked. Moreover, the *poilus* (French soldiers) thought about tactics, about platoons, companies and battalions using fire to cover their movement. France also emphasized training on weapons so that every man could use every infantry weapon—and those of the enemy as well.

Finally, the French believed rightly that fresh troops should lead attacks. This would maximize the chances of success. Using machine guns and grenades to keep the Germans in their trenches, the French sent their infantry in rushes at the enemy strong points. Follow-on troops could mop up.

Currie brought these maxims back to the Canadian Corps, and Byng accepted them. Infantry companies now were to be organized into four platoons of four sections, each platoon team capable of fighting its own battle with fire and movement. Soldiers would not be automatons any longer; now they had to show initiative and react to the battlefield, bypassing pockets of resistance if possible but subduing them if necessary with their own weapons. Moreover, instead of attackers being closely bunched and separated from each other by one metre, as the doctrine at the Somme had specified, now the infantry were intended to be much more spread out, five or six metres between the men of the first

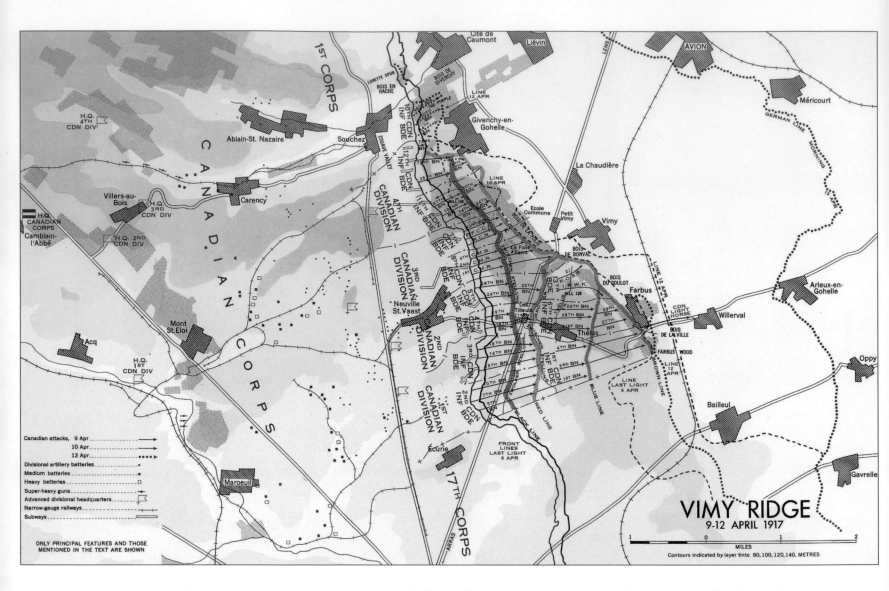

The map contains the following labels:

1ST CORPS

CANADIAN CORPS

Cité de Caumont · Liévin · AVION · Méricourt

H.Q. 4TH CDN DIV · Ablain-St. Nazaire · Souchez · LORETTE SPUR · BOIS EN HACHE · BOIS DE GIVENCHY · LINE 12 APR · Givenchy-en-Gohelle · GERMAN LINE · MORNING

4TH CANADIAN DIVISION · ZOUAVE VALLEY · 10TH CDN INF BDE · 12TH CDN INF BDE · 11TH CDN INF BDE · La Chaudière

Villers-au-Bois · H.Q. 3RD CDN DIV · Carency · H.Q. CANADIAN CORPS Camblain-l'Abbé · H.Q. 2ND CDN DIV · LINE 10 APR · Ecole Commune · Petit Vimy · Vimy · BOIS DE BONVAL

3RD CANADIAN DIVISION · La Folie Farm · 4TH CDN INF BDE · 5TH CDN INF BDE · BOIS DU GOULOT · Arleux-en-Gohelle

Mont St. Eloi · Acq · H.Q. 1ST CDN DIV · Neuville St. Vaast · 2ND CANADIAN DIVISION · 6TH CDN INF BDE · HILL 135 · Tilleuls · Thélus · Farbus · CDN LIGHT HORSE · Willerval · Oppy

1ST CANADIAN DIVISION · 3RD CDN INF BDE · 2ND CDN INF BDE · 1ST CDN INF BDE · BOIS DE LA VILLE · FARBUS WOOD · LINE 12 APR · BROWN LINE · BLUE LINE · Bailleul

Maroeuil · Écurie · FRONT LINES LAST LIGHT 8 APR · BLACK LINE · RED LINE · LINE LAST LIGHT 9 APR · Gavrelle

17TH CORPS · ARRAS

Legend:
Canadian attacks, 9 Apr
10 Apr
12 Apr
Divisional artillery batteries
Medium batteries
Heavy batteries
Super-heavy guns
Advanced divisional headquarters
Narrow-gauge railways
Subways

ONLY PRINCIPAL FEATURES AND THOSE MENTIONED IN THE TEXT ARE SHOWN

VIMY RIDGE
9-12 APRIL 1917

MILES

Contours indicated by layer tints: 80, 100, 120, 140, METRES

Courtesy Directorate of History and Heritage, National Defence Headquarters, Ottawa.

wave. Combining the best of French practice with what they themselves had learned on the battlefields of 1915 and 1916, the Canadians now had a tactical doctrine that worked. The corps would put it into effect at Vimy Ridge.

THE POSITION AT VIMY had been in the enemy's hands since October 1914. The Germans had beaten off strong French and British attacks, and they had fortified their lines to resist any further assaults. Their bunkers had been deeply dug—almost always deeper than similar Allied positions—and their artillery carefully aimed at all likely targets, and they had three strong trench lines, connected by communications trenches. The chalky ground rose gently towards the crest of the ridge, affording a clear view of Lens and much of northern France, but the sharp drop was behind the German lines. No Canadians scaled a cliff to attack Vimy, mythology to the contrary.

General Byng had carefully worked out his attack plan over the winter. The corps had four objectives, each designated by a coloured line. The first objective, the seven-hundred-metre-deep Black Line, was the Germans' forward defence. The Red Line, the final objective for the left flank of the corps attack, was the fortified La Folie Farm and Hill 145, a high point on the ridge. To the right was the Blue Line, encompassing Thelus, Hill 135 and the wooded area overlooking the town of Vimy. The final objective, the Brown Line, included the second line of enemy trenches. There was no plan for a breakthrough, no expectation of an opportunity to exploit a victory.

Byng had laid down a strict timetable for the assault by the four divisions of the corps. The attack was to begin at 5:30 AM, first light, and the Black Line was to be reached in 35 minutes. After a 40-minute period to regroup and consolidate, the attackers had 20 minutes to secure the Red Line. Two and a half hours later, the reserve brigades of the 1st and 2nd Divisions would assault the Blue Line, and after a pause of precisely 96 minutes, the same brigades would take the Brown Line. If everything went to plan, Vimy Ridge should be taken by shortly after 1 PM.

Was that as hopelessly unrealistic as the battles on the Somme had been? Byng and his staff officers believed not. They planned to bring machine guns forward in profusion and to begin digging defensive lines as soon as objectives were seized, thus letting them counter German efforts to regain their ground. The artillery planning was precise, calling for 863 guns to fire on the German lines and rear areas, and when additional British supporting guns were added, there was one heavy gun for each twenty metres of front, and one field gun for each ten metres. The plan called for a two-week softening-up program, fire escalating towards a crescendo. "Enemy bombarded continuously," Georges Vanier of the 22nd Battalion wrote in his diary on April 6. "Our bombardment more and more intense." The shellfire weakened the strong points, exhausted the defenders who tried to repair the gaps at night and disrupted resupply. It was the Germans' "week of suffering," or so prisoners described it.

The heavy howitzers especially focused on the enemy wire, and the gunners employed with great effect a new fuse that exploded on contact with barbed wire. By April 7, Canadian commanders had satisfied themselves that most—or enough—of the enemy's wire had been flattened. The attackers also would advance behind a rolling

barrage, the artillery accompanying the assault. Massed Vickers machine guns, 150 of them firing indirectly at the enemy lines, also laid down a deadly hail. All this supporting fire required good training of the Canadian troops and demanded that the advance proceed at a steady pace. "Chaps," Byng told the troops, "you shall go over on the exact time, or you shall be annihilated."

Moreover, the counter-battery preparations were superb. McNaughton's guns had all the ammunition (including newly issued gas shells) and all the time they needed to blast at German batteries as soon as they were spotted. The gunners worked closely with aircraft in spotting targets and adjusting their fire. The motto of the gunners was "See first, hit first, and keep on hitting," and they did. By the time of the Canadian attack on Vimy, more than 80 per cent of the Germans' 212 artillery pieces had been neutralized. That was critical—the German counterattacks could not be supported by devastating gun fire, though they employed gas in an effort to slow the Canadian advance. Vimy was an artillery battle, and the Canadian and British gunners won.

The Canadian Corps also made other preparations. Trench raids aimed to keep the enemy on edge, frightened of the "wild colonials," and to secure prisoners for interrogation. (A large raid by 1,700 troops from four battalions of the 4th Division on March 1 had resulted in 687 Canadian casualties, including two battalion commanding officers, company commanders and senior non-commissioned officers—a self-destructive disaster severe enough to weaken the ultimate attack on Vimy Ridge, or so some believed then and later.) The supply system mobilized itself to produce and stockpile tens upon tens of thousands of shells for the intense artillery program, and the ammunition moved forward over specially constructed rail lines. Closer to the front, subways and tunnels had been carved into the chalk soil by the five tunnelling companies provided by the Canadian Engineers, making the forward movement of men and supplies invisible to enemy spotters. Everywhere, telephone cables had been buried, water lines constructed and maps printed and distributed. It was an extraordinary effort of professional planning.

The corps also followed General Currie's recommendations. Men were to carry relatively light loads: just 120 rounds of ammunition, grenades, a rifle and bayonet and a shovel. Packs and blankets were left behind. Significantly, each man knew what his section, platoon, company and battalion were to do, each had seen the map and aerial photo-

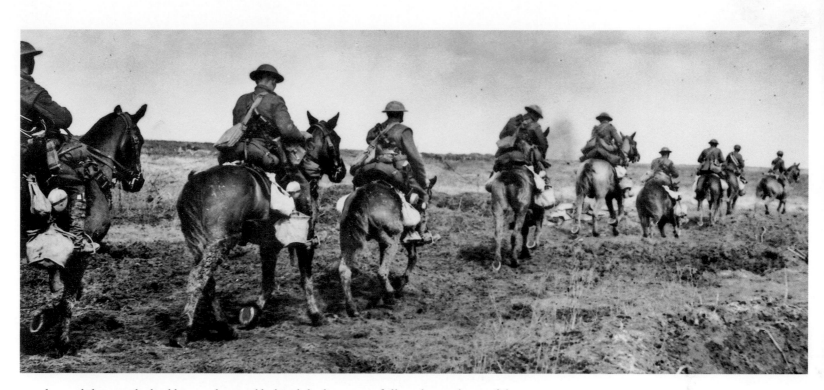

graphs, and the attacks had been rehearsed behind the lines on a full-scale mock-up of the enemy positions. The only secret was the zero hour, and officers learned this on April 8, Easter Sunday. The attack was to go over the top on the morning of Easter Monday, when fifteen thousand men from twenty-one Canadian battalions would take Vimy Ridge.

Extraordinarily, the attack achieved a measure of surprise. The enemy knew of the Canadian preparations, but it did not know precisely when the corps' attack was to begin. The Germans' ability to respond quickly, moreover, had been weakened by the prolonged artillery attacks, and the first waves of attackers proceeded behind a huge barrage of fire. "At the break of day," Gunner Fred Sim of Lethbridge, Alberta, wrote to his father, "the whole country seemed on fire ... Each gun firing four rounds a minute, with six guns to the battery, and we were only one battery in hundreds ... It was some fireworks." The guns supporting the corps' attack fired an incredible forty thouand tonnes of high explosive on April 9, as well as thousands of gas shells. Padre Frederick Scott saw and heard the gunfire, but his reaction was different:

> I knelt on the ground and prayed to the God of Battles to guard our noble men in that awful line of death and destruction, and to give them victory, and I am not ashamed to confess that it was with the greatest difficulty that I kept back my tears. There was so much human suffering and sorrow, there was such tremendous issues involved in that fierce attack, there was such splendour of human character being manifested now in that "far flung line," where smoke and flame mocked the calm of the morning sky, that the watcher felt he was gazing upon eternal things.

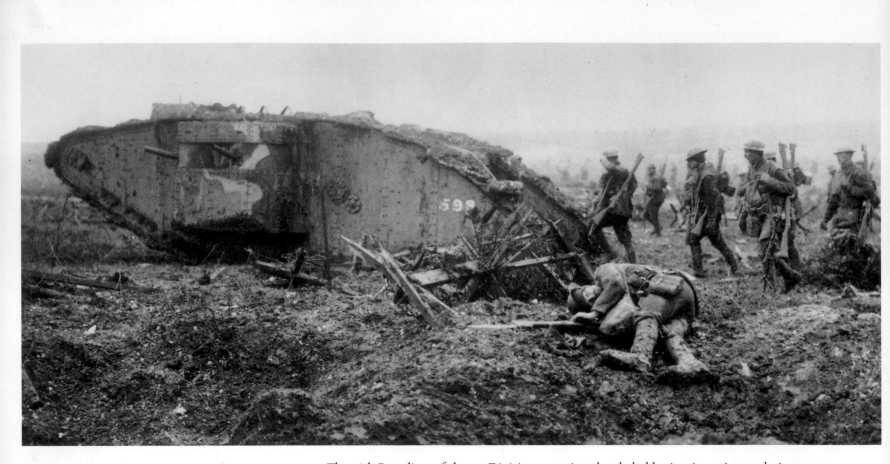

The 16th Battalion of the 1st Division went into battle led by its six regimental pipers and took its objective, like most units of Currie's division, on time. They found Germans, quickly dispatched by bombing, still in their dugouts. Those who could not be killed were penned in their bunkers while the rest of the attack moved on. One lieutenant said that "there was not very much excitement where I was. I only saw two live Germans" and "two dead ones... I think our artillery barrage had chased them all down into their dug-outs and they afterwards came out in bunches and were taken prisoners." The artillery support was extraordinary. The war diarist of the 5th Canadian Mounted Rifles noted that "60 guns are covering our own advance... Smoke and debris, thrown up by the bursting shells, give the appearance of a solid wall."

Attacking was gruelling work. The historian of Canadian trench warfare, Bill Rawling, observed that "maintaining a steady pace behind the creeping barrage, fighting a series of small actions against machine-gun positions and strong points, only to move off to repeat the process at the next objective, was exhausting. Companies eventually ground to a halt, with troops panting and sweating, having expended all their energy in what was essentially a war of movement... to capture the parapets before German riflemen and machine-gunners could prepare to defend themselves... The only way to maintain momentum," Rawling wrote, "was to ensure companies would be replaced when they could go no further."

HELL'S CORNER

By the time the advance arrived at the second line, enemy sniping and machine gun and artillery fire (including gas shells) were inflicting casualties. But, spurred on by success, the fresh infantry companies rallied and took out the machine guns. Aided by snow and sleet blowing towards the east, the Black Line was in Canadian hands by 7 AM and the Red Line by 8 AM, and by 9:30, the 1st and 2nd Divisions had almost reached the Blue Line. One battalion ran into heavy opposition, surmounted it and moved forward. The final objective, the Brown Line, also fell to the two divisions, but only after a downhill bayonet charge.

Private Donald Fraser, now serving in a machine gun section with the 27th Battalion, noted that he passed two hundred prisoners ("a miserable looking lot, in a hurry to get off the ridge") and made it to the enemy trenches. "The terrain from now on was one mass of shellholes. Several contained dead, principally our own ... the going was very difficult. The mud was thick and heavy, the shelling so severe that we began to scatter ... the route lay between the wounded and the dead." Padre Scott, going forward, saw "hundreds of men ... now walking over the open in all directions. German prisoners were being hurried back in scores." Lieutenant-Colonel Agar Adamson of the PPCLI told his wife that his regiment had taken four hundred prisoners, every one with "a photo of one or more most repulsive naked women. One of our Divinity student sergeants," he said, "made an officer eat three most filthy postcards." More seriously, he added that one German major refused to be sent with prisoners to the rear, except in charge of a major. "He will trouble us no more."

Despite the casualties, the attack was going wondrously well, as the artillery hurriedly moved forward to keep the advance under covering fire. Only the 4th Division faced great difficulty—in its task of securing Hill 145, the highest point on the ridge. The defences were strongest here, four lines of trenches with bunkers dug into a reverse slope that rendered them all but immune to artillery fire. Two brigades, each reinforced with an additional battalion, battered against the position, came close to taking it, fell back and then struggled to contain counterattacks. Despite extraordinary efforts by two British Columbia battalions, the 102nd and the 54th, Hill 145 remained in German hands at dark. A nighttime assault by the 85th Battalion, a Nova Scotia unit that had just reached France and that had been intended for use at Vimy only as labour, finally took the position.

The rest of the Red Line fell after two battalions reached it in a mad charge on the morning of April 10. Private John Pattison won the Victoria Cross for destroying a machine gun nest with three grenades, and then finishing off five surviving enemy soldiers with his bayonet. The 4th Canadian Division's losses were most severe: 4,401 of its men were killed or wounded, about one in three of the infantrymen. The PPCLI, in 3rd Division, had ten officer casualties and some 350 casualties among other ranks, and Agar Adamson wrote: "We have done very well, though suffered a lot." That was true for the entire Canadian Corps.

One final position on Vimy Ridge was still occupied by the Germans. The Pimple, at the very northern tip of the ridge, had been intended to be cleared by British troops. Instead, on April 12, three western Canadian battalions of the 4th Division's 10th Brigade

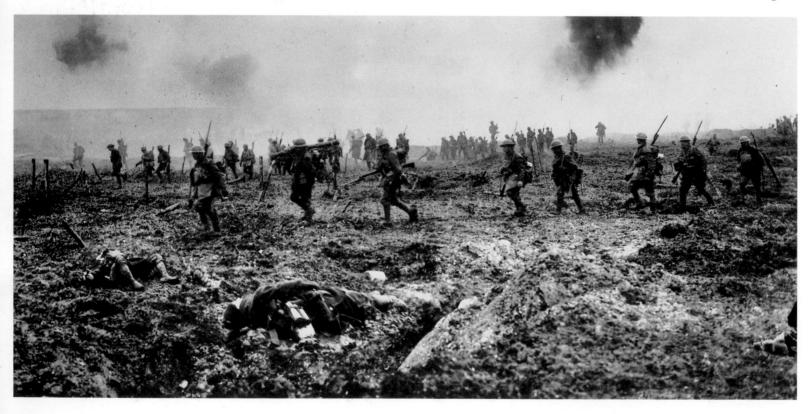

HELL'S CORNER

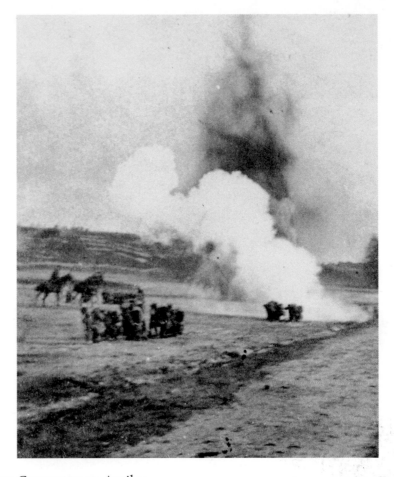

launched a night assault in a howling gale, battered the Guards Regiment that was manning the position in a hand-to-hand struggle and took control by dawn. The ridge was now completely in Canadian hands. The Germans, their positions overlooked from the new Allied vantage point, pulled back.

The enemy did not go quietly, however. Canadian units probing into the new no man's land beyond the ridge were shelled incessantly, and gas was used against them. Private Frank Maheux, an Ottawa Valley lumberjack, wrote home ungrammatically but graphically to say that "they sent gas we had our respirator for 3 hrs in one time that what save our life." Later, he noted that "when the gas comes it is like pineapple it smells so good if you smell a [little] you die choke and you can't get your wind[.] I saw many dying like that healthy young men the best in the nation just kids." Nursing Sister Clare Gass wrote on April 15 that "the casualties . . . have simply filled all the hospitals hereabouts to over flowing." Some of the wounds were "heart breaking—Gas gangrene is very prevalent & we have lost several cases."

Vimy Ridge was the great Canadian victory of the war, the point at which Canada became a nation—or so we are told. Certainly it was a model of a set-piece attack, a perfectly planned, superbly executed assault. The infantry, artillery, engineers and supply services worked together professionally to demonstrate that the Canadian Corps could take almost any position. And, without question, the successful battle and its four-kilometre advance made Canadians at the front and in Canada enormously proud. Percy Wilmot, a young non-commissioned officer in the 25th Battalion, wrote home that the battle had been won by "men of C[ape] B[reton], sons of NS & NB, F[rench] C[anadian]s & westerners—all Canucks . . . Canada may well be proud of the achievement." The nation's 10,602 casualties, including 3,598 killed, in five days of fighting were almost justifiable.

But Vimy was not followed up by the British and French armies. This was no breakthrough, and no general advance was led by the cavalry divisions that had been waiting since late 1914 for their chance. The battle drove the Germans off the ridge and forced

them to retreat to new positions, but it had no effect at all on the outcome of the war. Indeed, British attacks in the Second Battle of the Scarpe, launched in conjunction with Vimy, failed completely. The war went on.

SOON AFTER VIMY, Sir Julian Byng was promoted to army command and left the Canadian Corps that he had transformed. To replace him, Field Marshal Sir Douglas Haig, the British commander on the Western Front, chose Sir Arthur Currie, the 1st Division commander who had been knighted after the Vimy victory.

Currie was the obvious choice, but in the Canadian Expeditionary Force (CEF) nothing was ever easy. Major-General R.E.W. Turner, commanding the Canadians in Britain, had seniority over Currie and pressed his claims. Prime Minister Borden left the decision to the minister for the overseas forces of Canada, Sir George Perley. In a Solomon-like decision, Perley agreed that both Currie and Turner should be promoted to lieutenant-general, that Turner should keep his seniority and Currie should keep his corps. The best man stayed in France and Flanders.

One major problem weighed on Currie's mind: just before the war, he had misappropriated government funds intended to purchase uniforms for his Victoria militia unit. In a financial panic when he seemed on the verge of losing everything he had worked for, Currie had dipped into the militia till to cover his personal shortfalls. He lived in fear that his defalcation might be known to Sam Hughes, the minister of militia. Not until September 1917, when two of his officers paid the outstanding bills, was Currie free of fear. Even then, he had to worry about Hughes's possible actions.

Complicating Currie's problem was the fact that when Prime Minister Borden had passed the ball to Perley to select the corps commander, he had urged that Major-General Garnet Hughes, the son of the former militia minister, should get command of the 1st Division. At the moment, Hughes commanded the 5th Canadian Division in England, a force of 21,000 trained soldiers waiting their time to go to France. The difficulty was that Currie would not have Hughes as a division commander, preferring to give that post to Brigadier-General A.C. Macdonell, a notably popular and successful brigade commander. (Macdonell was known as "Batty Mac," and soldiers talked of his mad courage. In the front line he once insisted on taking a look at the enemy trenches. "Be careful, Sir, there's a sniper,"

BELOW: Objectives in the Great War
too often lost all value in the battles.
The Canadian capture of Lens left the
victors in control of a sea of ruins.
(CWM 19780067-004 P.23)

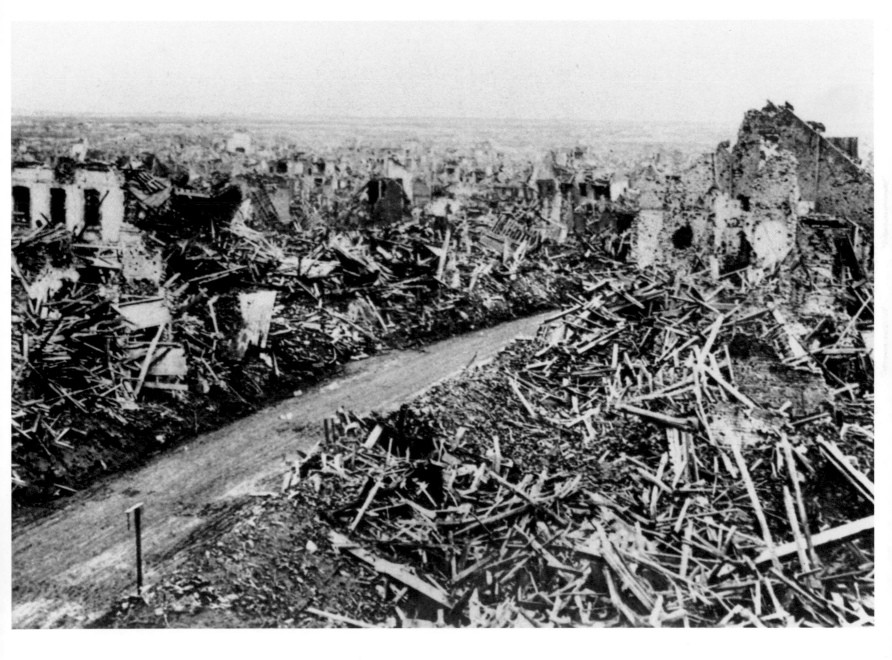

TRIUMPH AND HORROR

he was warned. "Fuck the sniper," came the brigade commander's reply, and Macdonell was promptly shot in the shoulder. "My God, his language!" an observer remembered. "You could hear him for miles around.") That Currie insisted on the best man for the post, despite his personal troubles, was the truest example of his integrity. Sam Hughes, still in Parliament if no longer in the Cabinet, raged impotently, and Borden and Perley reluctantly acquiesced in Currie's decision.

All this mattered because conscription was a fractious issue at home, and Currie, pressed to indicate his support for the measure, was reluctant. The men of the 5th Division, all volunteers like the rest of the CEF and already trained, were far more important than reluctant conscripts who could not be ready for months. But if Hughes could not have a division in France, then he must keep the 5th in England, and the corps would have to find its reinforcements by breaking up newly arrived battalions. Currie duly sent a message to Canada, calling on the country to provide the men the Canadian Corps needed. When the election was called, however, he was reluctant to lend public support to the government, primarily because, as he wrote to one of his officers who had returned home, "I

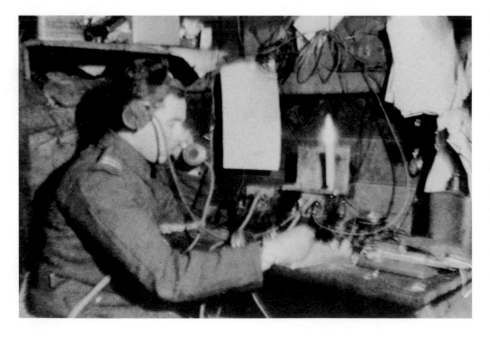

gather that the national campaign is being conducted on the same low level as previous ones." On the other hand, if conscription were likely to be defeated, he was more than willing to tell the Canadian public how important it was to keep the corps at strength. Once again, the man's integrity was clear.

Currie exercised similar integrity on the battlefield. Haig ordered the Canadian Corps to take the mining city of Lens, which was heavily defended and dominated by two hills. Currie instead argued that Hill 70, if captured, could force the Germans to counterattack into killing zones. Astonishingly, his arguments prevailed, and he began to ready his men for the assault.

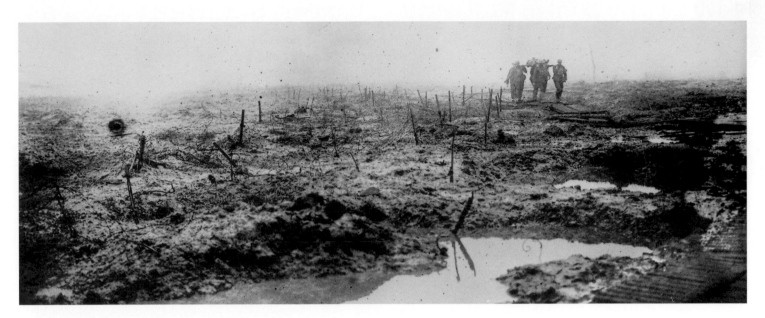

His plan called for a two-division assault behind massive artillery support. The troops rehearsed their roles over and over again, stressing the immediate mopping-up of enemy strong points and the quick advance of machine guns. Currie ordered that platoon-strength machine gun posts be put immediately in place to halt enemy efforts to regain their ground.

The 1st and 2nd Divisions attacked behind smoke and a creeping barrage in the early hours of August 15, the corps artillery pounding the German gun positions with explosives and phosgene gas. The first objectives were quickly taken, except for those of 2nd Brigade, and the heavy and repeated enemy counterattacks ran into murderous and pre-planned fire, not least from that of ninety-six machine guns. "The Germans would come and drive us a little ways," said one soldier in the 26th Battalion, "and we halted them and drove 'em back." A stretcher-bearer, astonished by the "heaps" of enemy dead, attributed them to "our guns—my God! This isn't war; it's murder." The objectives missed on the first day were attacked on the second, and a seesaw battle developed that lasted for days. Private Bob Gardner of the 21st Battalion wrote home that "there were fights in cellars, dugouts, tunnels and everywhere imaginable . . . I was buried five times in four days" from shellfire.

The Germans also fired up to twenty thousand mustard gas shells, new on the front, and the Canadians, well disciplined and hastily prepared to attack with respirators on and to defend while wearing rubberized groundsheets, barely managed. Agar Adamson of the PPCLI wrote on August 22 that the gas shells "come in flocks of twenty, make very little noise and almost no smell . . . the only advice we have as to treatment is to take a hot bath and get into clean pyjamas at once"! The gas hit especially hard at the artillery, but incredibly the batteries continued firing. The gunners knew that the success—indeed, the survival—of the infantry depended on them. Padre Scott wrote that the gunners could

War artists sought to capture the
devastation caused by the struggle.
Cyril Barraud's mournful party entering
Ypres through the ruins eerily points
to the horror. (CWM Barraud 91331)

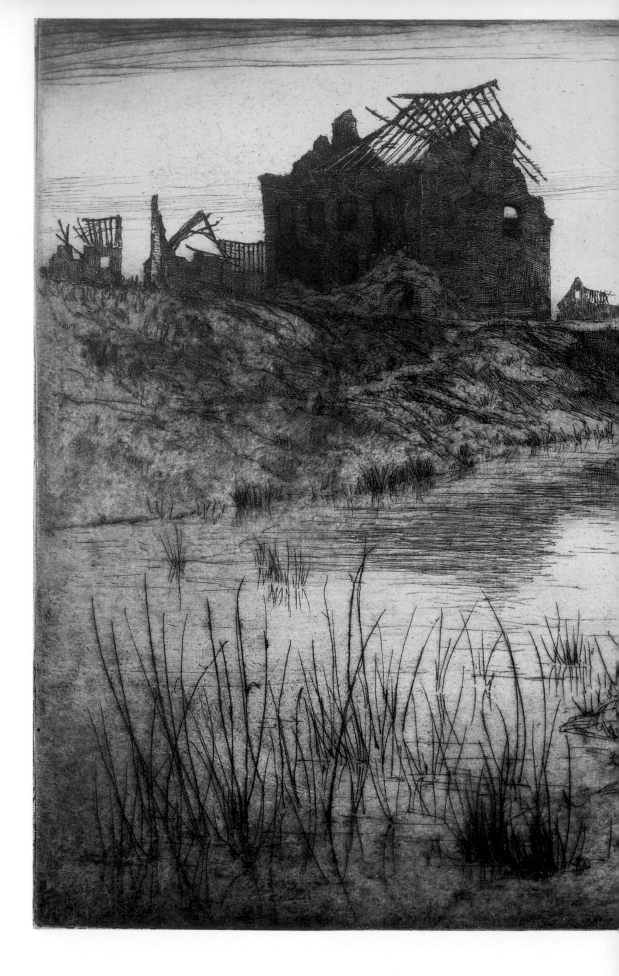

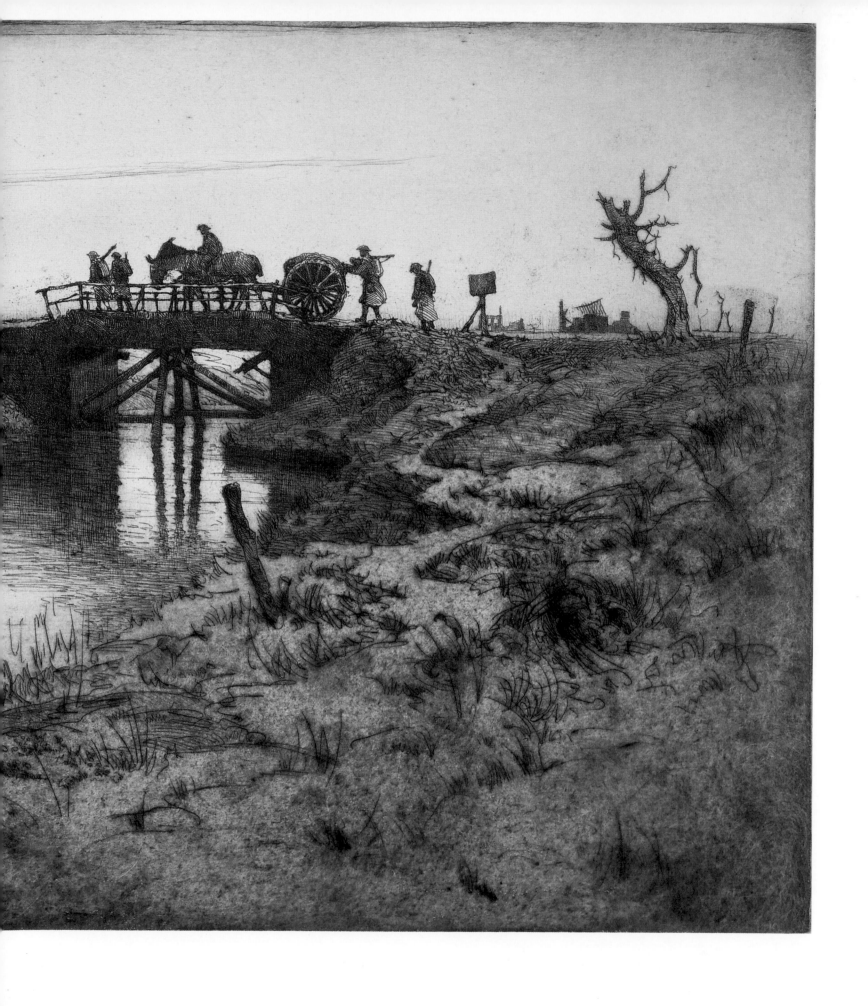

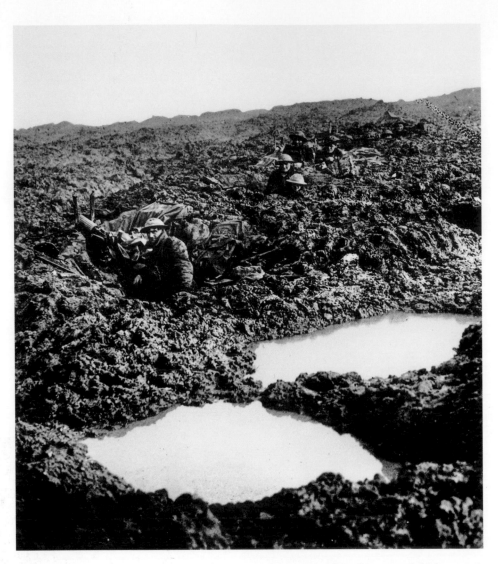

not see their sights when the eye holes in their gas masks fogged up "and so chose to face poison unprotected rather than run the risk of injuring our infantry by bad firing. There were of course heavy casualties..." Dozens of artillerymen fell victim to the gas.

One soldier noted that the new gas "remains effective for as long as thirty hours. You can absorb it through the skin by rubbing your clothes with your hands." An infantryman recalled that the gas settled into the muck and froze, initially causing no ill effects. But while his platoon rested, "the sun came out nice and strong, thawed out the mud and the gas rose again. Because it was heavy, it drifted into the dugouts and we got it when we were asleep." Those who were gassed suffered in painful blisters that erupted in their armpits, groin, knees and back. They vomited violently and suffered inflamed eyes. Adamson added that mustard "affects certain parts not mentioned, and gloves must be worn when performing certain functions of nature."

Even so, the Germans could not regain Hill 70, despite their best—and worst—efforts. The price was high. Arthur Lapointe of the 22nd Battalion noted that his company, which had numbered 117 men at the beginning of the battle, now had less than fifty. The PPCLI also had many shell shock cases, presumably increased because of fear of mustard gas. "The men," Adamson said, "have to be held down."

Currie then launched the 2nd and 4th Divisions at the southern slope of Hill 70. The Germans resisted stoutly, their artillery and machine guns inflicting terrible losses. The objectives had been only partly seized, and ten days' fighting had produced over nine thousand casualties. Currie called Hill 70 "the hardest battle in which the Corps has

LEFT AND BELOW: At Passchendaele, men lived in a lunar landscape of mud and water. Imagine fighting in such conditions. Imagine having to carry duckboards forward to create paths through the mud, knowing that if you fell off you could drown in the ooze. (Photographs by William Rider-Rider, National Archives of Canada; *left:* PA-002162, *below:* PA-002084)

participated." If any had believed that Vimy had been a turning point on the Western Front, this struggle should have persuaded them otherwise. The Germans were still prepared to fight.

Indeed, the enemy had good reasons to believe that they were winning. Yes, the Americans had come into the war, but the Russians, after their revolution in March 1917, were on the verge of collapse. Italy, fighting in its mountainous north, was making no headway for huge losses; and the French, troubled by mutinies in 1917, were thought to be incapable of serious fighting. Only the British Empire among the Allies seemed willing to fight it out.

And the Canadians had the nastiest job of the fall of 1917: Passchendaele. The Ypres salient continued to be a slaughterhouse, a place of almost no strategic significance. But, because Ypres was the sole Belgian town of importance left unoccupied, it was of

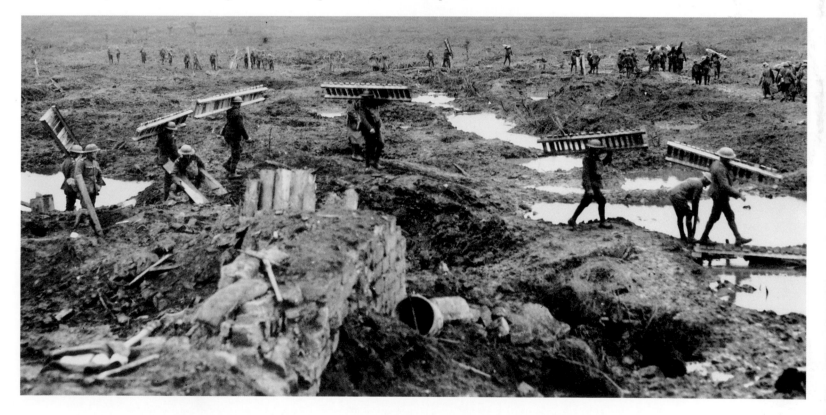

symbolic value to *les braves Belges*, as the British and Canadians always referred to their ally without any sincerity. Passchendaele also was an obsession to Field Marshal Haig, the British commander, who simply could not abide the fact that the Germans continued to hold the smashed remnants of the original village. After huge losses were incurred by attacking British and Australian forces, the Canadian Corps in October received orders to capture Passchendaele, and Currie set out to reconnoitre the ground.

He was horrified by what he saw—clinging mud, corpses, wreckage, all mixed into a deep and watery yellow morass of shell holes. Currie initially refused to send his troops into action there, and certainly not if he had to serve under the Fifth British Army, in whose commander he had no confidence. Haig agreed to switch the Canadians to the Second Army, but he insisted that Currie undertake the attack. Passchendaele mattered to the British commander, and even though Currie estimated that taking it would cost sixteen thousand casualties, Haig prevailed. The reluctant Canadian set out to do the job; he had less than two weeks to get the corps ready. That, however, was more time than the British and Australians, who had tried and bloodily failed to take Passchendaele, had received from Haig.

On the muddy, viscous battlefield, movement was all but impossible. A greatcoat that weighed a kilogram when dry could weigh twenty kilograms when mud and water were applied to it. Men who fell off "trench mats" or duckboards went into the mud or into shellholes and could drown. Artillery pieces sank into the ooze up to their breeches, their gunners working thigh-deep in mud, unless the guns had firm wooden platforms that left them open and exposed. Supply was all but impossible, and Currie had his engineers build corduroy roads, using timber supplied by the Forestry Corps. Railway troops, as at Vimy, pushed rail and tramway lines forward. Harold Becker of the 75th Battalion wrote of his work laying a trench mat path: "Six foot lengths of mat had been dumped from lorries at the side of the road. Each man picked one up and followed along the path. At the end each laid his section, waited for the rest to pass and then returned to the dump for another load." The men building the paths suffered 1,500 casualties from German gunfire.

At Passchendaele, preparation was the key, artillery the only way to blast the enemy from his bunkers, and determined, well-rehearsed assaults by infantry essential. That the enemy had air superiority over the salient made the task all the more difficult, and Private

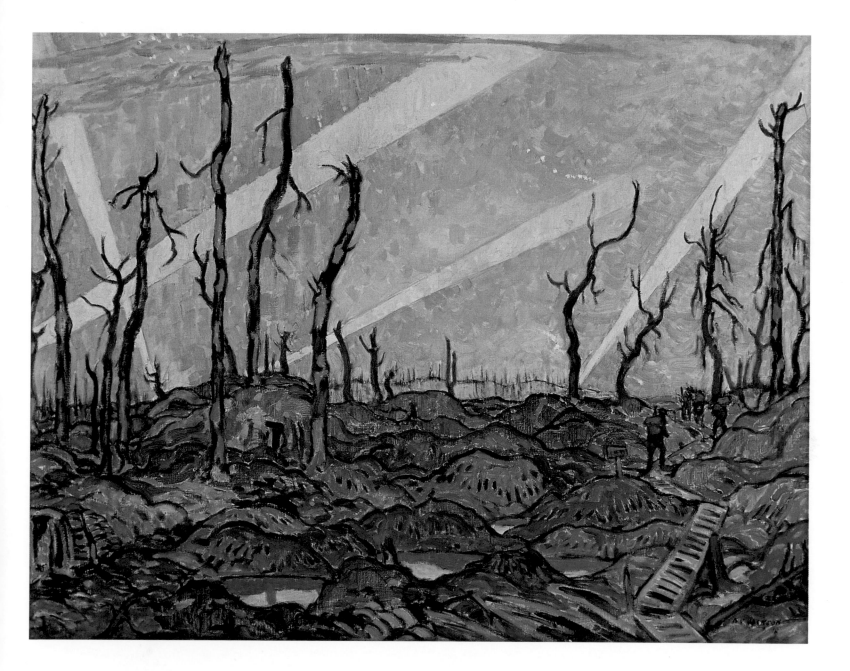

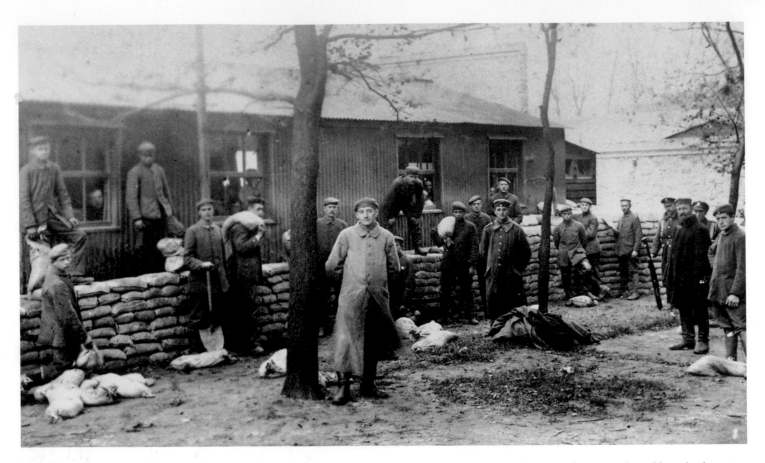

Becker remembered being strafed while building his trench mat path and bombed on October 28 in a "rest camp" just behind the front.

The attack on the enemy lines began on October 26, the 3rd and 4th Divisions running behind a creeping barrage of gunfire and heavy fire on enemy supply roads. The objective was to gain 1,200 metres of mud, and the soldiers almost did, though their efforts cost 2,500 killed and wounded in three days. The 46th Battalion suffered 70 per cent casualties in the advance, most from machine gun fire directed at them from concrete pillboxes, each of which could be subdued only by determined men with grenades who looked for blind spots and exploited them. "We had to take them by stealth," one Canadian in the 5th Canadian Mounted Rifles recalled, "get our men together, work our way in sections behind the pillboxes, and start bombing." The casualties were terrible, but this tactic worked, in part at least because the Germans too suffered terribly. One wrote that Passchendaele was "horrible. You often wish you were dead, there is no shelter, we are lying in water, everything is misery, the fire does not cease for a moment night and day, our clothes do not dry."

The enemy artillery used gas against the Canadians, the Germans knowing that wearing respirators exhausted the Canadian combatants, already worn out by the mud and fear, to the point of breakdown. Soldier Cameron Ross remembered that "gas shells were

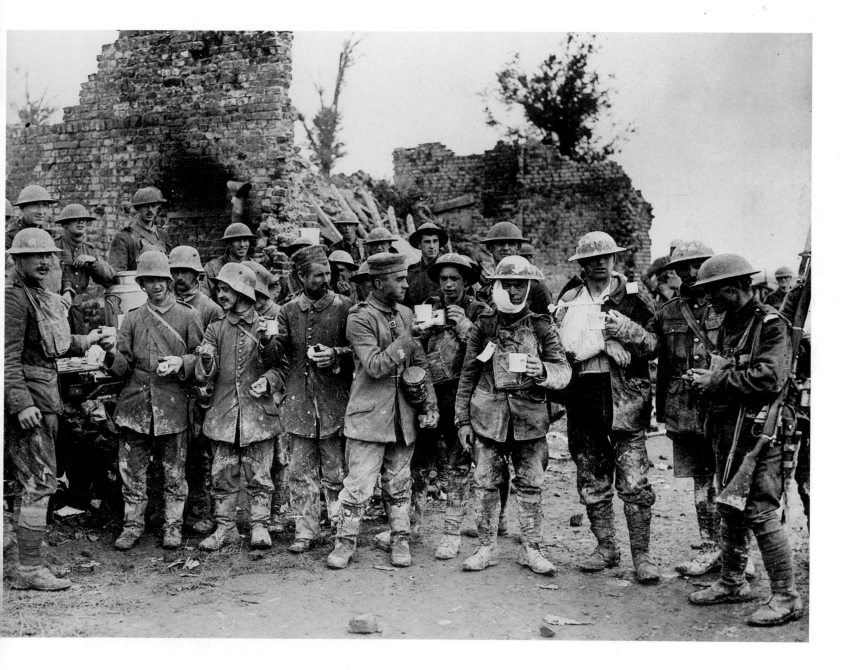

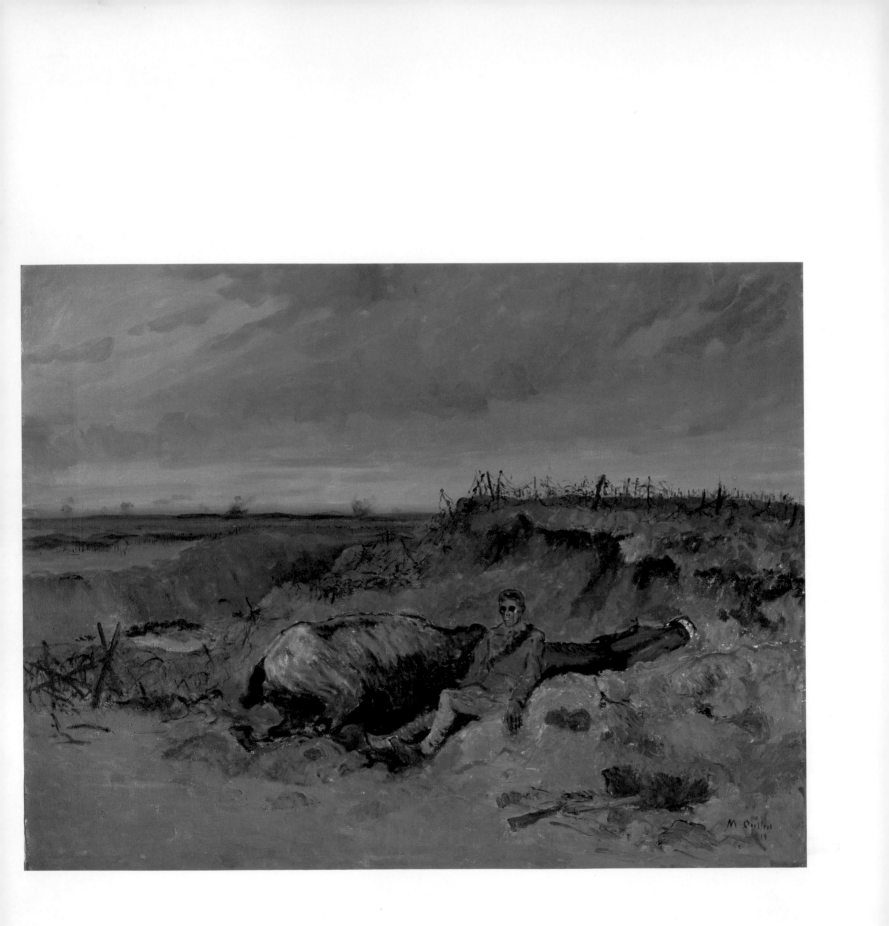

HELL'S CORNER

bursting over me and I couldn't see where I was going. All of a sudden, my foot slipped on the slippery plank and I went right into a muddy hole." Ross found himself up to his neck in freezing mud. "Other fellows came across, but they ran and took no notice as I shouted to them. At last, two fellows came with a rope and hauled me up and lay me on the muddy ground." Then, he said, he had three buckets of water thrown on him "and was left there. I was choking with gas and couldn't see." Men had to struggle merely to survive; that they had to fight was almost inhuman. Corporal Tom Walker wrote his fiancée that "I couldn't smell the gas at all and felt no effects at all . . . All was well till I went to get up the next day," when he was very ill. Walker was fortunate to be evacuated at once.

Others had much worse luck. Stretcher-bearers could scarcely function in the gloppy mud, and it took four and sometimes six men to carry one wounded soldier. Frequently, it was several days before the seriously wounded could be evacuated. Only the "walking wounded" had much chance of getting to the rear, and at night, the only time that movement was remotely safe from enemy fire, the slippery duckboards were especially treacherous for weakened men. One soldier wrote that "the exposure and suffering here would make your blood run cold, and in lots of cases where the wounded are unable to get out themselves, they lay in the mud and eventually die of exposure." The dead were often buried where they fell, and few records were kept. "It was impossible to carry corpses out over those miles of trench mats," Private Becker recalled. Countless other Canadians simply disappeared into the Passchendaele mud.

On October 30, the attackers moved the line forward a further thousand metres, sustaining another 2,300 casualties in a cold rain that made the survivors wretched. Major George Pearkes of the 5th Canadian Mounted Rifles, at the extreme left of the Canadian attack, led his company against the fortified position at Vapour Farm. Though wounded in the thigh ("Now I've got it," he said to himself), Pearkes forced himself to keep going. His men followed, braving enemy machine gun fire. Then the company commander ordered his troops to use their bayonets to drive the enemy from Vapour Farm. With survivors from another company, Pearkes, his fifty men and two Lewis guns held the position against repeated counterattacks and bombing from the air. Relieved that evening, Pearkes was awarded the Victoria Cross. "Our men cannot be beaten," he told his mother in a letter he wrote while being treated at the casualty clearing station.

LEFT: The Newfoundland-born Montreal artist Maurice Cullen gruesomely captured the cost of war in *Dead Horse and Rider in a Trench*. (CWM Cullen 8140)

For his part, the PPCLI's commanding officer scribbled a note to his wife that he was "hanging on. Our attack was successful, but both it and holding have been awfully costly. Haggard, Papineau, Sulivan, Agar, Almon, Riddell, Williams, Morris, MacKenzie, killed. Wounded, McKay, Lalor, Beeston, Gibson, Pike, Robins, Stevens, Reynolds, Macartney." Those were only the officer casualties. The next day, three more officers were killed and three wounded. Only 160 men of the regiment survived unhurt on November 2.

Currie visited the brigades that he had designated to continue the attack. "I promise you," he told the men, "that you will not be called upon to advance—as you never will be—until everything has been done that can be done to clear the way. After that, I leave it up to you with confidence." In fact, the general had insisted on waiting six days before undertaking the next phase, allowing time for the brigades to be brought forward, acclimatized and carefully prepared. Men studied relief maps, rehearsed over taped ground and listened to repeated briefings. At the same time, the artillery also could move forward to new positions. Fortunately, the rain ceased and the ground firmed up somewhat.

On November 6, however, the weather was still cold and miserable. The 1st and 2nd Divisions attacked at high speed, advancing so quickly that the enemy gunfire fell behind them and the Germans had no time to get out of their bunkers to man their machine guns. Corporal H.C. Baker of the 28th Battalion got into Passchendaele village itself, where he found "the shell-exploded bodies were so thickly strewn that a fellow couldn't step without stepping on corruption." The Canadians losses were heavy: "Our boys were falling like ninepins," Baker added, "but it was even worse for them. If they stood up to surrender they were mown down by their own machine guns aimed from their rear at us; if they leapfrogged back they were caught in our barrage."

But at least it was over, and Currie was exultant—both the attacking divisions "taking all their objectives on time." The ruins of Passchendaele were in Canadian hands in under

three hours and, although there was one more attack on November 10 and enemy counterattacks and gunfire continued, Currie's corps had done its job. Georges Vanier of the 2nd Division's 22nd Battalion noted that he spent twenty-four hours in the rubble of Passchendaele village under continuous bombardment. Then, "we returned to the rear, marching in mud up to our waists," Vanier said. "The more I think of our assault," Lieutenant-Colonel Agar Adamson said, "the more wonderful it appears, we were given the impossible to do and did it."

The casualties overall were almost precisely the number that Currie had predicted. Passchendaele was worthless ground; certainly it was not worth the death and maiming of one Canadian, let alone sixteen thousand. Sir Robert Borden, in London for a prime ministers' meeting the next year and well briefed by Currie, told the British bluntly that "if there is ever a repetition of Passchendaele, not a Canadian soldier will leave the shores of Canada." He was right. That the Germans had quickly retaken Passchendaele in their spring offensive in 1918 made the losses even more unsupportable.

Nonetheless, that the Canadians had taken Passchendaele was a confirmation of their unquestioned status as elite troops. Bragging just a little, Arthur Currie wrote that "the Canadians were the only troops that could have taken the position at that time of the year and under the conditions under which the attack had to be made." It may even have been true; certainly, after Vimy, Hill 70 and Passchendaele, the Canadian Corps, like the Australian Corps, had won the dubious right to be in the forefront of every major attack. Fighting with their own methods, adapting and learning from friend and foe alike, the Canadian Corps became the premier formation on the Western Front. A French correspondent, writing after the Hill 70 fighting, said that "one Canadian is worth three Germans." Few men in the Canadian Corps would have believed this hyperbole. Nonetheless, the Canadians' victories were an astonishing achievement for a country of just eight million people, a tribute to the hard-won professionalism of the officers and men of the Canadian Expeditionary Force.

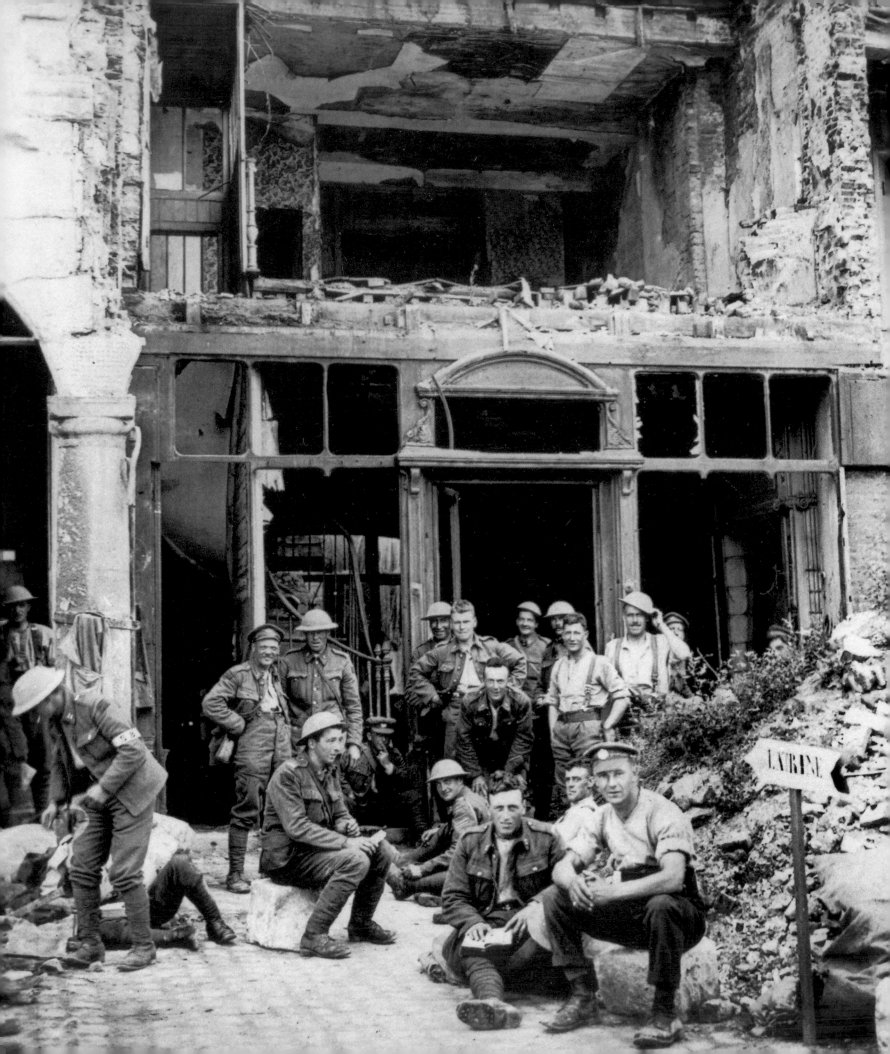

7 | WINNING THE WAR

LIEUTENANT-COLONEL GEORGE PEARKES, V.C., the commanding officer of the 116th Battalion, heard the shells explode on September 17, 1918. He hurried to see if any of his men had been wounded. His battalion had been in the thick of the fight since the Canadian advance began on August 8, and Pearkes, a fearless, conscientious commander, worried about his soldiers. Then more German shells landed, the explosions spewing shrapnel that hit the Victoria Cross winner in the arm and side. Taken by ambulance to the casualty clearing station, Pearkes's life hung in the balance. A private from the 42nd Battalion, at the station for treatment of a sprained ankle, was told he "had the type of blood required" to give Pearkes a transfusion. "I said, go ahead," William Carmichael recollected. "The nurse made a slit at my right elbow and drew two tumblers full of blood, then gave me a good shot of brandy." This was the fifth time Pearkes had been wounded, and although it was a close run, he survived again. A blood transfusion and good surgical care saved his life, one indication of the advances in medical treatment spurred by the war and another example of the Canadian Corps' efforts to ensure that its men received the best available care.

THE CANADIAN CORPS that crawled out of the mud of Passchendaele was battered but still a formidable force. Its four divisions had retained three brigades, each with four battalions. British divisions were about to be reduced to three three-battalion brigades in an effort to conserve men while retaining the same number of (weaker) divisions. A Canadian division had more men than a comparable British unit—21,000 versus 15,000—and in infantry, the Canadians had 12,000, compared with 8,100 for the British. The Canadian division had twice as many engineers; one machine gun for each 13 men, compared with

The Fort Garry Horse participated in the British attack against Cambrai in December 1917.

BELOW: Lieutenant Harcus Strachan won the Victoria Cross for leading the Garrys against German guns and then fighting his way back to British lines. (National Archives of Canada PA-002516)

RIGHT: Lieutenant Strachan (in the forage cap) rides at the head of his squadron. (National Archives of Canada PA-002515)

British units, which had one for each 61 men; and more trucks, more guns and more heavy mortars. The Canadian Corps also had a more efficient system for controlling its guns, the general officer commanding the artillery able to command and coordinate the use of the weapons; in a British corps, the chief gunner's role was more that of an adviser. Canadian counter-battery gunnery, which destroyed enemy artillery before and during attacks, was also the best on the Western Front. (As historian Shane Schrieber has noted, Andrew McNaughton, Harry Crerar and Alan Brooke all worked in the Canadian counter-battery organization. McNaughton and Crerar would command the First Canadian Army in World War II, whereas Brooke was to become chief of the Imperial General Staff.)

Essentially, thanks to Currie's emphasis on putting firepower first and constantly seeking better ways for his corps to operate, the Canadians had more of everything and, cru-

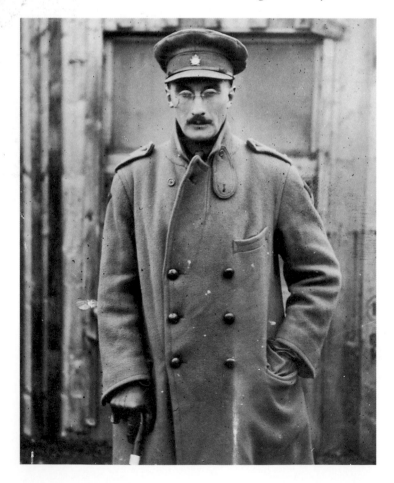

cially, better systems in place to use what they had. The corps' divisions also had become used to working with each other, generally following the same battle doctrine. British corps, however, were more like administrative formations and did not stay together very long. Moreover, once the 5th Canadian Division in England was finally broken up, as it was in 1918, the Canadian Corps had the reinforcements needed to carry it through the next rounds of heavy fighting.

The British in early 1918 proposed that Currie divide the corps in two, creating an army. Despite the promotion to general that would have accompanied that, Currie refused. "Will the new organization increase the fighting efficiency of the Canadian Corps in France?" he asked in a letter to one of his brigade commanders. His answer was that it would not. If the corps was divided in two, it would be weakened, and to Currie, the key was that "to preserve our hitting power at its maximum the Canadians must be under one command." The entire proposal, he believed, was being pushed by officers in England who hoped to gain commands at the front at last. He would not permit this.

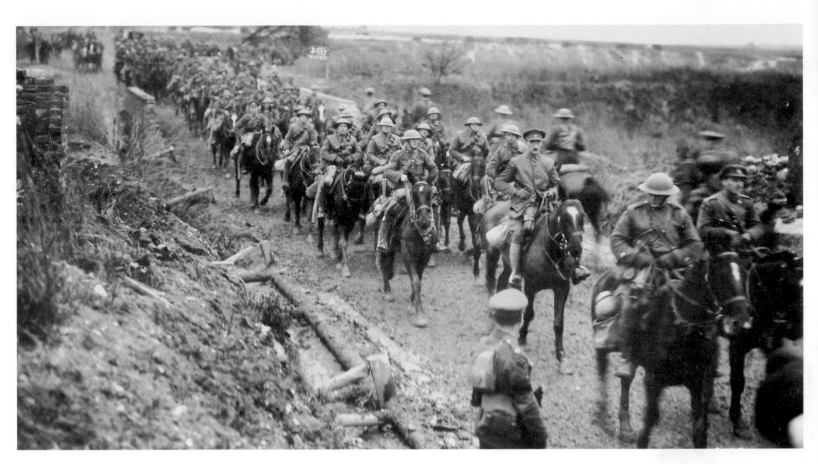

Nor would Currie willingly let his corps be broken up to be scattered among a number of British armies. In March 1918, Germany launched a series of massive attacks that drove into the Allied lines. These powerful assaults smashed whole armies and sent the Allied line reeling backward. The Canadian positions were not the target, fortunately for the men of the corps, but Field Marshal Sir Douglas Haig asked Currie to let his divisions be used to reinforce the line elsewhere. Currie was ready to see the corps used as a whole, but as a national commander responsible to the Canadian government, he would not agree to his men being scattered in two British armies and into three corps. Haig grumbled that "some people in Canada regard themselves rather as 'allies' than fellow citizens in the Empire," but Currie was absolutely correct, though he was unable to prevent the 2nd Canadian Division's assignment to a British corps. The Canadians simply fought better together and under commanders they trusted.

Thus the Canadian Corps, based in the Vimy area, was spared the heavy fighting that dominated the Western Front from March to June 1918. It was a difficult time; the British and French positions in Belgium and France were in jeopardy, and Russia was now under the control of the Bolsheviks and suing for peace. Yet, curiously, the Canadians were away from it all, based in a quiet sector and devoting themselves primarily to shoring up their trenches, which threatened to collapse in an unusually warm January, and to training.

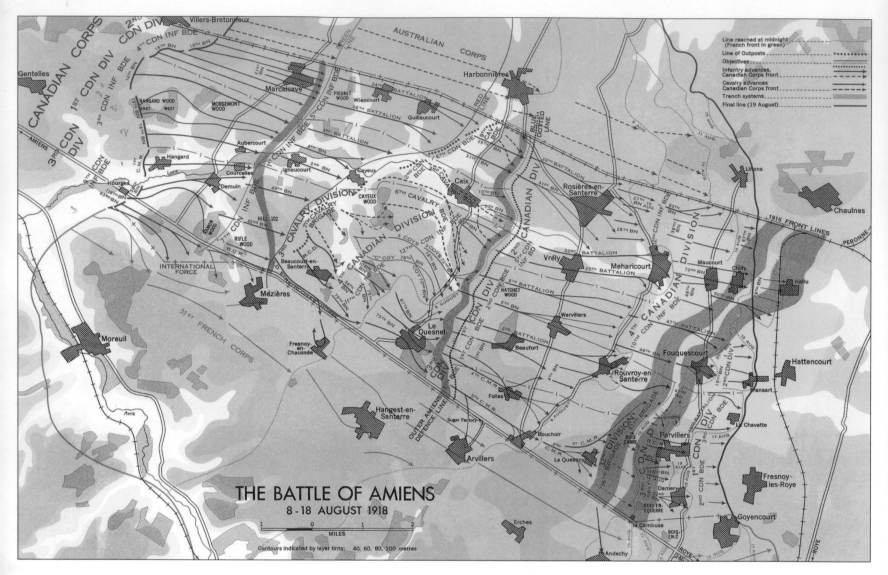

THE BATTLE OF AMIENS
8-18 AUGUST 1918

Contours indicated by layer tints: 40, 60, 80, 100 metres

Courtesy Directorate of History and Heritage, National Defence Headquarters, Ottawa.

Brooke Claxton, serving with the 10th Canadian Siege Battery at Vimy that month, lived with his gun crew in an old German dugout "about 6m deep, with two stairways, gas curtains over the entrance, an outside washhouse and wood-lined walls," wrote his biographer David Bercuson. "Off the trench leading to the gunpit, the men prepared a club-room with tables, chairs and an open fireplace … listened to a gramophone and played cards constantly." German trenches and dugouts were almost invariably deeper, drier and better constructed than any Allied trench lines. Claxton, later a Liberal politician and Cabinet minister, was extraordinarily lucky.

There were constant casualties, the usual "wastage" in the front lines, but the losses were nothing like those at Hill 70 or Passchendaele. The relative quiet allowed the Canadian Corps' battalions to recuperate and train, especially on the infiltration tactics the German "stormtroopers" had employed with such effect in bypassing British strong points.

Organized into almost autonomous platoons grouped around machine gun sections, the troops practised the use of their automatic weapons in the attack and experimented with a new "diamond" formation, and the corps' commanders worked to maximize the effectiveness of all arms—armour, artillery and infantry in combined arms operations in open warfare. Another special effort was made to improve the time it took orders to be issued and disseminated. An operation like Vimy had required months of preparation. Currie wanted to see the orders he issued reach the infantry platoons in three to eight hours, something that only superbly trained staffs and soldiers could do. The Canadian Corps, as it prepared for its greatest contribution in the Great War, had these men.

THE ALLIES' GREAT BLOW at the Germans had been set by Marshal Ferdinand Foch, the soldier appointed to lead all the armies on the Western Front when the enemy struck in the spring of 1918, for August 8. The Canadians, alongside the Australian Corps and a British Corps, were to attack east from Amiens. So secret were the plans—so fearful were the Allies that if the Canadians and Australians were discovered, the Germans would guess the direction of the advance—that Currie sent medical units, signallers and two infantry battalions into Flanders to pass meaningless messages back and forth. The deception scheme apparently worked: the concentration of tanks passed unnoticed by the Germans. Just as important, the massive logistical effort involved in moving the Canadians to the command of a new British army in a different part of the battlefield—and getting supplies to it—succeeded.

What gave the attackers even more confidence was that the Germans, moving westward for six months and with many soldiers suffering from the "Spanish flu," had not had the time to fortify their lines in their usual all-but-impregnable way. The enemy organized its defence in depth, but this time there were no concrete pillboxes. Moreover, German losses had been huge since March, and as a result units were understrength and some were on short rations. All the powers except for the United States had begun to scrape the bottom of the manpower barrel, but Germany was in especially serious trouble.

The attack moved off in heavy mist and chemical smoke at 4:20 in the morning. The weather was good, the ground firm. Most of the infantry had had a long march to get into position on August 7, and, although men were tired from their heavy loads, all were keyed

up. The guns had done no long softening-up. Instead, the attack was a surprise, the storm of artillery coming only as the infantry and tanks moved off. The tanks, concentrated a thousand metres back of the line, revved up their engines only twelve minutes before the assault time; aircraft buzzed the enemy trenches to camouflage the roar and so preserve surprise. Three divisions were involved, each moving with one brigade in the lead, the men using the tactics they had practised in bypassing strongpoints whenever they could and heading to their objectives. A fourth division was in near-reserve, ready to overcome tough resistance.

The attackers were led by infantry scouts in an extended line; tanks then followed, and behind the armour came three waves of infantry. Padre Frederick Scott was with the 16th Battalion as the advance began, and the commanding officer, Lieutenant-Colonel Cyrus Peck, v.c., told him: "If anything happens to me don't make any fuss over me; just say a few words over me in a shell hole." "You will be all right, Colonel," Scott replied. "There will be no shell hole for you." The padre was right, but Colonel Peck's piper was killed a few minutes later. "Piper Paul killed beside me," the colonel noted laconically. "B[attalio]n moved steadily ahead." Scott himself soon took three prisoners, something padres were not supposed to do. At least, those prisoners survived. Robert Graves, the British poet and classicist, noted in his war memoir that Canadians had "the worst reputation for acts of violence against prisoners" and that many "made atrocities against prisoners a boast, not a confession."

Unusually, the German defenders all but melted away. The Canadian battalions pressed forward, reaching the River Luce and, as engineers quickly threw pontoon bridges across it, making for the other bank. Although the Germans still could dominate the air in some sectors, huge numbers of the newly named Royal Air Force's aircraft flew over the lines, strafing enemy strong points. Small, fast tanks, Whippets armed with four machine guns, sped ahead to scout enemy positions and shoot them up. Heavier tanks accompanied the infantry, crushing the barbed wire and firing at enemy machine gun posts. But of the 342 Mark V tanks, huge beasts more than two metres high and four metres wide, that crossed the line on August 8, only six were still able to move four days later; the Germans had learned anti-tank tactics and developed specialized weapons that destroyed many. "We passed two large tanks that had met direct hits and were blazing merrily," recalled Pri-

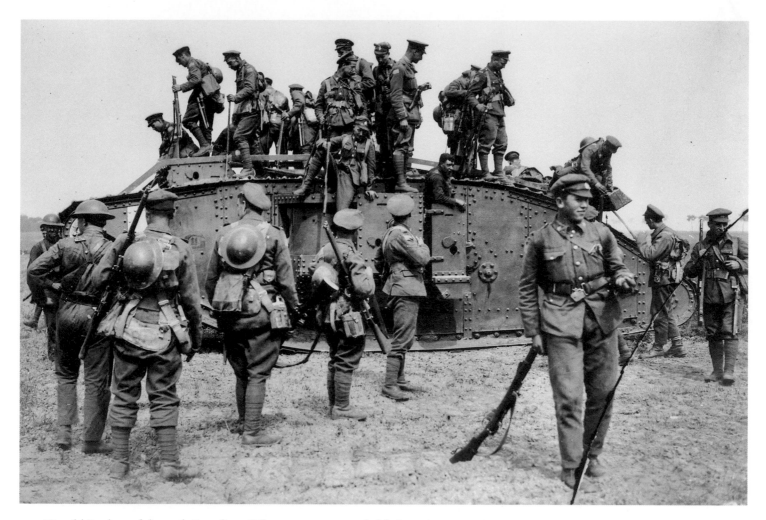

vate Harold Becker of the 75th Battalion. "The crews were probably burning to a crisp inside but we could do nothing for them." Mechanical breakdowns were also common, and poor support from the infantry—not all as well trained as they could have been—doomed others. Many tanks were immobilized when the foul petrol fumes from their engines sickened the crews. The 4th Division actually used tanks as rudimentary armoured personnel carriers, each tank supporting the 12th Brigade by carrying fourteen men and three machine guns inside the hull. Sadly, the infantry also fell prey to tank fumes.

Unhappily, the barrage did not keep up with some of the infantry, so fast were the men moving. When the gunfire fell on its objective, it killed many Canadians. As a result, the 10th Battalion suffered 40 per cent of its casualties on August 8 from what a later age would call "friendly fire." The Germans in a position code-named Croates Trench showed white flags to troops from the 3rd Brigade, but, as Brigadier-General G.S. Tuxford reported, "Upon our men advancing they were met with heavy fire again, and the fight recommenced. Two white flags were soon displayed by the HUN, but this time our men took no notice and practically exterminated the garrison."

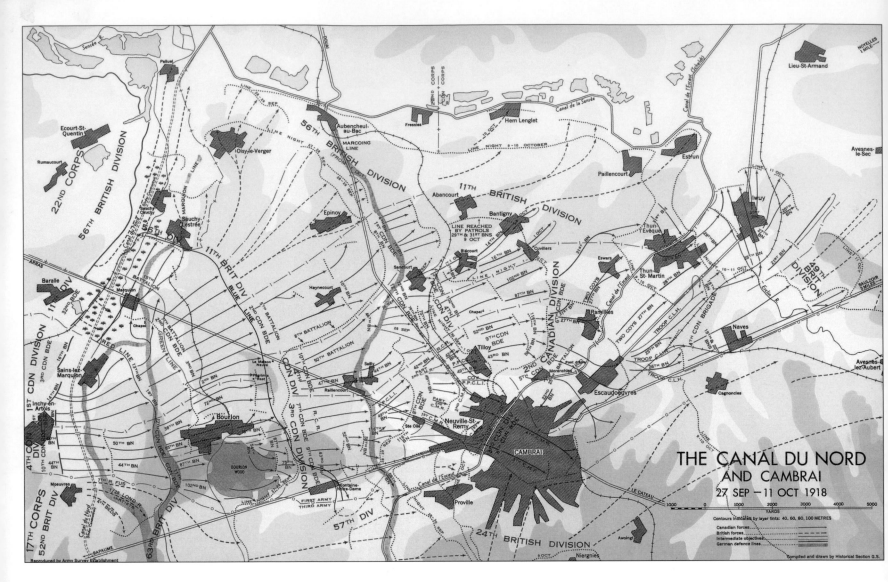

THE CANAL DU NORD
AND CAMBRAI
27 SEP – 11 OCT 1918

Courtesy Directorate of History and Heritage, National Defence Headquarters, Ottawa.

Some Germans were overrun almost before they could react. The 116th Battalion of the 3rd Division attacked Hamon Wood and found enemy artillery unaware of their danger. Some of the gunners, the battalion report said, "fought to the finish, firing with open sights, on the advancing infantry until surrounded." But Canadian fire brought the survivors to their senses. "Consequently, a record capture of enemy guns was made, and the survivors . . . came streaming forth and marched to the rear, led by their officers."

Almost everything had unfolded as planned. With the sole exception of the 4th Canadian Division's intended capture of the hamlet of Le Quesnel, the corps took all its objectives and made an extraordinary advance of twelve kilometres. By early afternoon, cavalry went into action to exploit the victory, the 3rd Cavalry Division, led by the Canadian Cavalry Brigade, charging forward. It was a slaughter; the German gunners fired into the massed horses and men. Harold Becker saw the cavalry going in. "Our

fellows stood up and almost cheered," he wrote, watching the "horsemen... running down groups of the enemy." Perhaps it seemed different from a distance. "Pennants fluttering," a Royal Canadian Dragoons officer wrote, "the regiment rode into a regular storm of fire... hell bent for election... swords drawn and yelling like mad." Only about fifty men in the squadron survived, and almost all the horses were killed. It was magnificent, but it was no longer war.

On the ground, the corps' soldiers exulted in the day's events. Major A.P. Chattell of the 49th Battalion wrote: "Our casualties have not been very heavy... The battalion captured about nine guns, twenty machine guns and some 200 prisoners—not a bad morning's work." In fact, the corps' casualties were high—3,868 killed and wounded—but the gains had been real, and for the first time, soldiers and commanders alike believed that the Germans were now just hanging on. The enemy suffered 30,000 casualties on August 8, some 20,000 men being taken prisoner. The Canadians alone accounted for 5,000 prisoners.

For two days more the Canadians continued their advance, the enemy resistance gradually strengthening and becoming fierce. The heavy artillery had not yet caught up with the advance; the aircraft were elsewhere, and most of the tanks had broken down or had been destroyed. So it was with rifles, grenades and machine guns that the Canadians struggled in the heat, fighting to clear strongpoints and then battling against counterattacks. Still, there were amazing events. The 31st Battalion, attacking the railhead village of Rosières-en-Santerre in daylight on August 9, ran into heavy machine gun fire and suffered many casualties. But the battalion took the town, including every one of the 527 Germans on a troop train that arrived at the railway station in the midst of the fighting. That night, soldier Louis Lent of the 31st wrote in his diary that he'd had nothing to eat all day and was exhausted, "but it was the greatest day I ever saw."

As the infantry advanced, the artillery tried to keep its guns moving forward, while the Canadian Army Service Corps tried desperately to supply shells and rifle ammunition, food and water and to meet the myriad demands of the army. By nightfall on August 10, his units having absorbed several thousand more casualties, Currie called a halt. The battles at Amiens, which officially ceased on August 20, cost 11,725 Canadian casualties. This was comparable to the losses at Vimy in April 1917, but the effects of Amiens, as well as the gains, were far greater. The corps' operations on August 8 and after had been

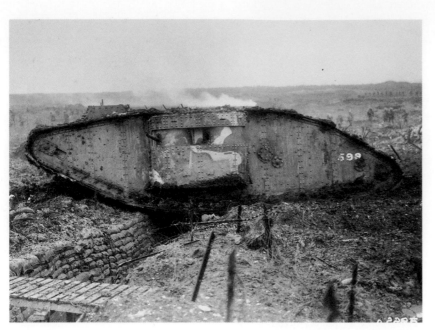

a near-perfect combination of infantry, armour, artillery, deception and air support. That General Erich Ludendorff, the brains of the German Army, later called the attack at Amiens "the black day of the German Army in the history of this war," only confirmed the corps' accomplishment.

The Canadian Corps soon moved north to Arras to ready itself for the next battle. The objective now was the Hindenburg Line, the well-fortified, brilliantly planned German defence barrier, and the city of Cambrai, which it protected. The Germans' defence in depth, line after line of carefully sited trenches and bunkers, made good use of natural barriers, notably the incomplete Canal du Nord. Given the nature of the ground and the operational situation, Currie had no chance of surprising the defenders. His tactic was a massive frontal assault that began at night on August 26, but the troops were hampered by having had too little time for preparation. George Pearkes, the commanding officer of the 116th Battalion, noted sharply that "there had been no opportunity for anyone to reconnoitre … and the time which could be devoted to explaining to the rank and file even the merest outline of the plan of attack was almost negligible." Pressure from higher up had obliged Currie to hurry his attack.

Nonetheless, the 2nd and 3rd Divisions led the attack, the first wave jumping off in full darkness at 3 AM. After eighteen hours of fighting, the divisions had taken Monchy-le-Preux, a key point in the enemy defences, and progressed a thousand metres beyond it. The plan for the next day called for a gain of eight kilometres and the breach of the German first line. This proved too ambitious—it took three days and six thousand casualties—but still the advance ground forward, until it came to the Drocourt-Quéant (D-Q) Line, an extension of the Hindenburg defences. Currie now insisted on a brief pause for rest and further planning, but the pressure from Haig's headquarters was relentless. The corps commander then sent his 1st and 4th Divisions forward on September 2. The 1st Division, the "Old Red Patch," its men called it, had the task of clearing the D-Q Line's support trenches and then breaching the Buissy Switch, a trench and fortification system protecting two small villages. The 4th Division had the task of breaking the main D-Q position.

A massive artillery barrage (ten thousand tonnes were expended from August 27 to September 2) cut the enemy wire. Armour rolled through, and the Germans folded—at first. The 1st Division took scores of prisoners, but the resistance increased and the brigades ground to a halt. The 4th Division took its objectives on time, but it too was soon stopped by intense machine gun fire. But the next morning, the surviving Canadians awoke to the realization that the Germans had withdrawn eastward. The corps had endured 11,423 casualties since August 26 and was reeling. The men and the staffs had to be restored and made ready to fight again, a process that took almost four weeks.

Now the Canadians faced the Canal du Nord, which was thirty metres wide, with steep banks protected by flooded marshes. The German bank was heavily defended with

BELOW: Private C.J. Kinross won the Victoria Cross and the right to have his portrait painted by war artist William Beatty. (CWM Beatty 8100)

RIGHT: The increasing use of technology in the Canadian artillery made it the best artillery on the Western Front. In this painting by Thurstan Topham, a "forward observation post" reports the fall of shot by telephone so that the gunners can adjust their aim. (CWM Topham 8862)

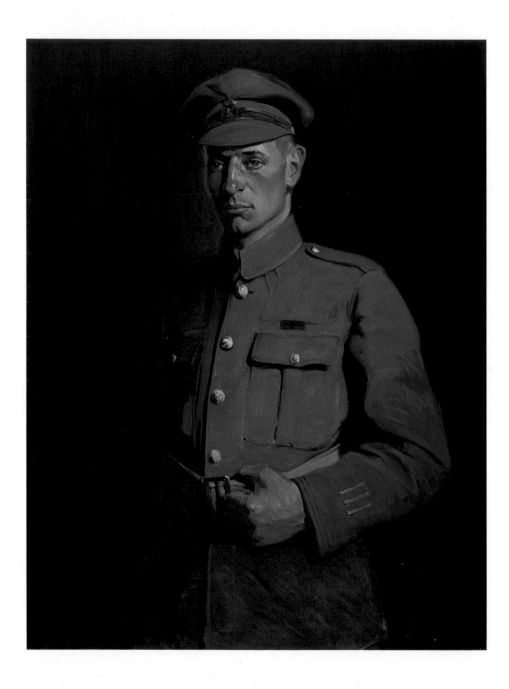

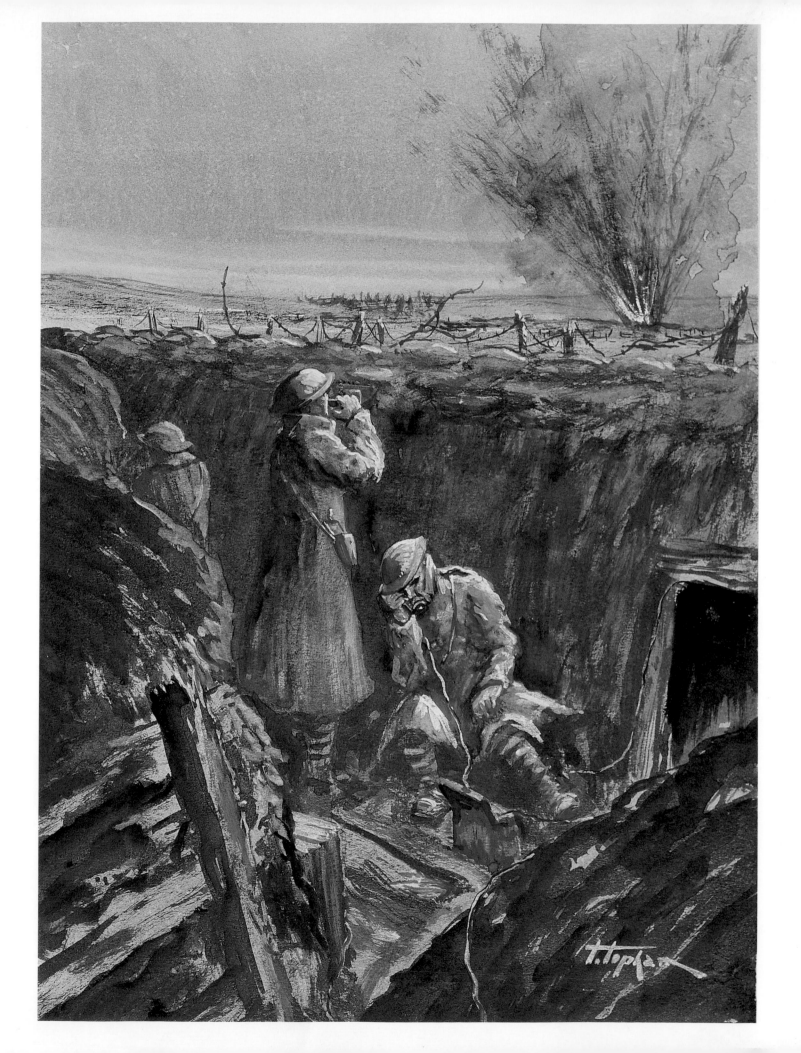

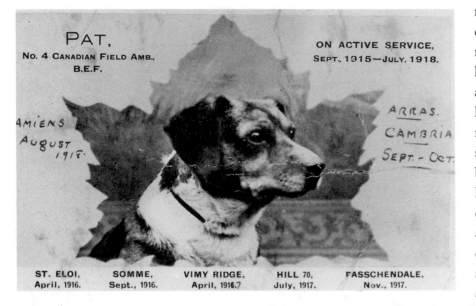

PAT,
No. 4 Canadian Field Amb.,
B.E.F.

ON ACTIVE SERVICE,
Sept., 1915—July, 1918.

AMIENS
AUGUST
1918

ARRAS.
CAMBRIA
SEPT. - OCT.

ST. ELOI,
April, 1916.

SOMME,
Sept., 1916.

VIMY RIDGE,
April, 1916.7

HILL 70,
July, 1917.

FASSCHENDALE,
Nov., 1917.

machine gun nests, well-prepared trench lines, cleared fields of fire and ample stocks of ammunition and gas. Even though German morale had sagged precipitously, the canal remained a formidable obstacle, and Currie puzzled over how to assault it. Then the Canadian commander and his staff realized that just to the south, a 2,400-metre section of the canal was both unfinished and dry, and the ground was less swampy. The Germans had readied their defences there too, but this was still a better approach than a defended water crossing. The difficulty was that Currie had to send fifty thousand troops through a narrow crossing point and, once they fought their way across the dry canal, fan them out over a front of up to fifteen kilometres under fire all the way.

This was a hugely complicated plan, one that Currie's army commander doubted the corps could accomplish. Currie was warned that if he failed, he would be sacked. But the Canadian nevertheless believed it was possible, though he spent a sleepless night worrying about the risks. His plan called for two divisions to cross the canal, the 4th then pressing on to clear Bourlon Wood. The 1st Division was to swing left after the crossing, freeing villages along the bank. If these two divisions accomplished their tasks, the front would stretch for some eight kilometres, room enough for the 3rd Division and a British division to move into the line.

The attackers jumped off on September 27 behind a huge barrage that included seventeen thousand gas shells. The commander of the 1st Brigade told his troops: "As you advance, more metal will be thrown over your heads on the enemy than in any previous action in which you have been engaged." It was true, and the infantry were also helped across the dry stretch of canal by engineers who provided scaling ladders to get them over the far bank. The engineers soon constructed ramps up and bridges over the Canal du Nord as well, greatly facilitating the efforts of follow-on units, artillery, tanks and heavy

equipment. The advance ground forward, the 4th Division facing enfilade fire, gunfire directed at the entire advance. After heavy casualties, the division cleared Bourlon Wood but could not reach its final objectives. Although the 1st Division met its goals, the fighting continued until the night of October 1. The enemy poured fresh troops supported by a heavy artillery barrage and what seemed like unimaginable numbers of machine guns into the struggle. The Canadian guns on October 1 alone had fired seven thousand tonnes of high explosive at the Germans, and (few Canadians realize this) the Canadian Corps was the major user of gas shells on the Western Front. Gas and high explosives broke the enemy will, and German troops surrendered in large numbers. "I could see the Germans

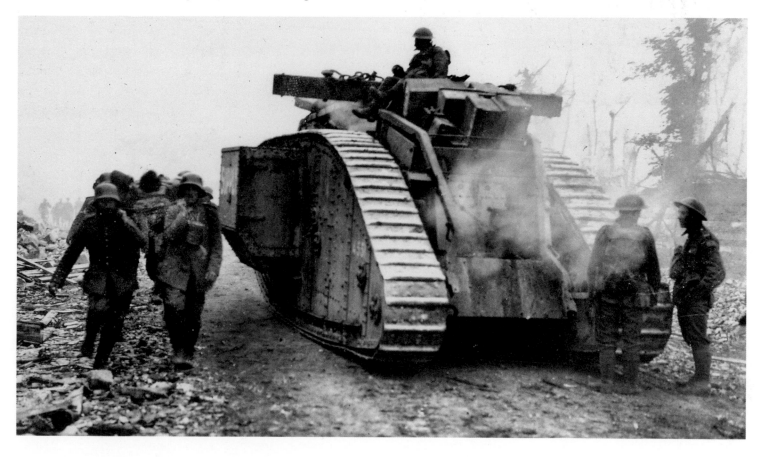

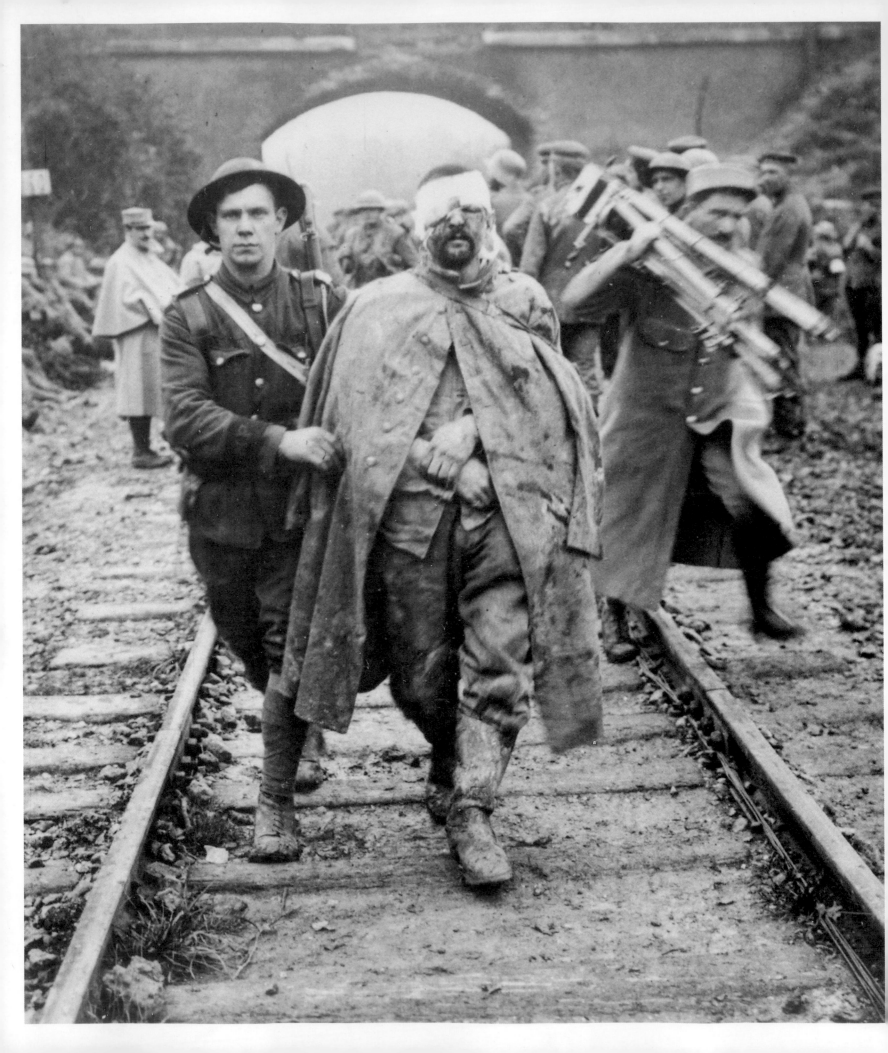

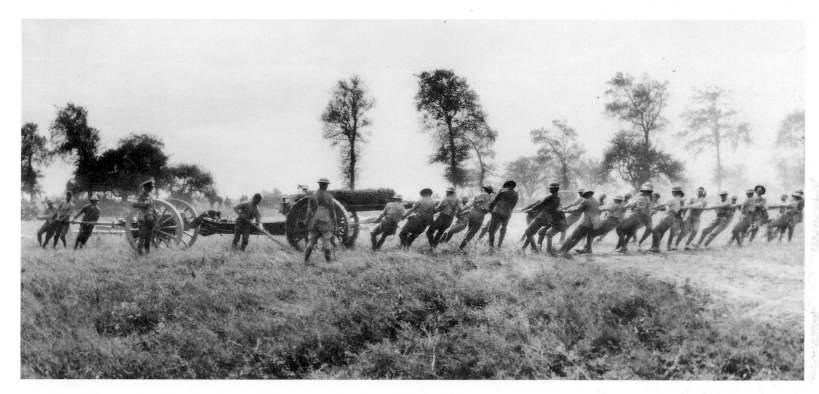

coming on the run toward our lines," one soldier remembered, "and lifting their hands to each man they met." Another reported hearing one prisoner shout in English, "You don't know it, but the war's over." Not yet, unfortunately. Currie finally called his men to a halt; the Canadians had taken the ground.

The battle for the Canal du Nord was arguably the single greatest achievement of the Canadian Corps. An all but impregnable position had been taken, thanks to an imaginative plan, almost flawless execution, massive fire support and the matchless courage of the Canadian soldiers. Everyone—infantry, artillery, armour, engineers, signallers, air support—had worked together, and the men on the ground, well-trained, well-briefed and well-equipped, had done their job. The raw recruits of August 1914 could not have carried out this operation, any more than the men of Ypres or of 1916 could have. Only experience, equipment, determination and leadership made the Canal du Nord operation possible.

But the cost in men was huge. Padre Frederick Scott, with the 8th Battalion, was talking to a Lieutenant Cope from Russell, Manitoba. "He was a splendid young fellow, and looked so fresh and clean. He had lost a brother in the Battalion in the early part of the war. I said, 'How old are you, Cope?' He replied, 'I am twenty.' I said, 'What a glorious thing it is to be out here at twenty.'" Cope had started to reply when he was hit in the head by a machine gun bullet that pierced his helmet. "He never recovered consciousness," the padre wrote, "and died on the way to the aid post."

The 10th Battalion of the 1st Division had been caught in a bungled barrage and sustained heavy losses. Three quarters of the officers who had crossed the canal were killed or wounded, and half the other ranks had become casualties. One lieutenant with good service to that point told his commanding officer: "I've had it. I can't take it no more ... This isn't war, it's murder. It's just pure, bloody murder." Brooke Claxton, in the artillery, did not crack, but he felt much the same as his battery suffered frequent casualties from German counter-battery fire. Death was "mean, mechanical [and] drab ... no heat of battle or any of the storybook stuff—just horribly inhuman."

The Canadian Corps' casualties since August 8 now totalled 31,000, close to a third of the corps' 100,000-man strength. This was an almost insupportable number. The 3rd Division in August lost 4,716 officers and men; the 4th Division in September took 7,352 casualties. With most of these losses falling on the men in the rifle companies, the battalions were literally on their last legs. Open warfare was proving even more costly than the trench struggles that had characterized the first three and a half years of war.

The 20,000 or so reinforcements from the break-up of the 5th Canadian Division had now been absorbed and spent. All that kept the Canadian Corps going were the conscripts, recruited under the terms of Sir Robert Borden's Military Service Act, who had begun to reach France. By mid-November, 47,509 conscripts had proceeded overseas and 24,132 drafted men had arrived at the front. These reluctant soldiers, who by all accounts performed satisfactorily, made it possible for the Canadian Corps' four divisions to carry on.

THE NEXT OBJECTIVE for all four divisions was Cambrai, the main German rail centre in northern France. Currie ordered his troops to cross the Canal de l'Escaut and cut the town off from the north on the night of October 8–9. Lieutenant Percy Wilmot of the 25th

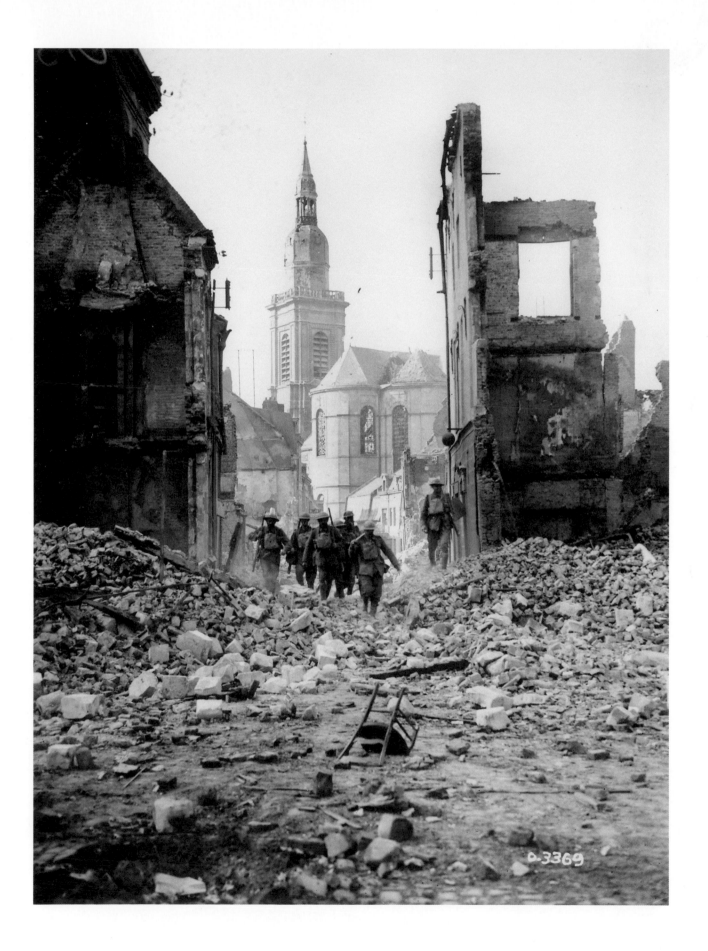

O-3369

BELOW: Alfred Bastien, a Belgian who painted the Canadian
Corps' actions, splendidly evokes the great victory parade in Paris.
His oil painting shows the Canadian Contingent passing by the
Arc de Triomphe. (CWM Bastien 8087)
RIGHT: Taking Cambrai, Canadians pause in one of the old town's
squares. (Photograph by William Rider-Rider, National Archives
of Canada PA-003270)

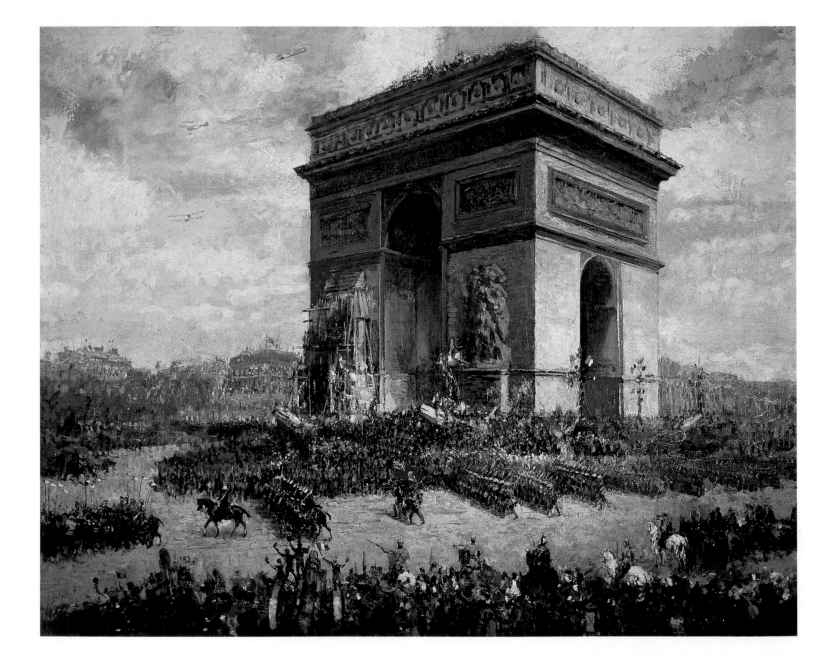

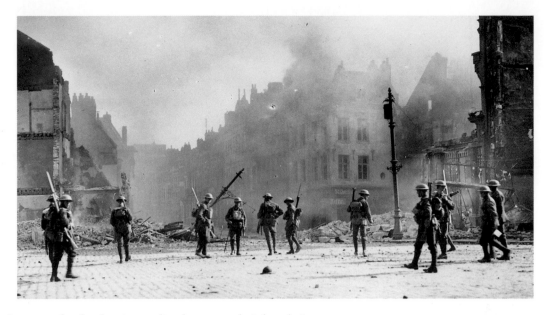

Battalion wrote to his family in Cape Breton that his unit was caught in the Canadian barrage just before reaching the canal, but he and his men got across. "I had not gone far, when I saw a number of Huns and these did not give me a chance to fire for they immediately put up their hands." A few moments later, he was wounded by a shell—getting him "this lovely 'blighty'"—and four of his prisoners carried him to the dressing station. Another soldier, Tom Held of the artillery, remembered his comrades rousting thirty or forty Germans out of a dugout. "Immediately all the troops make a wild dash for the souvenirs, tearing off buttons, badges, and belts to the resultant discomfiture of Fritz . . . He doesn't mind handing us his field glasses, his revolver . . . but he doesn't like to hand out his love letters."

The German High Command had already decided to abandon Cambrai and to withdraw eastward into its still incomplete defensive position, dubbed the Hermann Line. The Cambrai shambles of confused orders, bungled advances and misplaced gunfire suggested that even in the Canadian Corps, operations could go wrong. They also suggested strongly that the casualties of the last two months had taken a serious toll on the leadership cadres of the Canadian Expeditionary Force. Nonetheless, the blasted ruins of Cambrai, set on fire by special squads of enemy detailed for the task, were captured soon after dawn.

The pace was picking up, the Allies now moving eastwards at speed and outrunning their supplies. As the Canadian battalions liberated towns, the men were cheered. In Denain, "the local people covered us with masses of flowers and flags," one of the soldiers wrote, "laughing, clapping, shouting, crying." The Canadians' triumphal progress moved on to Valenciennes, the key point of the German defences. On November 1, the corps attacked the enemy lines under smoke and behind a huge barrage. Currie had called Brigadier-General Andrew McNaughton, who commanded the corps' heavy artillery, and told him, "The war must nearly be over now and I do not want any more fighting or casualties than can be helped." To this end, McNaughton had planned the barrage, using more than three hundred guns. Behind the gunfire, the 10th Brigade took Mont Houy, a long,

low ridge dominating the plains south of the city. McNaughton wrote later that "the most intense barrage in history" allowed "a single infantry brigade" to break through "a German key position . . . the Canadian Corps had paid . . . 'in shells and not in life.'" The disoriented Germans, staggered by the furious artillery concentration, surrendered in large numbers, and Valenciennes was liberated—at a cost of under four hundred casualties. The victory made the enemy positions untenable, and the Germans withdrew on the night of November 1–2, while the bulk of the corps bridged the canal to the west of the built-up areas.

The Canadians could now tell that the end was near. One soldier, A.W. Strudwick, recollected that "there wasn't much fighting . . . heavy fighting . . . When we got near [Valenciennes] they were surrendering in droves. We knew then that the enemy was practically breaking up."

True enough. The Germans were now desperately seeking peace, even as their allies surrendered. Following orders to keep up the pressure, patrols from the Canadian Corps continued to press forward. The advance units ran into machine gun posts that were plastered with mortar shells and into extensive demolitions, carried out with ruthless efficiency by the Germans and in a way that won them lasting enmity. Occasionally, a German unit, usually a machine gun company, might fight hard, but frequently the enemy retreated under cover of darkness. By November 10, as surrender talks progressed, advance units of Canadians were on the outskirts of Mons, Belgium, the site of the first contact between British and German troops in August 1914. The next day, at 11 AM on the eleventh day of the eleventh month, the Armistice came into effect—but not before one Canadian died and fifteen were wounded in liberating Mons. Private Price, the last Canadian to die on the Western Front, fell at 10:58 AM, killed by a sniper two minutes before the guns finally ceased fire. His remains lie in the British war cemetery at St. Symphorien, near Mons, close by the grave of Private Parr, the first British soldier to die in the Great War, on August 21, 1914.

At the front, the soldiers' reaction to the Armistice was muted. Belgian civilians, like those in Paris, London and Toronto, cheered themselves silly, but the soldiers, while relieved, seem to have felt little exultation. "I don't mind telling you now," Private Floyd White wrote to his mother on November 12, "that there was a time, not very long ago that I had given up all hope of ever seeing 53 New St. again." White had survived; but so many of his comrades had not, that there was little to celebrate. At least it was over.

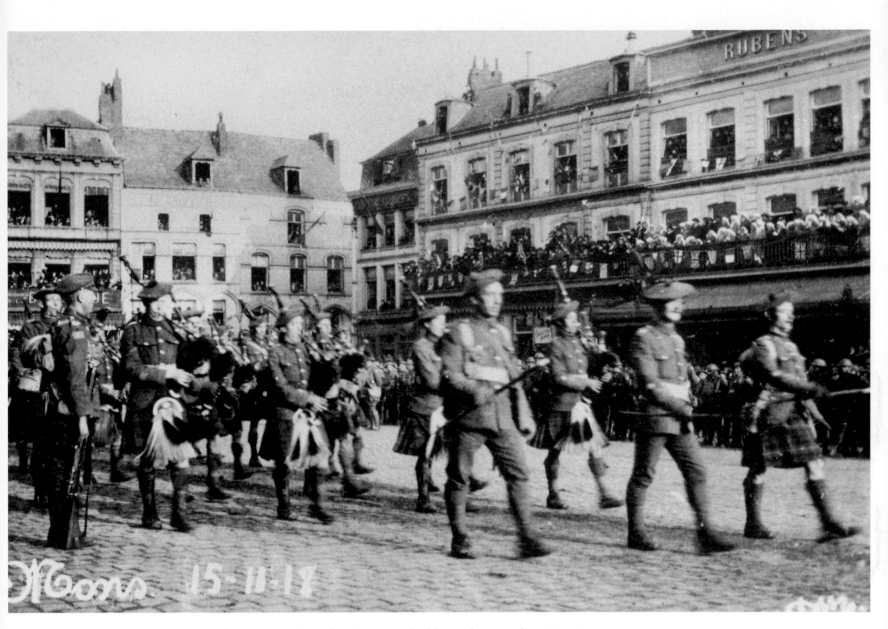

THE HUNDRED DAYS from August 8 to the Armistice had been the Canadian Corps' finest hour. It had faced and smashed German divisions wholesale, successfully assaulted enemy defensive positions of great strength and made a huge contribution to the Allied victory. A single corps of four divisions cannot determine the outcome of a great war, no matter how capable it is. But the Canadian Corps unquestionably played a disproportionate role.

Brooke Claxton wrote to his father just after the Armistice that he had learned from his service that Canadians were different from British troops. "We get into a hole & our feeling is 'come on boys, this—thing is in a hole. We've got to get into action as soon as possible so let's get it out and get to bed' & everyone jumps & pulls & heaves and uses his

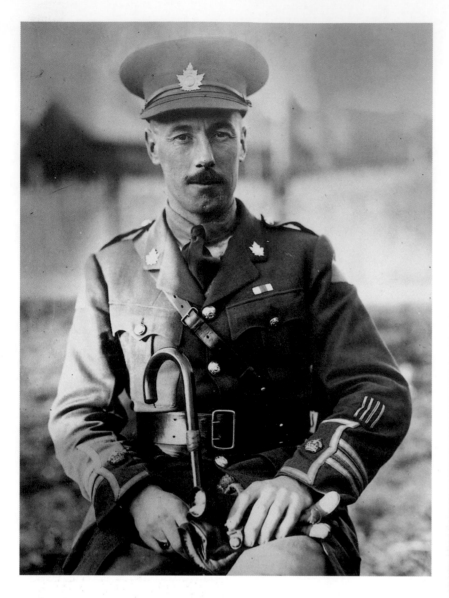

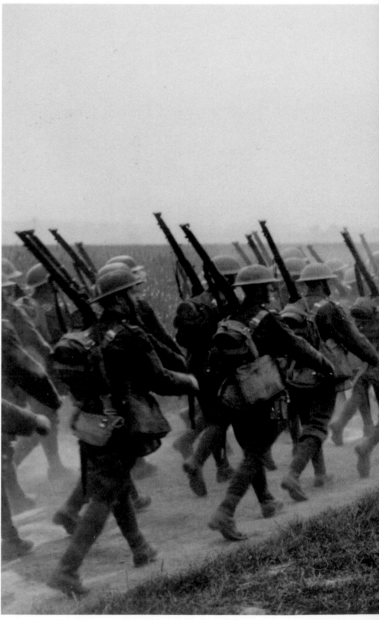

The war had been won by the soldiers of the Canadian Expedition-
ary Force and their commanding officers.

LEFT: The brave officers included George Pearkes. (National Archives
of Canada PA-002364)

BELOW: Prime Minister Sir Robert Borden and the Canadian Corps'
commander, Sir Arthur Currie, take the salute. (National Archives
of Canada PA-002746)

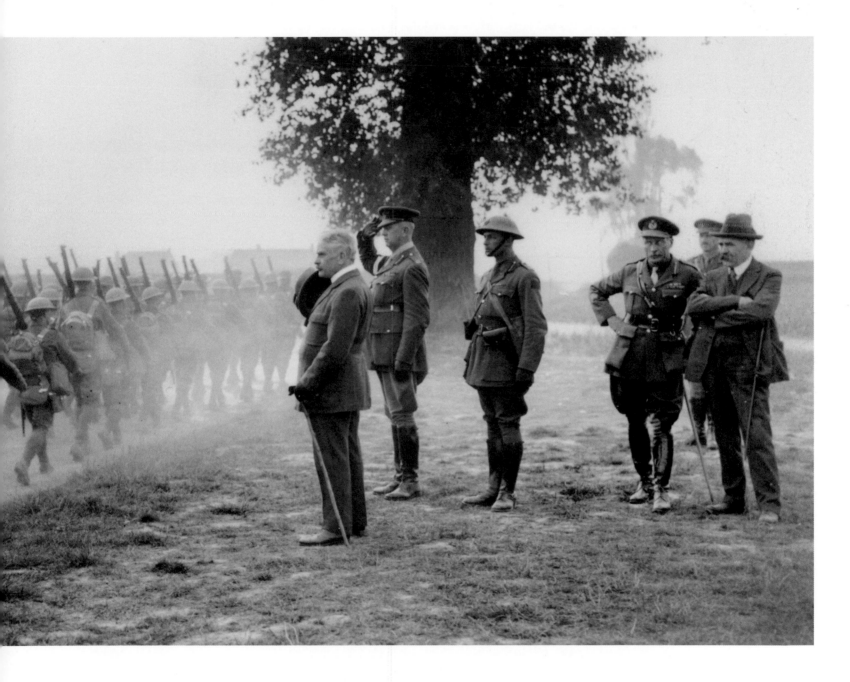

brains. The Imperial says 'fuck the fucking thing. I'm going to fucking well let it stay in the bloody hole' & it stays." The Americans, the French and the Belgians recognized this difference, Claxton claimed. The war was a nasty job that had to be done, and the Canadians did their part in extraordinary ways.

The casualties of the Hundred Days were also disproportionate. The corps suffered 45,835 men killed, wounded or captured, almost 20 per cent of all the Canadian casualties suffered during the war. This was 45 per cent of the corps' strength on August 8, 1918; to put this toll into perspective, the casualties of the Hundred Days were greater than the casualties suffered by the much larger First Canadian Army in its World War II campaign in northwestern Europe from D-Day to VE Day. Canada paid in full for its victories.

In the Great War, Canada lost 60,000 dead and 173,000 wounded of the 619,636 men and women who enlisted or were conscripted (not all of whom proceeded overseas to England or to the front). Consider what such casualty numbers meant for an infantry battalion. The 1st Battalion, an Ontario regiment in the 1st Division with an establishment strength of some 900, had 6,500 officers and men in its ranks during the war. The casualty toll was 49 officers and 699 men killed, and 126 officers and 3,055 other ranks wounded. The casualties totalled 3,929, although some of the combatants were undoubtedly wounded more than once. This was a casualty rate of *60 per cent* of all those who served in the battalion—a figure that would be higher if those who never made it to England or France or the front were counted. Very simply, to have served in the Canadian Corps was to have an almost certain chance of being wounded or killed. Almost no soldiers who enlisted in 1914—particularly in the infantry—survived unhurt until the Armistice.

Now the Canadians wanted to go home.

LEFT: The soldiers of the Canadian Expeditionary Force were mostly
ordinary men who performed extraordinary deeds. Not all won the
Victoria Cross, but all served well in hard times, surviving the defeats
and exulting in the victories. (*top left:* CWM 19760346-002, *top right:*
CWM 19820140-012 P.4B, *bottom left:* CWM 19780188-002 P.13C,
bottom right: CWM 19810649-028 P.64B)

BELOW: Liberated civilians welcome the incoming troops. (National
Archives of Canada PA-003547)

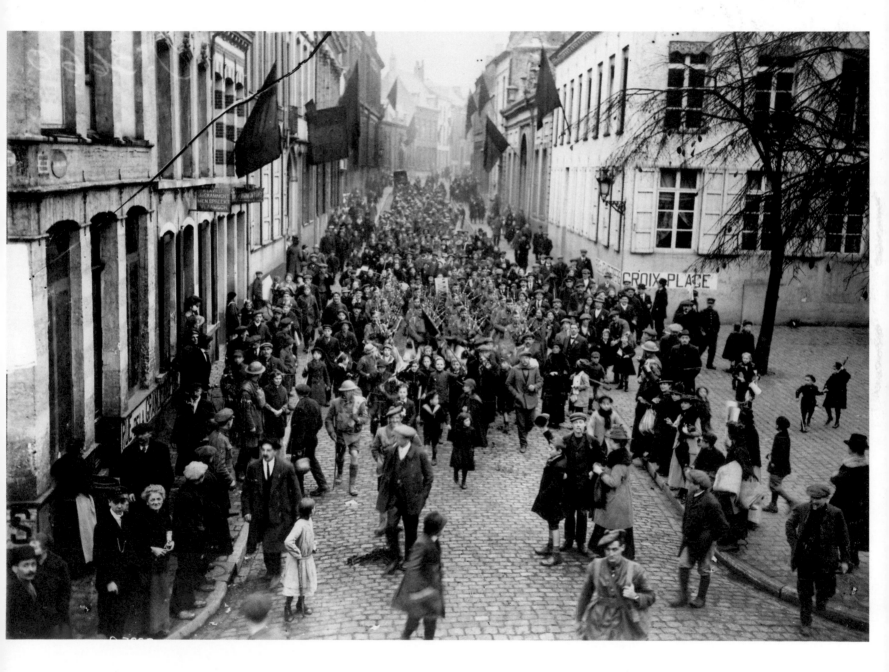

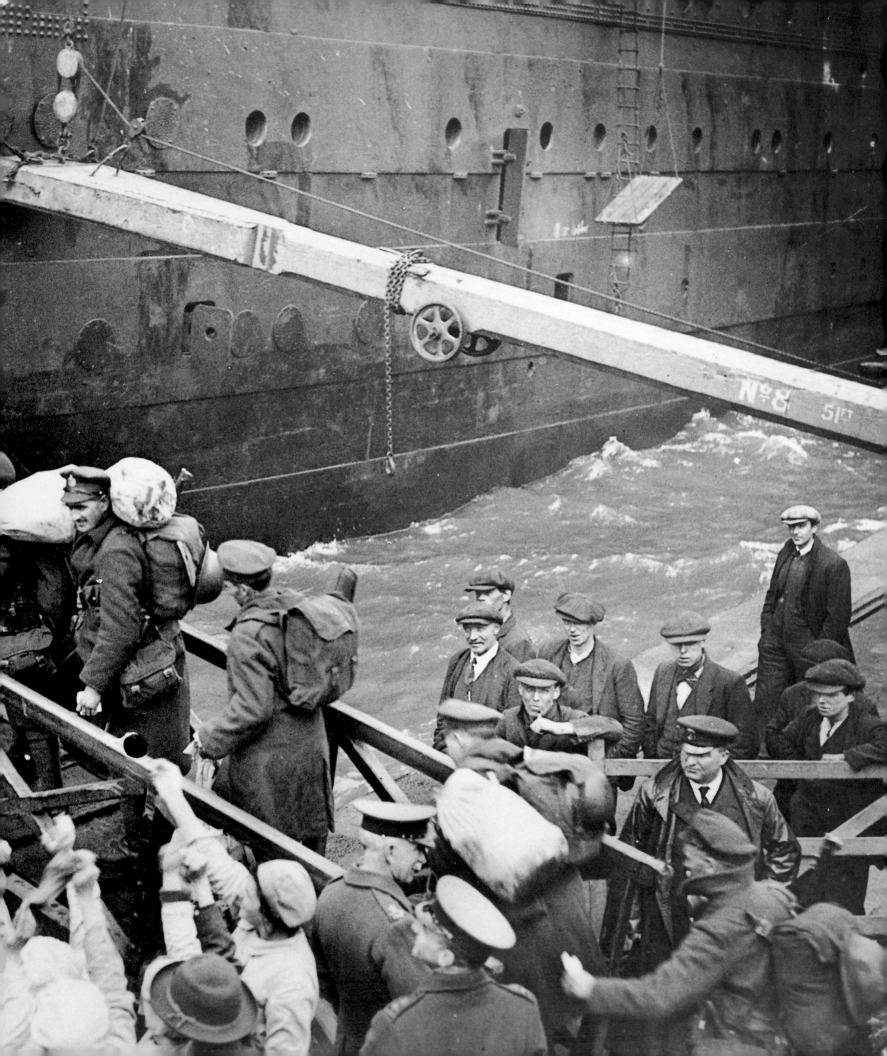

CONCLUSION

THE TASK OF RESTORING normal life after the Armistice was enormous. Much of France and Belgium was in ruins, eastern Europe was in chaos, great empires had dissolved. People were hungry, revolution was in the air and millions of soldiers, whether volunteers or conscripts, wanted only to return to their homes.

The Canadians were no different, but first they had duties to carry out. Under the terms of the Armistice, the Allied armies were to march to the west bank of the Rhine River and occupy a number of bridgeheads on the east bank. The Canadian march to the Rhine began on November 18, all four hundred kilometres in tactical formations and under military discipline lest German troops stage a surprise assault. The 1st Canadian Division headed to Cologne, the 2nd to Bonn. The 3rd and 4th Divisions remained in Belgium.

Marching through Belgium, the Canadians were met only with cheers. Once they entered Germany, however, the mood understandably was much colder. The Canadians understood: General Currie's order as they crossed the frontier on December 4 had cautioned them to remain "a close-knitted army in grim deadly earnest." The men were told to ensure they remained "that powerful hitting force which has won the fear and respect of your foes and the admiration of the world." On December 13, the troops arrived at their bridgehead positions.

The fierceness disappeared very quickly as the Canadians settled in and the Germans gave no trouble. Fraternization was frowned on but impossible to prevent, especially because most of the soldiers were billeted with the residents. Morley Willoughby, a Regina law student in the artillery, went off to Ostheim on the outskirts of Cologne to seek billets

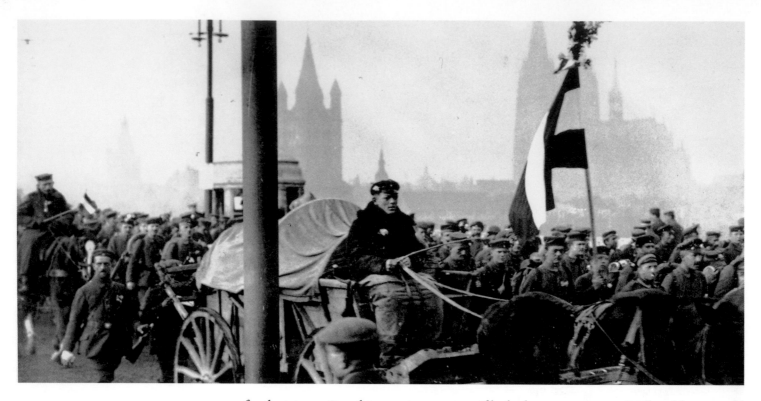

for the troops. On asking a mine manager if he had any extra rooms, Willoughby was told that the manager did have "a spare bedroom, which adjoined the bedroom occupied by his two teenage daughters. He said he was fearful of what might happen." According to his diary, Willoughby told him he need have no fear, "as the soldier would be Murray Cathcart who was perfectly safe. As a result, Murray had a first-class billet with a nice German family. The two girls did not come to any harm."

As that anecdote suggests, the occupation was benign, even polite. Soldiers quickly struck up liaisons with local women and many had affairs. The much-decorated Corporal Roy Macfie, one of the very few original combatants left in the 1st Battalion, met Maria Gessner, of Lohmar, and exchanged letters with her after he returned to Canada. Those letters "allude to promises made but not kept." Still, the time in Germany passed almost without serious incident. On January 17, 1919, Willoughby wrote in his diary, "Left Ostheim 10 AM. Receiving a good send off from the German civilians. The girls and young boys were lined up on the streets yelling and waving handkerchiefs."

The two divisions in Belgium had similar experiences with the locals. Some men took courses at the Khaki University, which was set up to teach high school and university curriculum. Others devoted themselves to sports. All hoped to get demobilized as quickly as possible.

Demobilization was a complex task, as the Canadian Expeditionary Force (CEF) overseas numbered more than 300,000 men. Ottawa initially suggested that men be "demobbed" on a priority basis, depending on time in service and marital status. General

Currie, however, disagreed. He wanted the army's fighting units to return home in formed units, not only so that the cities and towns that had raised the units might see them, but also because he feared that pulling individual soldiers out of the occupation forces might lead to a complete breakdown in discipline. There was much to-ing and fro-ing, much debate in the Cabinet, but in the end Currie won the day. The CEF units would leave Europe, proceed to England and then return to Canada. Of course, that depended on shipping, and troopships were in short supply. The Canadian railways were also in trou ble, and the best estimates were that no more than thirty thousand men a month could be carried from East Coast ports inland. Halifax, of course, was still operating under capacity after the great explosion of December 1917.

LEFT: The defeated German armies returned in good order to their home country. (CWM 19780188-002 P.53A)
BELOW: The victorious Canadians also wanted nothing more than to go home. (CWM 19780188-002 P.21E)

BELOW: Canada's greatest soldier, Arthur Currie, returned to Canada by the same means as his men. Here with his son, Currie was greeted coldly by a Canadian public that was already hurrying to forget the tribulations of wartime. He deserved much better. (CWM 19680113-001 Album 1 P.122F)

RIGHT: The first Canadian battalion to see action, the Princess Patricia's Canadian Light Infantry, returned to Ottawa in March 1919. (CWM 19840059-223 P.39A)

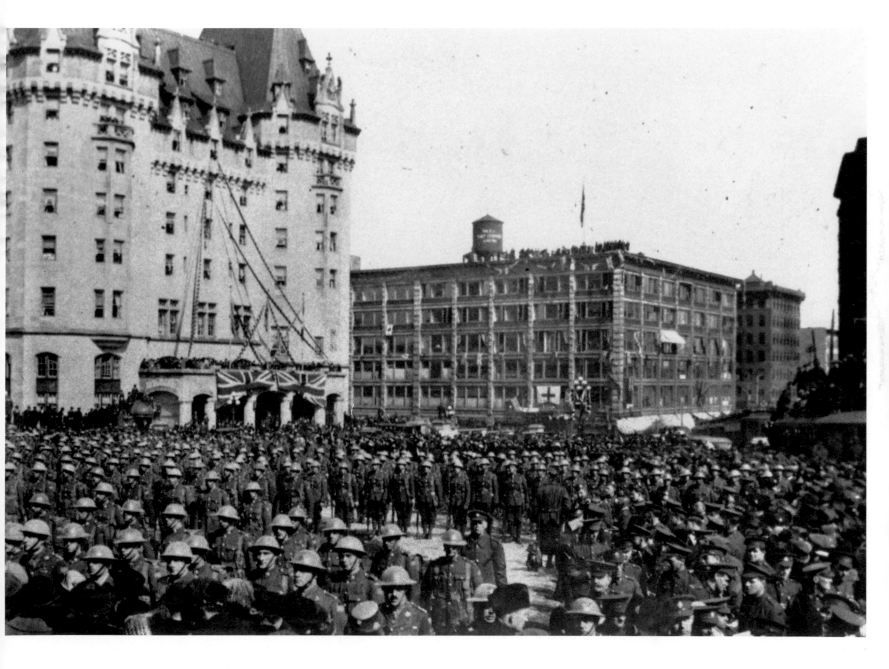

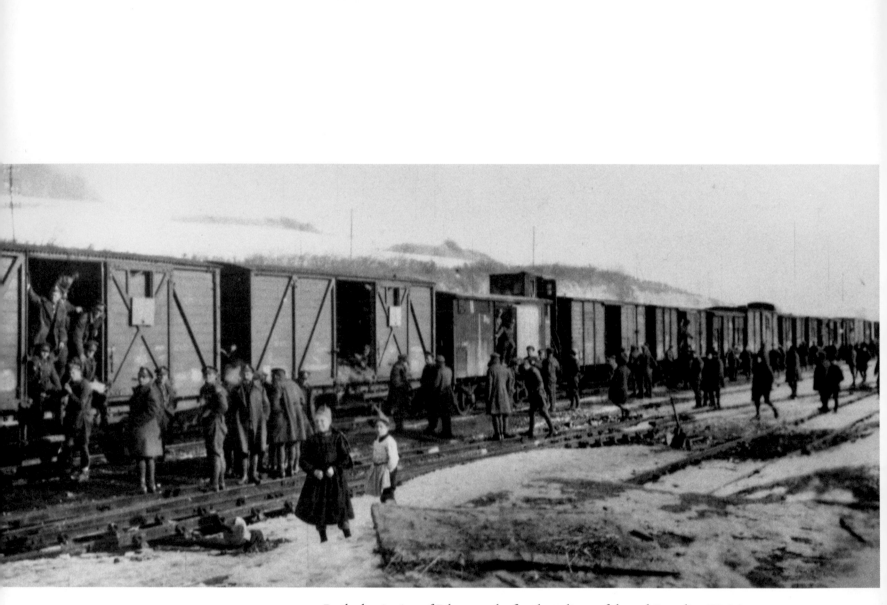

By the beginning of February, the first battalions of the 3rd Canadian Division were en route to "Blighty." Then it was a smooth process, one division succeeding the next, until by mid-April the last of the units reached England. There were serious difficulties in England, however, most notably at Kinmel Park. At this camp in Wales, a full-scale riot erupted for a host of reasons, including the 3rd Division's pride of place in the return home. Frustrated at the delays in repatriation, soldiers went amok in a wild mutiny that was put down by "loyal" troops and military police. The 3rd was thought to be full of conscripts, and hence undeserving. Five soldiers died in the alcohol-fuelled riot, and twenty-three were injured. There were other disturbances in Britain and Belgium, as discipline cracked. The CEF,

Desmond Morton said, "had become an army of homesick civilians, cold, restless, fed up." The revolutionary rumblings in the air, the "Red" agitation that frightened politicians throughout the West, undoubtedly contributed to the restlessness. Nonetheless, by the early autumn of 1919, virtually every soldier was home, receiving the plaudits of the crowds—for a few days, at least.

While the CEF was dissolving much faster than it had been created, Canadian soldiers were in action in northern Russia. The Bolshevik revolution frightened the Allies, who were fearful of the widespread discontent in their nations and who also had a vital interest in keeping Russia in the war. In 1918, Britain sent troops to Archangel and Murmansk to try to protect supplies from seizure by the Bolshevik troops. By agreement with Ottawa, the contingent included five hundred Canadians in an artillery brigade and a substantial number of Canadian pilots in the Royal Air Force. There was heavy action against the "Bolos," as the Canadians called the Bolshevik troops, and five were killed in action before the contingent withdrew in June 1919. At the same time, some 5,600 Canadians were serving in Vladivostok, Siberia, in a brigade commanded by Major-General J.H. Elmsley, a Canadian. Their task, in co-operation with British, American and Japanese troops, was to train the anti-Bolshevik forces, or Whites, and to protect rail and supply lines. By the spring of 1919, Ottawa—never enthusiastic about this operation—had pulled the Canadians out. Nineteen soldiers had died, three in accidents and sixteen of disease. The veterans of Russian service soon joined their CEF comrades in the ranks of the returned men.

ALMOST ALL THE VETERANS generally found their countrymen ungrateful. Canadians at home simply did not understand what the CEF had done or what war was like. The civilians wanted only to tell the soldiers how tough it had been in Canada, how rationing had cut down their food and how "aliens" were the only ones who had got rich out of the war. Some wives and girl friends had found the war too long and had made other living arrangements; many women and children could scarcely understand what had happened to so change their father, son or brother. And through it all, the great influenza pandemic of 1918–19 snatched away the weak and strong alike, perhaps as many as fifty thousand in Canada (and more than twenty million around the world). It was a hard, uncomprehending time.

CONCLUSION

189

BELOW: While the Canadian Expeditionary Force demobilized, Canadian soldiers were serving in Russia as part of an anti-Bolshevik coalition. Artist Louis Keene painted *Canadians Outside the Depot, Siberia* in 1919. (CWM Keene 8334)
RIGHT: In Halifax, the men disembark to begin the long train ride to their homes. Arthur Lismer's drawing splendidly captures the mood. (CWM Lismer 8382)

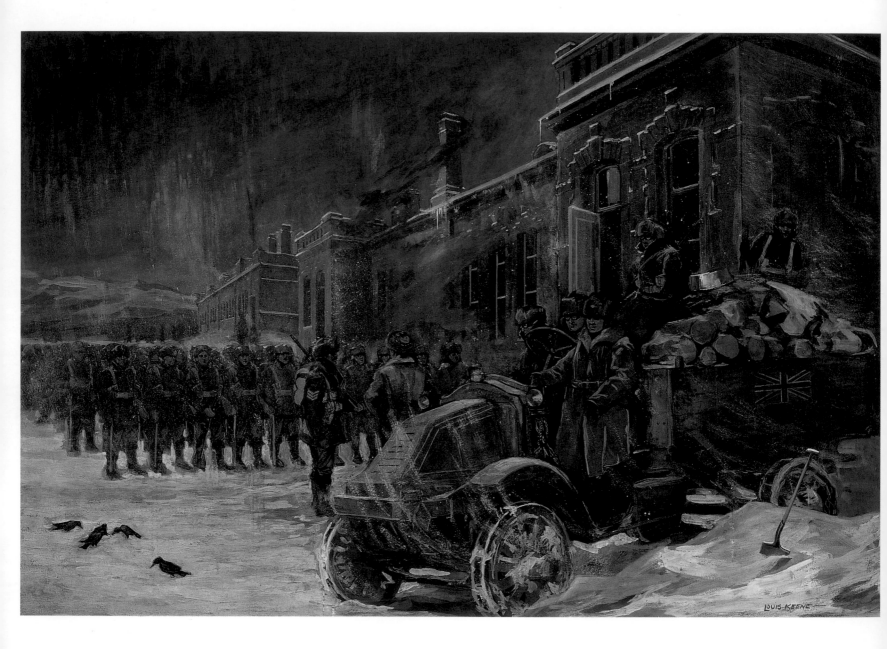

What made it worse was that the government did little to make the veterans feel welcome. Paying off the debts of the war and reducing taxation were the top priorities now. Yes, the federal politicians offered some programs, but these seemed inadequate to soldiers. Farmland could be had—in Kapuskasing. Pensions were small, offered at differential rates to officers and men, and contingent on the extent of disability. Each man did receive a war service gratuity, based on length of overseas service, a thirty-five-dollar clothing allowance and free medical care for one year. There was much bitter complaining that Canadians were trying to forget the promises that had been made when men were needed.

Lieutenant-General Sir Arthur Currie too grumbled. No one understood what the Canadian Corps had accomplished; no one wanted to remember the losses and sacrifice. Currie himself received a cold welcome home; the government was still afraid of the mad Sam Hughes, who carried his desire to get revenge on Currie into the peace. British generals of lesser accomplishments received large cash gifts from their government; Currie received nothing but a promotion to general and the post of inspector-general. It was mean and niggling; Canada's greatest soldier deserved much more from the country that he and his men had made into a nation.

The Canadian government, moreover, quickly returned the Permanent Force to its pre-war impotence. Canada was to have no regular army to carry on the tradition of professionalism that the Canadian Corps had created. The militia too was allowed to sink into desuetude. For a brief period in May and June 1919, while a general strike paralyzed Winnipeg and threatened to spread to other Canadian cities, it looked as if the government might keep the military at a strength sufficient to ensure competency and professionalism. But the strike failed and order was restored. The army's one chance to be efficient and well equipped disappeared.

The war lived on, ever more dimly, in memory. Veterans' organizations sprang up, lobbying for more money from a reluctant government and squabbling among themselves. Returned men went to school, found work, married, had children, restored their spirits and rebuilt their lives. Except for those who had been killed or whose loved ones had died, and those who had yet to recover from their wounds or to forget the horror, it was almost as if the war had never been. How terrible that in 1939, just twenty years after the legions had returned in triumph, Canada and Canadians had to do it all over again.

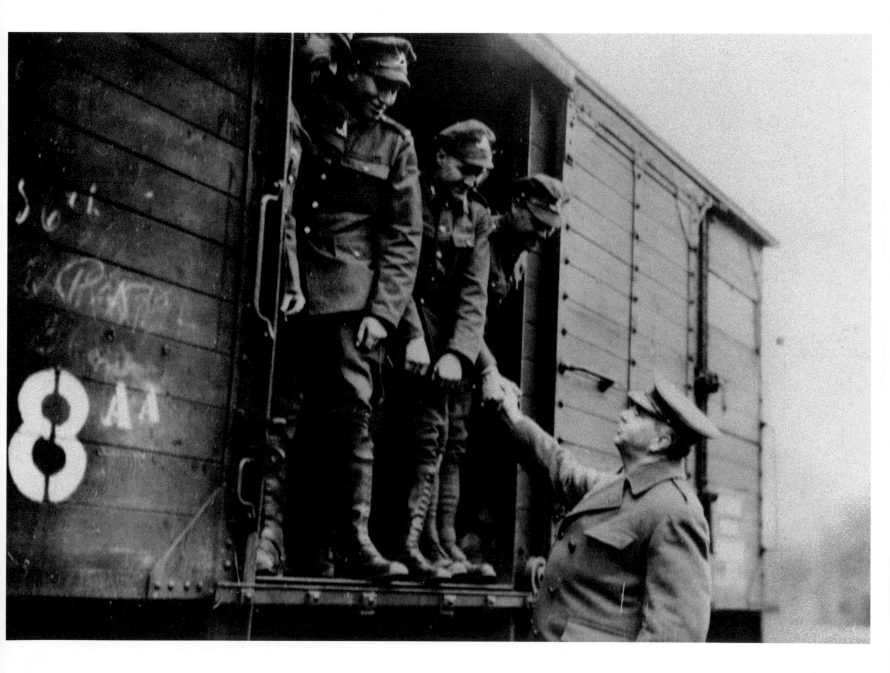

APPENDIX

Distinguishing Patches of Canadian Units in the Field

(Courtesy Directorate of History and Heritage, National Defence Headquarters, Ottawa)

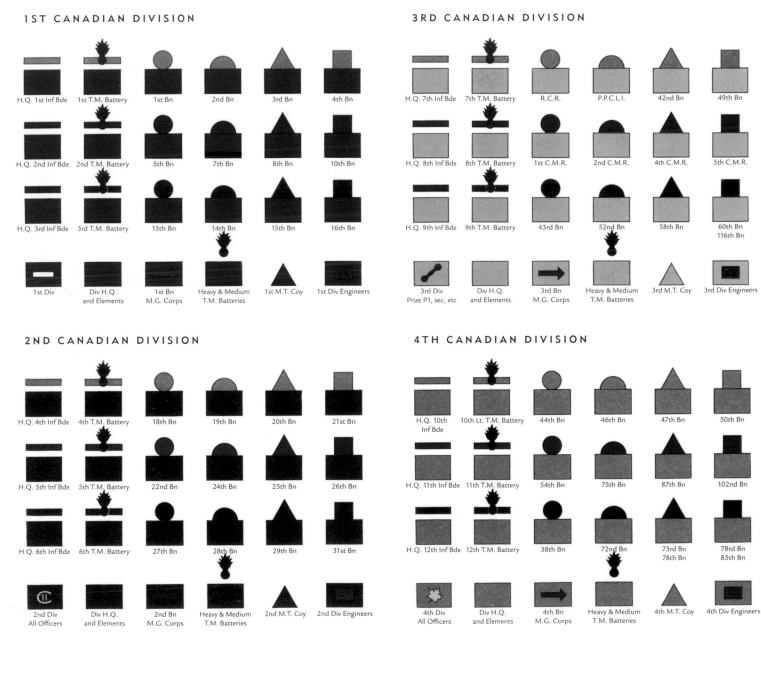

1ST CANADIAN DIVISION

H.Q. 1st Inf Bde	1st T.M. Battery	1st Bn	2nd Bn	3rd Bn	4th Bn
H.Q. 2nd Inf Bde	2nd T.M. Battery	5th Bn	7th Bn	8th Bn	10th Bn
H.Q. 3rd Inf Bde	3rd T.M. Battery	13th Bn	14th Bn	15th Bn	16th Bn
1st Div	Div H.Q. and Elements	1st Bn M.G. Corps	Heavy & Medium T.M. Batteries	1st M.T. Coy	1st Div Engineers

3RD CANADIAN DIVISION

H.Q. 7th Inf Bde	7th T.M. Battery	R.C.R.	P.P.C.L.I.	42nd Bn	49th Bn
H.Q. 8th Inf Bde	8th T.M. Battery	1st C.M.R.	2nd C.M.R.	4th C.M.R.	5th C.M.R.
H.Q. 9th Inf Bde	9th T.M. Battery	43rd Bn	52nd Bn	58th Bn	60th Bn 116th Bn
3rd Div Prize P1, sec, etc	Div H.Q. and Elements	3rd Bn M.G. Corps	Heavy & Medium T.M. Batteries	3rd M.T. Coy	3rd Div Engineers

2ND CANADIAN DIVISION

H.Q. 4th Inf Bde	4th T.M. Battery	18th Bn	19th Bn	20th Bn	21st Bn
H.Q. 5th Inf Bde	5th T.M. Battery	22nd Bn	24th Bn	25th Bn	26th Bn
H.Q. 6th Inf Bde	6th T.M. Battery	27th Bn	28th Bn	29th Bn	31st Bn
2nd Div All Officers	Div H.Q. and Elements	2nd Bn M.G. Corps	Heavy & Medium T.M. Batteries	2nd M.T. Coy	2nd Div Engineers

4TH CANADIAN DIVISION

H.Q. 10th Inf Bde	10th Lt. T.M. Battery	44th Bn	46th Bn	47th Bn	50th Bn
H.Q. 11th Inf Bde	11th T.M. Battery	54th Bn	75th Bn	87th Bn	102nd Bn
H.Q. 12th Inf Bde	12th T.M. Battery	38th Bn	72nd Bn	73rd Bn 78th Bn	78rd Bn 85th Bn
4th Div All Officers	Div H.Q. and Elements	4th Bn M.G. Corps	Heavy & Medium T.M. Batteries	4th M.T. Coy	4th Div Engineers

L.O.C. (LINES OF COMMUNICATION), ARMY AND CORPS TROOPS

C.L.H

5th Div Arty
14th Field Amb
5th Div Train Det

8th Army Bde
Cdn Fd Arty

Army Tps Coy C.E.
1st & 2nd Tramway Coys C.E.
A.A. Searchlight Coy

Cyclist Bn

C.C.H.A.

1st Bde C.G.A.

2nd Bde C.G.A.

3rd Bde C.G.A.

Cdn Corps
Survey Sec

Cdn Corps
Siege Park

1st M.M.G.
Bde

2nd M.M.G.
Bde

1st
Tunnelling
Coy

2nd & 3rd
Tunnelling
Coys

58th Broad
Gauge
Operating Coy

1st Aux
H.T. Coy

2nd Aux
H.T. Coy

Railway Troops

Labour Group
H.Q.

1st Inf
Works Coy

2nd Inf
Works Coy

3rd Inf
Works Coy

4th Inf
Works Coy

5th Cdn Div Arty
M.T. Det

8th Army Bde
Cdn Fd Arty
Park Section

C.M.M.G.
M.T. Coy

C.E.
M.T. Coy

Cdn Corps Tps
M.T. Coy

H.Q. Cdn Corps
Clerks

CANADIAN CAVALRY BRIGADE

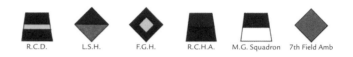

R.C.D.　L.S.H.　F.G.H.　R.C.H.A.　M.G. Squadron　7th Field Amb

SIBERIA AND N. RUSSIA

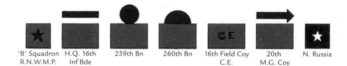

'B' Squadron
R.N.W.M.P.

H.Q. 16th
Inf Bde

259th Bn

260th Bn

16th Field Coy
C.E.

20th
M.G. Coy

N. Russia

INDEX

Page numbers in *italics* refer to figure captions or maps. Military units appear at the end of the index.